THE GOLDEN AGE
OF DISCOVERY

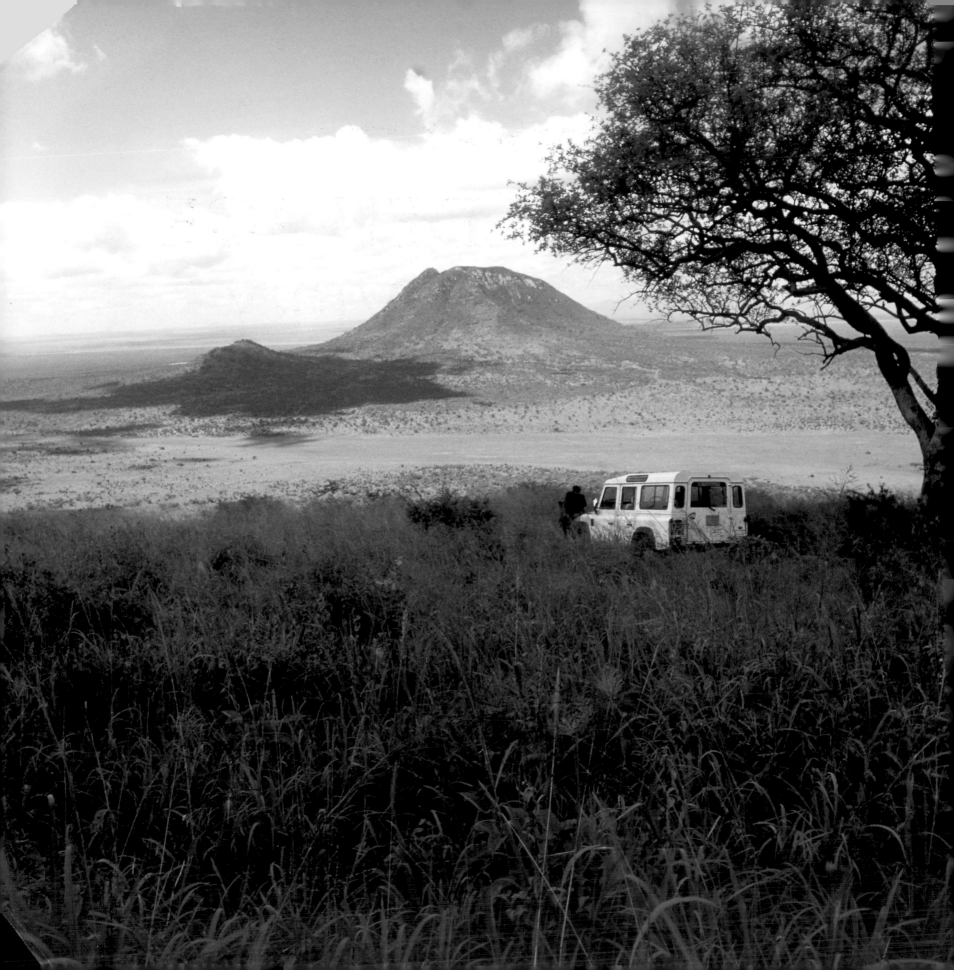

In celebration of 50th Anniversary

THE GOLDEN AGE OF DISCOVERY

John Hemming

PAVILION

First published in Great Britain in 1998 by
PAVILION BOOKS LTD
London House, Great Eastern Wharf
Parkgate Road, London SW11 4NQ
www.pavilionbooks.co.uk

This paperback edition published in 2000

The Land Rover Name and Logo are trademarks of Rover
Group Limited used under license by Pavilion Books Limited
© Rover Group Limited 1987 and 1996

Designed by Derek Forsyth and Partners
Picture Editor: Jenny de Gex

A CIP catalogue record for this book is available from the
British Library

ISBN 1 86205 356 1

Set in Gill Sans and Garamond
Colour reproduction by Colourpath, England
Printed in Italy by Conti Tipocolor

10 9 8 7 6 5 4 3 2 1

This book can be ordered direct from the publisher.
Please contact the Marketing Department. But try your
bookshop first.

FIFTY YEARS OF LAND ROVER

1998 marks the fiftieth anniversary of Land Rover, a truly remarkable and uniquely British institution. The name has become universally identified with the definitive four-wheel-drive vehicle and is recognized from Anchorage to Addis Ababa and from Tashkent to Tierra del Fuego.

The original Land Rover was conceived as an agricultural workhorse, stark and basic in the extreme, but possessed of sound engineering and enormous heart. Today's Defender, despite changes dictated by time or experience, or indeed legislation, still looks the part of a global explorer, with the seemingly limitless capabilities of its predecessors.

From humble beginnings, the brand has developed through the years with station-wagon variants of the workhorse, evolving into the versatile and supremely confident Range Rover (1970), a 4x4 estate car for the family in Discovery (1989), new Range Rover (1994), which redefined off-road luxury and refinement, and most recently Freelander (1998), which brings Land Rover's unique credentials to the small 4x4 market.

Land Rover's history is filled with drama and excitement, whether exploring remotest Africa, penetrating dense jungles or crossing vast desert expanses. It evokes images of tropical expeditions and humanitarian relief in faraway lands, often heaped in mud, sweat and toil or baked in equatorial sun.

In all its guises the Land Rover brand has become synonymous with exploration and adventure, and John Hemming's account of the Golden Age of Discovery is a fitting tribute to Land Rover's first five decades of achievement.

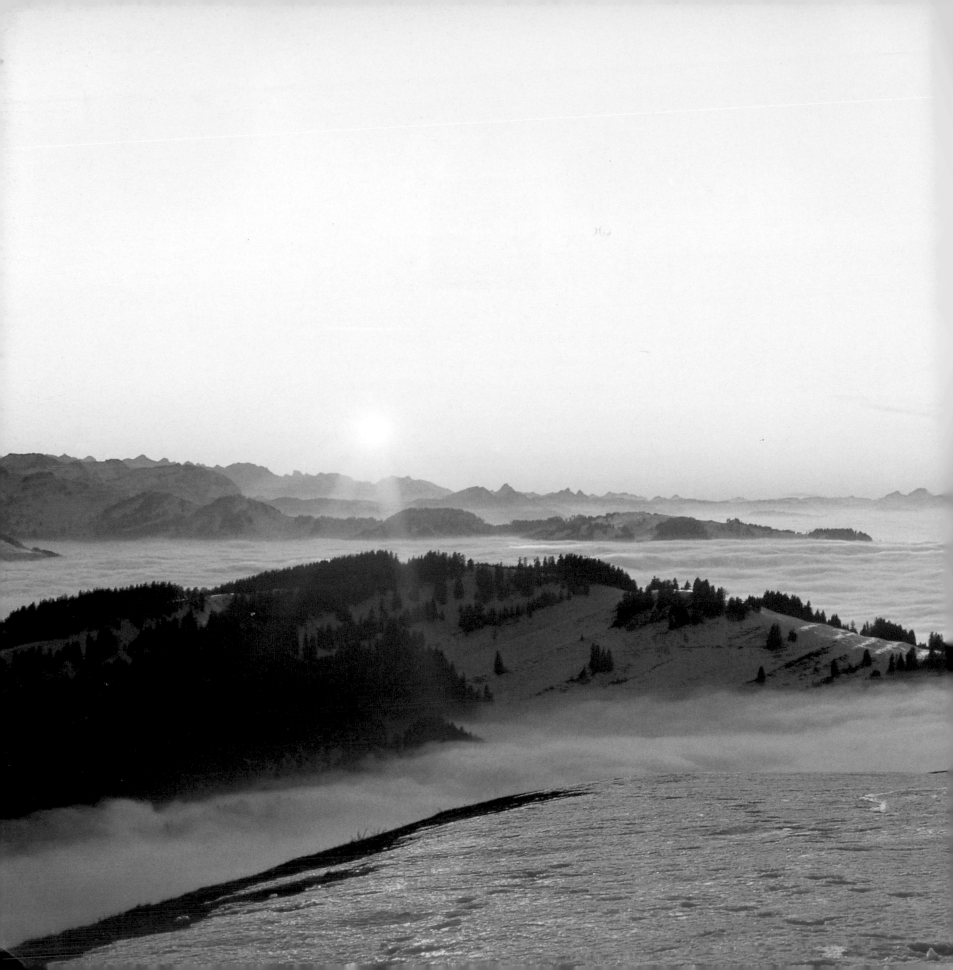

CONTENTS

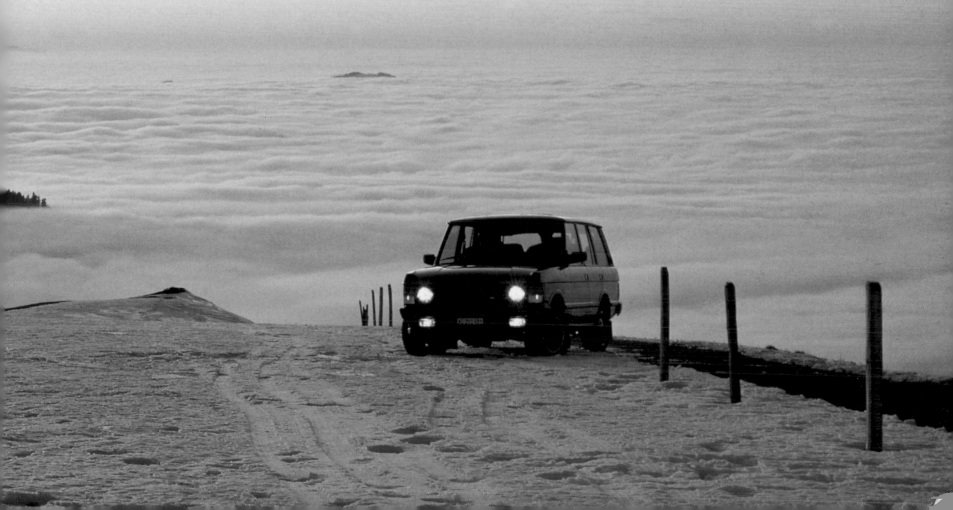

INTRODUCTION

As Director of the Royal Geographical Society from 1975–96, I was often asked: 'What is there left to explore?' This question often came from educated, intelligent and well-meaning people, and it amazed me. Ever since my first expedition in unexplored territory, in central Brazil in 1961, I have been surrounded by people making discoveries. The Royal Geographical Society (with IBG) organizes its own large multi-disciplinary projects, it gives training and advice to hundreds of small research expeditions, every year it hears talks or learned papers by a great many scientists, it publishes three scholarly journals and its library subscribes to several hundred journals that record the findings of researchers and explorers from all parts of the world. During the twenty-one years that I ran the Society, these activities all expanded hugely, both in quantity and probably also in quality. I also met many of the people mentioned in this book, and I concluded that we are living now in the golden age of discovery.

I have great admiration for the famous explorers of the past. In my office I had Dr David Livingstone's table and clock; outside was a statue of Sir Ernest Shackleton; and every day I walked past portraits of the Society's gold medallists – all the great names of exploration from every country. But those admirable men and women were just opening a crack in the door of discovery. They were fulfilling my definition of an explorer: 'someone who penetrates beyond the world known to his own society, discovers what lies there, and returns to describe it to his own people'. But the explorers of the nineteenth and early twentieth centuries enjoyed almost none of the advantages of the fortunate discoverers of our own lifetimes.

Present-day scientists and explorers travel with improved communications, to take them to almost any part of the planet. They confront fewer political obstacles in the post-war and post-Cold-War eras. They can use remarkable inventions and improvements in equipment to penetrate everywhere from the bed of the oceans to the highest mountains, into deep caves or the rain-forest canopy, and to

Opposite: Cloud clings to the forest canopy in Brunei. Tropical rain forests precipitate moisture back into rain clouds through evapotranspiration but this ancient ecosystem is in balance in absorbing and emitting carbon.

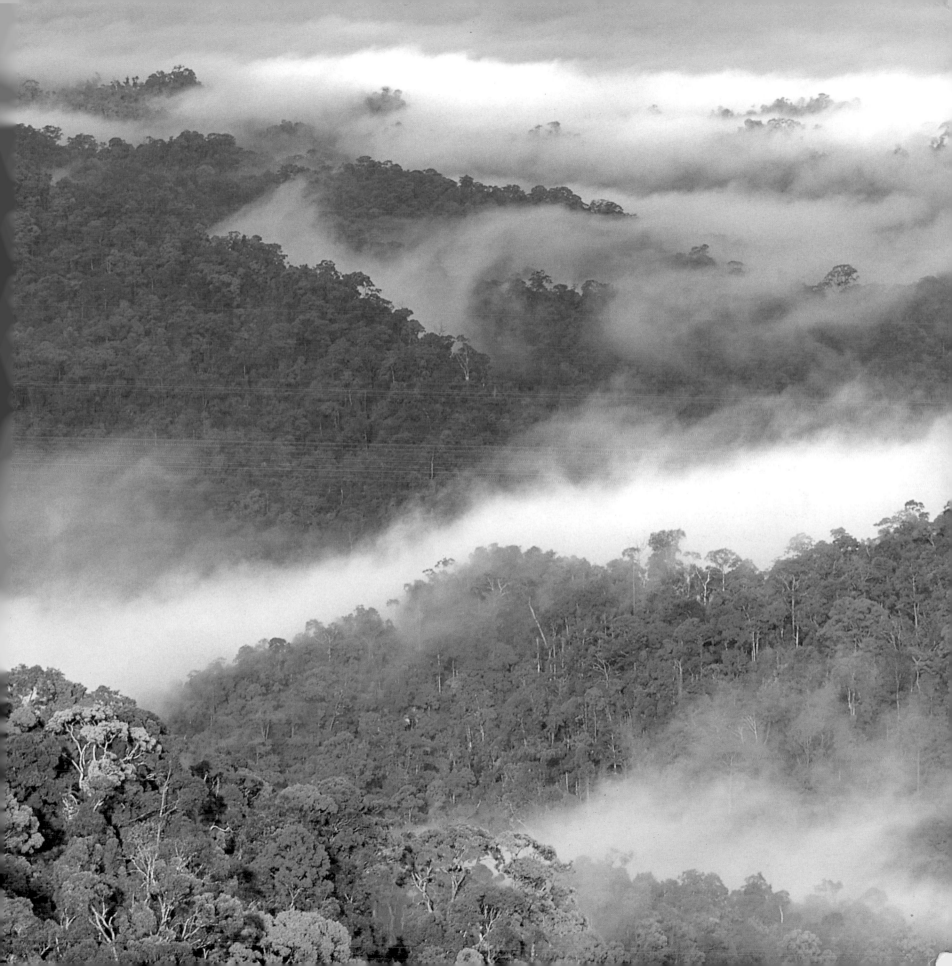

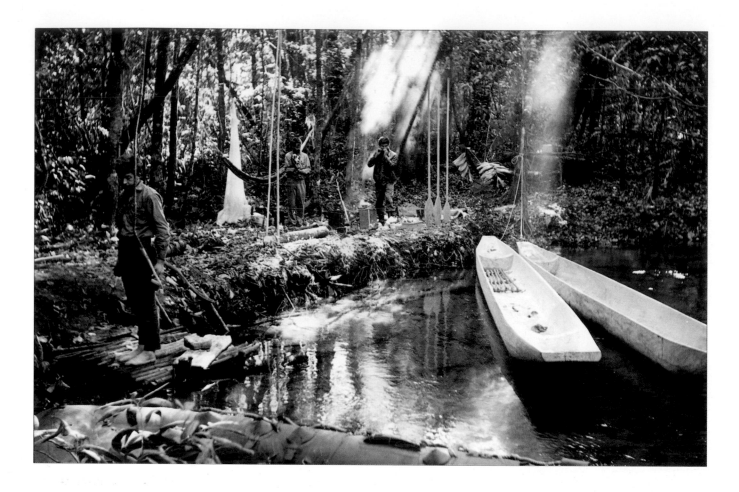

Above: Camp on a newly discovered headwater of the Iriri river, central Brazil. John Hemming's picture of the expedition's two dugout canoes and Dunlop inflatable boat, with Richard Mason on a jetty (left foreground), and Kit Lambert standing among the hammocks and mosquito nets.

survive in the harshest environments of the polar regions or the deserts.

There are vastly more trained scientists than ever before; and they are better educated, so that their research builds on a corpus of existing knowledge. Our discoverers enjoy the immense good fortune of having a wealth of material still to be recorded for the first time. Vast areas of the planet, including the seven-tenths that lie beneath the oceans, as yet untrodden by humans; and a great part of the natural world is pristine territory, with processes and species unknown to our science. To their credit, thousands of researchers are seizing this amazing opportunity with zeal.

Witnessing this flowering of discovery, I came to agree more and more with the American oceanographer Robert Ballard when he wrote: 'The key is science. Science gives legitimacy and worth to exploration. You see a lot of stunts today, but if you're not doing worthwhile science, you're not an explorer. You're just wandering around.'[1] The trouble with scientific explorers is that they are too modest. They take risks, endure great hardships and deploy impressive skills in

the pursuit of their research quarry. But it does not occur to them to boast to the media on their return; and editors often think that their readers prefer to learn about the adventures of what Dr Ballard calls stunt men. Also, scientific research is a slow process. An honest researcher returning from an expedition keeps an open mind until all the data gathered in the field has been analysed. That can take months or years, and it may be scientifically complicated and difficult to explain in lay terms. So there are few soundbites or headlines from these true explorers.

Below; Land Rover provided vehicles for the savannah research expedition to the Kora National Reserve, Kenya, organized by the National Museums of Kenya and the RGS in 1983.

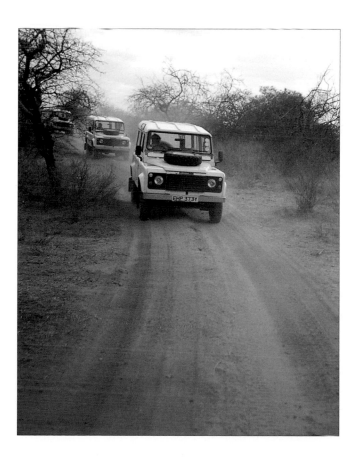

This book is presumptuous. It seeks to give only a personal overview of a few of hundreds of expeditions of discovery, in the mainly remote realms of nature. Vast areas of research are omitted altogether, and I can mention only a tiny fraction of the astounding discoveries being made, particularly about tens of thousands of plants and animals in the various habitats and ecosystems. Also, because scientists tend to be too modest to write about themselves, I have sometimes included the readable and impressive achievements of Ballard's stunt men – the gallant mountaineers and cavers, and the purists who walk to the poles or cross the deserts without machines. As such expeditions are moving across country and overcoming physical obstacles, they cannot conduct much scientific experiment. But they do penetrate places that were previously untrodden; and that in itself is a form of discovery.

Despite its limitations, I hope that this book will give an impression of our generation's remarkable achievements. It should demonstrate emphatically that we are living in the golden age of discovery. It should stop anyone asking whether there is anything left to explore. Instead, they should consider the words of the palaeontologist Maeve Leakey, wife of Richard Leakey: 'Exploration is an obsession. The more I discover, the more I want to know. Unfortunately I will never discover everything I want. One can never, never find all the answers.'[2]

RAIN FORESTS

Tropical rain forests are located around the Equator. It takes plenty of sunshine and rainfall to produce the exuberant flora and fauna of the world's richest ecosystem. The tropics are closest to the sun. Since the earth spins on a polar axis, the equator travels farthest and fastest in each daily revolution. The resulting centrifugal force helps to create trade winds, whose warm air is laden with moisture which, when the air rises and cools, is deposited as heavy tropical rain. Over half the earth's tropical rain forests are in the Americas: 9.2 million square kilometres (3.55 million square miles); and almost all of this is in South America, in the basin of the Amazon – which is by far the largest river system – and the adjacent Orinoco basin.

Until recently, exploration of rain forests was based entirely on rivers. The main Amazon is a vast waterway capable of taking ocean-going ships; but movement up its gigantic tributaries is often blocked by rapids, particularly towards the headwaters of the forested rivers far from the main Amazon. So, soon after the War, the Brazilian government decided to launch an ambitious overland expedition, to cut

diagonally into the centre of their great country. The explorers would move through virgin forests, from the Araguaia river system to the Xingu (pronounced Shin-goo), and then on to the Tapajós, all of which are southern tributaries of the Amazon and each as large as any European river.

It was decided to recruit only backwoodsmen for the years of arduous cutting in this Roncador-Xingu Expedition. But three young brothers called Villas Boas from the city of São Paulo went inland to enlist, pretended that they were experienced *sertanistas* (woodsmen), and were taken on. With their powerful, exuberant personalities and their superior education, the Villas Boas soon took charge of the expedition. Years of exhausting and dangerous trail-cutting ensued. The teams drove their *picada* forward by slashing through the undergrowth, occasional swamps and tangles of creepers with nothing more than blows of their men's machetes. This is still the only way for non-natives to push

Opposite: *Sungai Enkiang photographed during the Brunei University and Royal Geographical Society survey of the Batu Apoi Forest Reserve in Brunei Darussalam in 1991–2.*

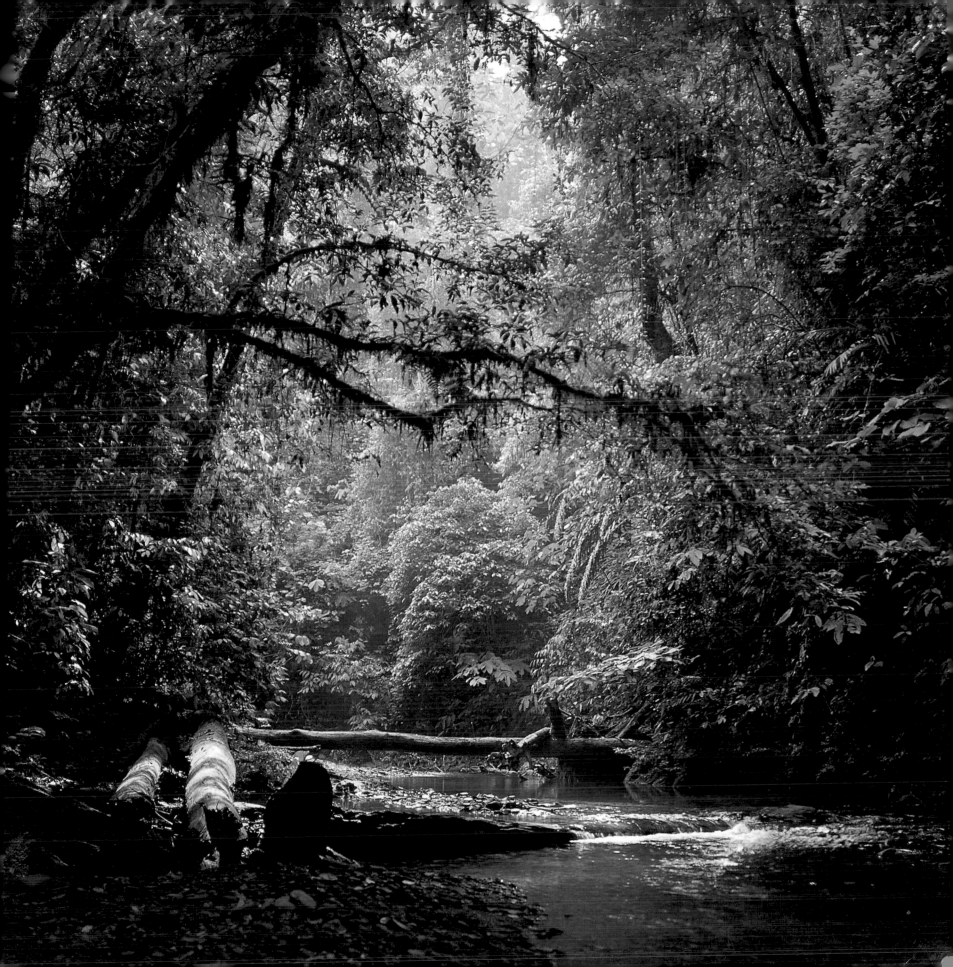

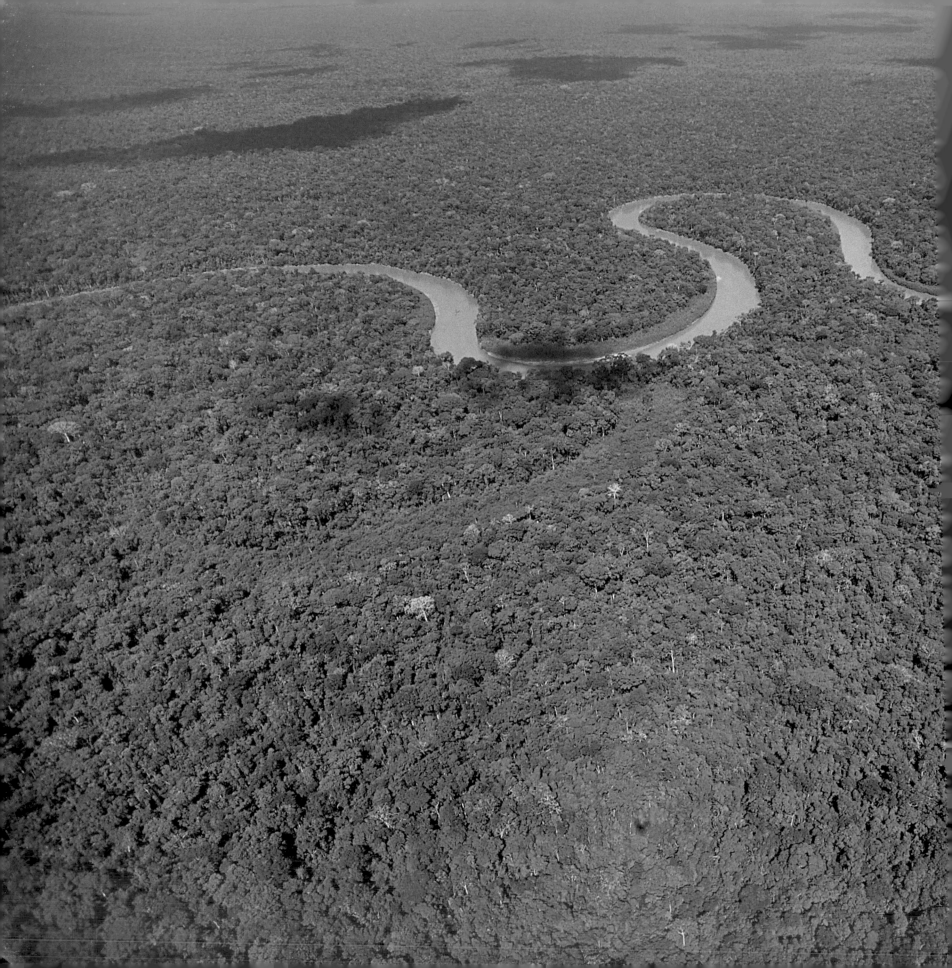

into rain forests. It is sweaty work in the tropical humidity, often slithering on the muddy pink soil and the roots and dead leaves of the forest floor. At times the heat is suffocating or the rains torrential. Some explorers dislike the gloom of a high forest, where weeks are spent without experiencing direct sunlight. Food is always a problem, for there are few edible fruits at ground level near the tree roots, and game is scarce and elusive. In the early weeks, the twenty men of the Roncador-Xingu Expedition's cutting party were supplied by ox and mule trains along the path they had cut. Later, the trail was too broken for draft animals, and the weary explorers were fed only by occasional air drops. They suffered terribly from hunger and frequent illness. Some were prostrate from malarial fever, so weak that they had to be carried from their hammocks to defecate.

The first few hundred kilometres were across the country of the Xavante (pronounced Shavante), a proud and hostile tribe that had, during the preceding century, killed or repelled all intruders who crossed the aptly named Rio das Mortes (River of the Dead) into their territory. The Xavante prowled round the expedition's camp at night, making ominous noises of bird calls, animal cries or drumbeats. They finally launched an attack. Warriors, shouting fearsomely, advanced through the trees. But, by climbing a termite mound, the Villas Boas saw that this was a feint: the main onslaught was from the opposite direction. A desperate volley of gunfire, into the air, stopped the Xavante; and they then allowed the explorers to move on across and out of their territory.

Left: *Aerial view of the meandering Rio Pinquan, showing the lowland rainforest forming the Manu Biosphere Reserve in Peruvian Amazonia, one of South America's first protected rainforest areas.*

By the end of 1947 the expedition had cut through to the basin of the Xingu River, into an area where a dozen tribes of different language groups lived in generally amicable contact with one another. These Xingu tribes had had intermittent contact with whites who made their way down from savannahs at the source of their river. But the Indians (as American natives have been known since Columbus' day) had not changed their cultures in any way. They were handsome people, living in superbly constructed, great thatched huts in harmonious villages in the midst of edenic forests and fish-laden rivers and sandbanks. Brilliant hunters and fishermen, their weapons and tools contained almost no stone, and their only apparel was feather ornaments and shell necklaces. The Villas Boas brothers fell in love with this forest paradise and came to devote their lives to protecting its indigenous peoples. One brother died of disease. The survivors are Orlando – portly, swarthy with a straggly black beard, exuberant and with an expansive personality that won the Indians' affection – and Cláudio, quieter, a Marxist

Below: *A Parakanã girl standing in her communal hut, central Brazil, soon after her tribe was traumatised by its first contact with the outside world.*

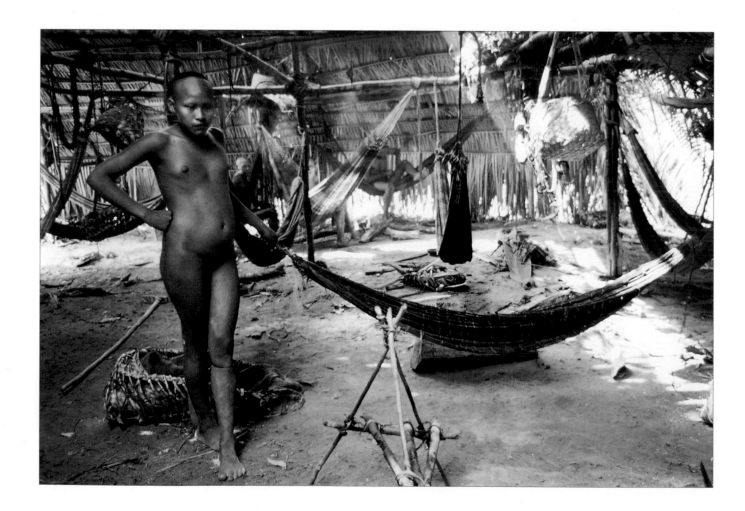

philosopher and heavy drinker, but equally brilliant as a forest explorer and champion of native rights. The author has been on expeditions with both brothers and seen how skilfully they and their teams of Indians fish, hunt and move through the forests.

One purpose of the Roncador-Xingu Expedition was to clear airstrips out of the rain forest. A string of such bases, diagonally across the forests of central Brazil, opened the way for meteorologists to staff weather stations in this ocean of vegetation, and for medical teams, anthropologists and Indian-service officials to work with the tribes.

The Villas Boas brothers spent the year of 1950 cutting another trail north-westwards to the Cachimbo hills, and in 1956 they moved on for several hundred more kilometres to the Tapajós river system. During more than thirty years after their arrival on the Xingu, Orlando and Cláudio Villas Boas became both the greatest defenders of the Indians and the leading Brazilian explorers of recent times. They pushed their boats up countless rivers and over innumerable rapids and cut trails into many unexplored forests, and they made first contact with half a dozen isolated tribes. The Indians under their care were affectionately nurtured. The Villlas Boas brothers were also astute politicians, impressing successive governments with the need to treat Indians well, and using the glamour of their primeval world to enlist the media in their campaigns. As a result, a huge swathe of forests and rivers around the upper Xingu was declared an Indian Park. This preserved the tribes' lands and hunting grounds. It gave them the protective cushion they needed to adapt, at a speed to suit them, to the strange world that was advancing inexorably towards them. The Villas Boas' philosophy was not to create a 'human zoo', but rather to allow

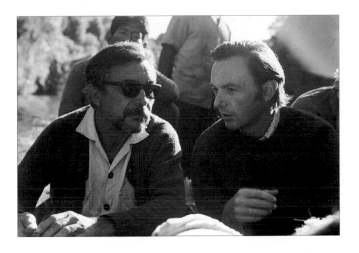

Above: *John Hemming with Claudio Villas Boas, one of the legendary brothers who championed Brazil's Indians and among the world's greatest explorers of new territory. Claudio Villas Boas died in 1998.*

the Indians themselves to decide whether, when and how to change their customs.

In 1961, the author was on the Iriri River Expedition that cut for the first time into the forests north east of the airstrip recently cleared by the Villas Boas at Cachimbo. The area was completely unexplored, like so much of Amazonia. The Brazilian government's mapping agency sent three of its best surveyors and gave us permission to name any new rivers or other geographical features. By modern standards, our exploratory methods were archaic. We had no air cover, no aerial photography, no helicopters and, of course, no satellite imagery. So we relied on cutting trails along straight bearings, constantly checking with a compass before pushing and hacking forward. We occasionally calculated our co-ordinates by star fixes, using a theodolite and radio time signals, even if this meant cutting down a tree for clear observation of the stars we wanted to use. All went well for six months of hard going – opening trails, pressing forward

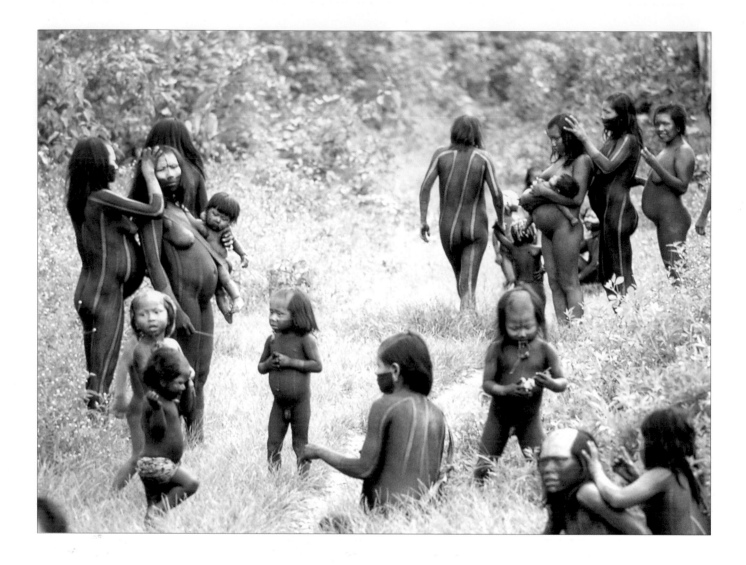

on lightweight explorations to see the lie of the land, carrying supplies to each successive hammock camp, and having our five woodsmen build dugout canoes with their axes. Although we sometimes shot game – peccary, tapir or game birds – most of our food was the black beans, rice and jerked meat heaved forward in our backpacks. So we ate only one dish of food a day and were constantly hungry. There was even time to do some collecting, which yielded new specimens for the herbarium at the Royal Botanic

Above: *Women and children of the Xikrin group of Kayapó Indians in Brazil dye their bodies with black genipapo juice, as decoration and protection against insects.*

Gardens, Kew, and to enjoy the majestic beauty of pristine rain forest.

One day, tragedy struck. The expedition's leader, my close friend Richard Mason, was ambushed while carrying a load forward along our main trail. His body was laid on the trail, hit by arrows and with the head smashed; and his killers

had left some forty arrows and seventeen heavy clubs arranged around him. The attack was completely unexpected, for Brazil's leading Indianists, Orlando Villas Boas and Chico Meirelles, had both assured us that no tribe was thought to live in the Cachimbo hills. The expedition returned to the tiny Cachimbo airstrip. We went back five days later, with a medical team and Indians from another tribe, to embalm Mason's body and carry it out, for eventual burial in the British cemetery in Rio de Janeiro. In ensuing years, the Villas Boas brothers led a series of attempts to contact the elusive tribe that was thought to have attacked us. For a time it was rumoured that they were unusually tall 'giants'. After dangerous expeditions that entered their deserted villages and left presents (of machetes, axes and beads) on their paths, the Villas Boas in 1971 finally achieved a face-to-face meeting with these people, the Panará (then known as Kren-Akrore). Study of their village locations showed that the tribe's northernmost settlement was some forty kilometres from where they ambushed Richard Mason. This confirmed that it was done by a long-range hunting party, that had come across our trail and killed the first person to walk along it into their trap.

There have been expeditions similar to ours (although mercifully without a fatal ambush) all over the immense forests of Amazonia in recent decades. Elite teams of the Brazilian Indian service have occasionally made contact with isolated tribes. The author has had the amazing experience of seeing four such tribes, in different Brazilian rain forests, at the time of their first sight of people from our world. As human beings, each group reacted differently to the trauma of this contact with clothed aliens. One tribe was hostile, with the men constantly holding their bows and arrows; two groups were in a state of shock; and a fourth treated us strangers like gods, trying to give us all their few possessions. Such contacts were necessary because outsiders were approaching: either frontier settlers, or ruthless gold or diamond prospectors, or workers cutting a road toward a tribe's remote forests. It was essential that the indigenous group be contacted by well-intentioned professionals, and its lands defined and legally protected before the onslaught of our aggressive civilization.

Once contacted, Amazonian Indians have taught anthropologists much about sustainable survival in their forests.

Below: *John Hemming and Richard Mason (front) carry an inflatable boat towards the headwater of the Iriri River. Mason was later ambushed and killed, on this path, by the then-unknown Panará tribe.*

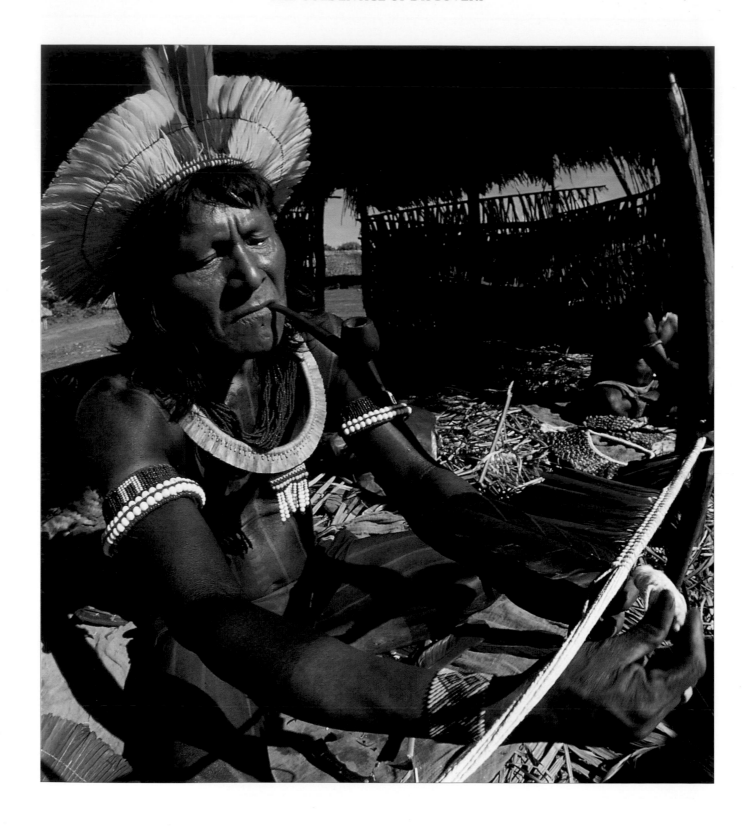

Professor Richard Evans Schultes of Harvard University developed the academic discipline of ethnobotany, the study of native uses of plants. Schultes was the first senior botanist to take tribal shamans seriously. By gaining their confidence and sharing their hallucinogenic trips, he learned some of their amazing knowledge of forest plants and particularly of their medicinal properties. Professor Schultes is a conservative New Englander in manner and dress; but he was the inadvertent founder of the hippy drug movement through his rediscovery of peyote, ayahuasca (yagé) and the various 'magic mushrooms'. Schultes was also a remarkable explorer, pushing far up the rivers of Colombia's Amazonas province, often delirious from malaria, and making extremely challenging traverses of the forested watersheds between the rivers. He also lived for months on end with the tribes of north-western Amazonia.

Early naturalists made great collections of the rain forests' flora and fauna. But until recently nothing was known about how these richest of all ecosystems function. So the thrust of modern research is to learn more about the biodiversity of the habitats that contain perhaps half the ten million or more species with which we share our planet. We are starting to understand the myriad and complex ways in which these organisms interact with one another.

Most scientific observation is static. Researchers need to remain in one location, quietly monitoring activity over as

Opposite: Brazilian Indians are entirely self-sufficient, making all their string, ornaments, tools and weapons from rain-forest plants and animals. A Kayapó sews macaw feathers into a handsome headdress.

Right: A team surveys an artificial clearing being opened for a series of experiments in forest regeneration, on the Royal Geographical Society's Maracá Rainforest Project in Brazil, led by the author.

long a period as possible, tracking individual species through a relatively small area of movement, or setting traps to collect insects, reptiles, bats and other small mammals, or the litter that is constantly falling from the forest canopy. Such work is best done from a permanent research station. Scientists enjoy a base's simple logistics, which includes native 'tree-climbers' or *técnicos* with a wonderful fund of vernacular knowledge of forest lore. The researchers move out each morning to monitor their plots or establish trail systems and substations deeper into the forest or up the surrounding rivers. Over the years each station acquires a corpus of baseline data, with ever-growing collections of specimens. Successive teams of scientists add to their predecessors' findings.

One of the oldest research stations is Barro Colorado, an island in a lake in the midst of the Panama Canal. Founded in 1923, Barro Colorado has been maintained by the Smithsonian Institution of Washington ever since. Although only 54 square kilometres (21 square miles) in area, the island supports all the usual species of a Central-

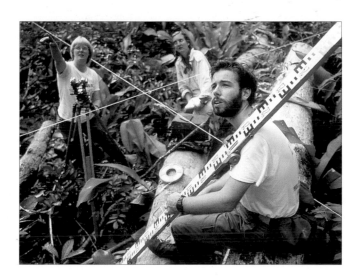

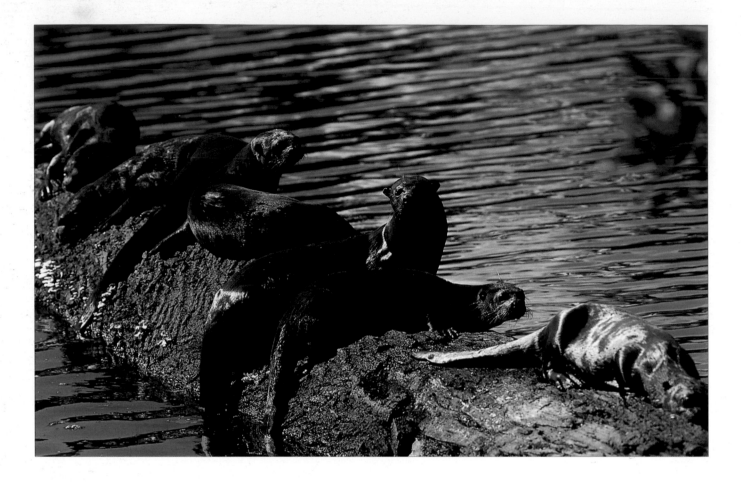

American rain forest. So researchers have been able to study some of its insects, birds and plants in great depth. Nearby Costa Rica has lost a greater proportion of its forests than any other American country; but it has now protected what remains. Useful work is done in the Costa Rican research stations such as Braulio Carrillo, near the capital city, with a system of aerial ropeways for studying the forest canopy. But the most important stations are, of course, in the vast Amazon forests of South America. The eastern slopes of the Andes in Peru have the highest biodiversity of any neotropical forest – several hundred different major tree species and record numbers of animal species in

Above: *Giant otters,* Pterornura brasiliensis, *have been hunted almost to extinction for their skins. One of the twenty-three most-endangered species in the world, they are protected in the Manu Biosphere Reserve in Peruvian Amazonia.*

Opposite: *A researcher ascends into the rain-forest canopy in Peru.*

any patch of rain forest. There are two centres of research in the Peruvian part of this beautiful region: in the Manu biosphere reserve, where a large part of the 15,328 square kilometres (almost 38 million acres) of protected forest is reserved for scientists, and at the almost equally large Tambopata-Candamo reserve, down-river on the Madre de

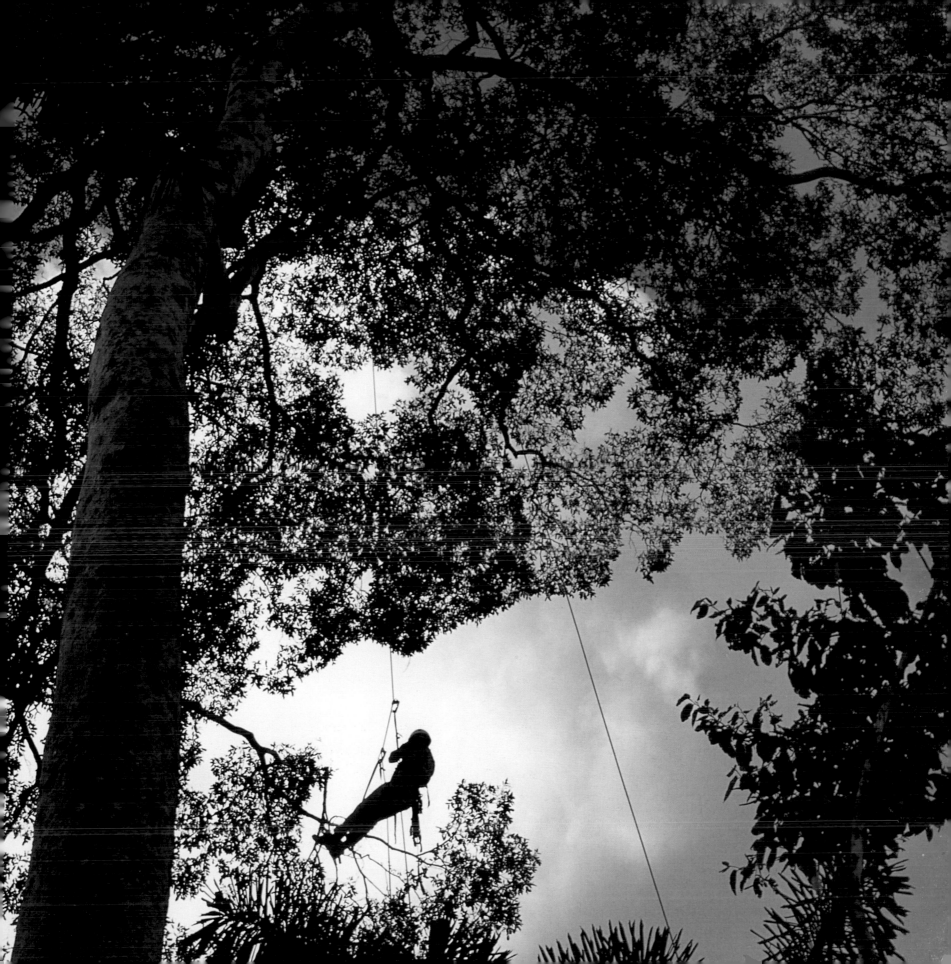

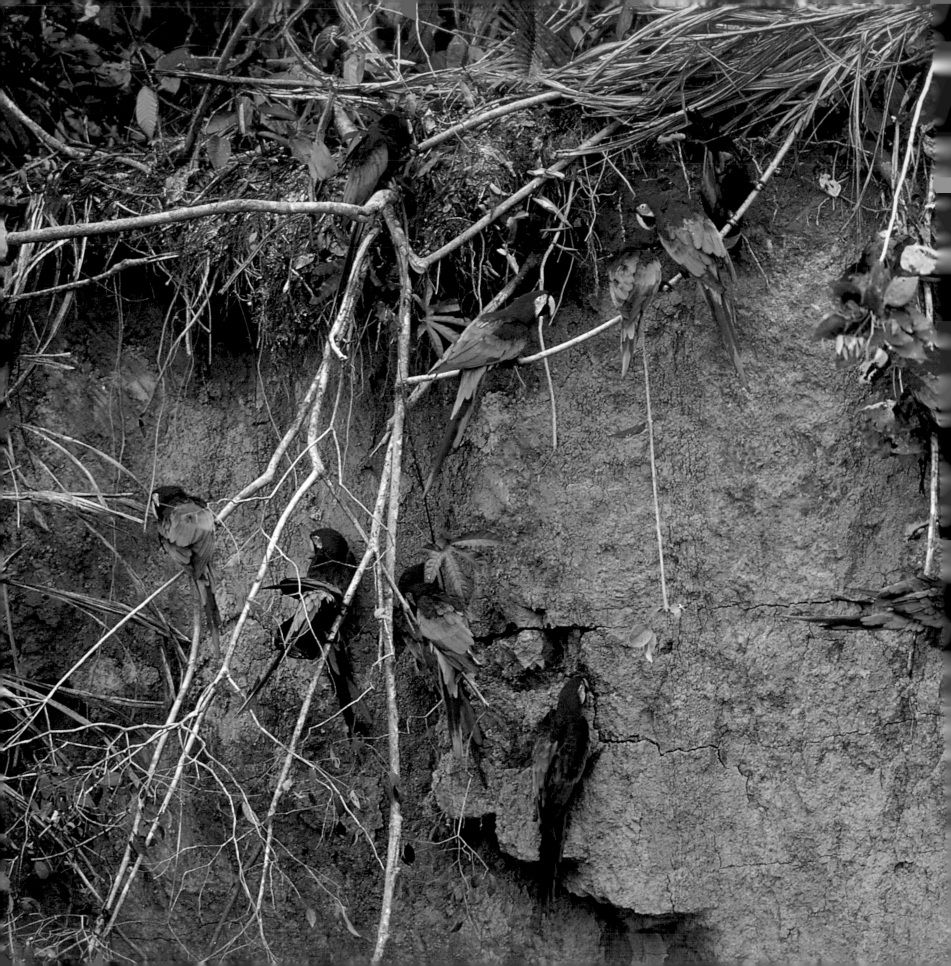

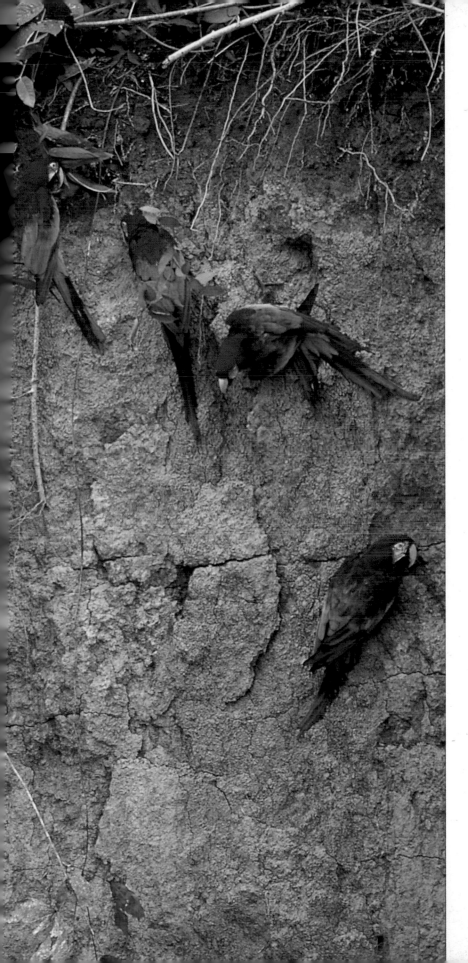

Dios River. Particularly important studies have been done on macaws and giant otters, rare species that abound in the Manu. The giant otter, *Pteronura brasiliensis*, has so luxuriant a pelt that this delightful animal has been hunted almost to extinction – it is one of the world's twenty-three most endangered species. In Brazil, there are two large urban campuses devoted to all aspects of rain-forest investigation: the national Amazon research institute INPA at the edge of the city of Manaus, and the Goeldi Museum in the city of Belém do Pará near the mouth of the Amazon. The hundreds of scientists based in these two federal-government research centres, and the hundreds more in Brazil's many universities, have a few ecological stations in their country's tens of millions of hectares of forested national parks and protected areas. Most such parks are simply uninhabited expanses of forest with virtually no government presence. For instance, the Jaú national park, up the Rio Negro from Manaus, covers 22,720 square kilometres (8,800 square miles). The Pico da Neblina Park on the watershed between the Negro and Orinoco rivers is almost as large, as is the Xingu Indian Park achieved by the Villas Boas brothers; and there are dozens of smaller reserves. In the south-western Brazilian state of Acre is the first 'extractive reserve', a protected area of rain forest rich in *Hevea brasiliensis* trees that can be sustainably milked by *seringueiro* rubber tappers. This experimental reserve is named after Chico Mendes, the charismatic leader of the National Council of Rubber Tappers, who was murdered in 1988 by cattle ranchers seeking to destroy the forests and try to convert them to pasture.

Left: *One of the finest sights in the tropics is a* collpa; *a river bank where a host of brilliantly coloured macaw come daily to lick salts and other antidotes to the poisons in plant seed kernels.*

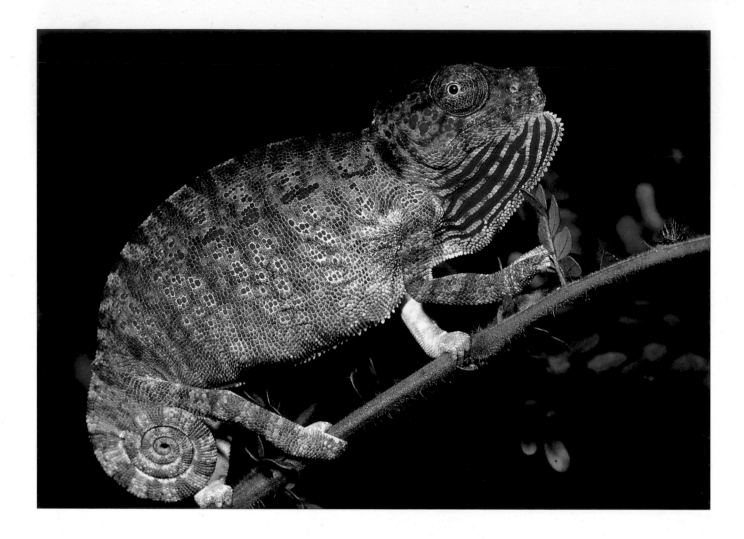

Across the Atlantic in West Africa, a rapidly growing population – which doubles every twenty years – is destroying the remaining forests. Civil strife in some countries aggravates the problem. There are a few protected areas, such as Gola in Sierra Leone, Tai in the Ivory Coast, the Cross River National Park in Nigeria, and particularly the research station of Korup across the border in Cameroon. Eighty per cent of the continent's rain forests are in central Africa, notably in the two Congos, and there are research efforts at such protected areas as Odzala in Congo Brazzaville,

Above: *The brilliantly coloured snub-nosed chameleon,* Chamaeleo labordi, *is one of Madagascar's many unique or endemic species. As its name suggests, it changes its colouring to suit the background.*

Opposite: *Madagascar, isolated from Africa by continental drift, has one of the world's highest ratios of endemic species. These include many species of lemur, such as this Ring-tailed lemur,* Lemur catta.

Salonga National Park in Congo Kinshasa, Dja in Cameroon and various reserves in Gabon.

Madagascar, the world's fourth largest island, has been isolated by continental drift for forty million years. Thus, four-

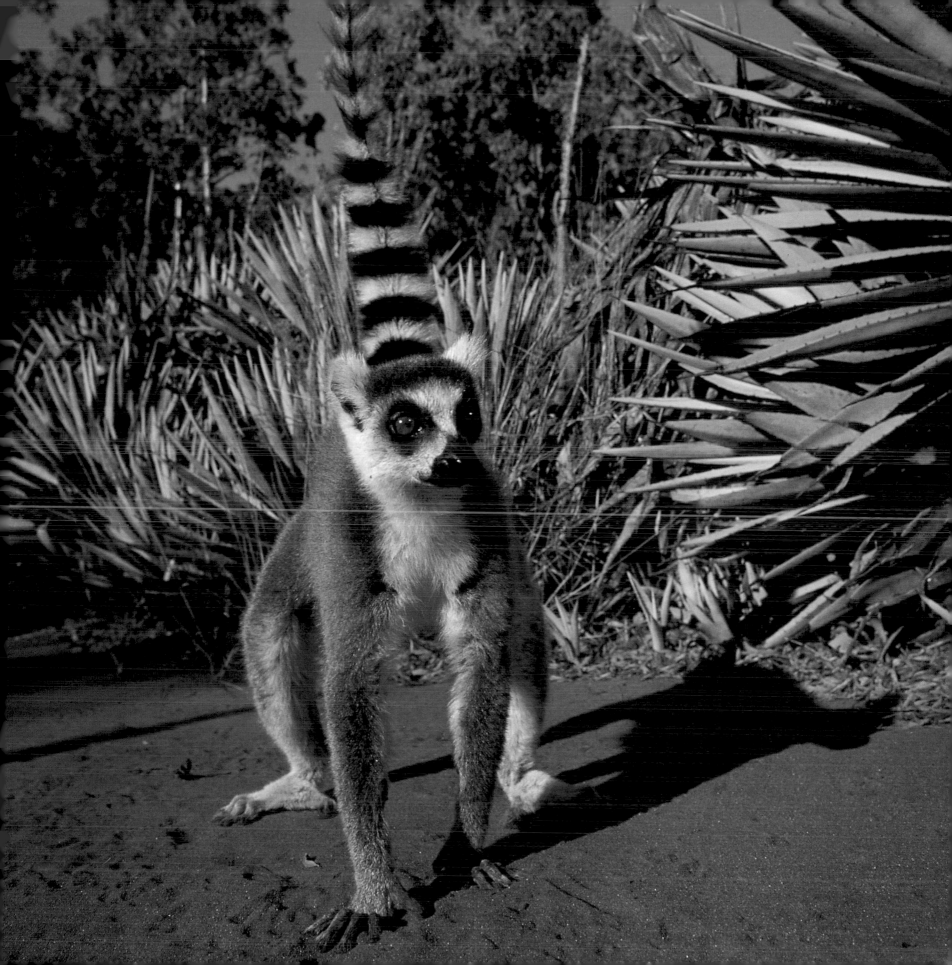

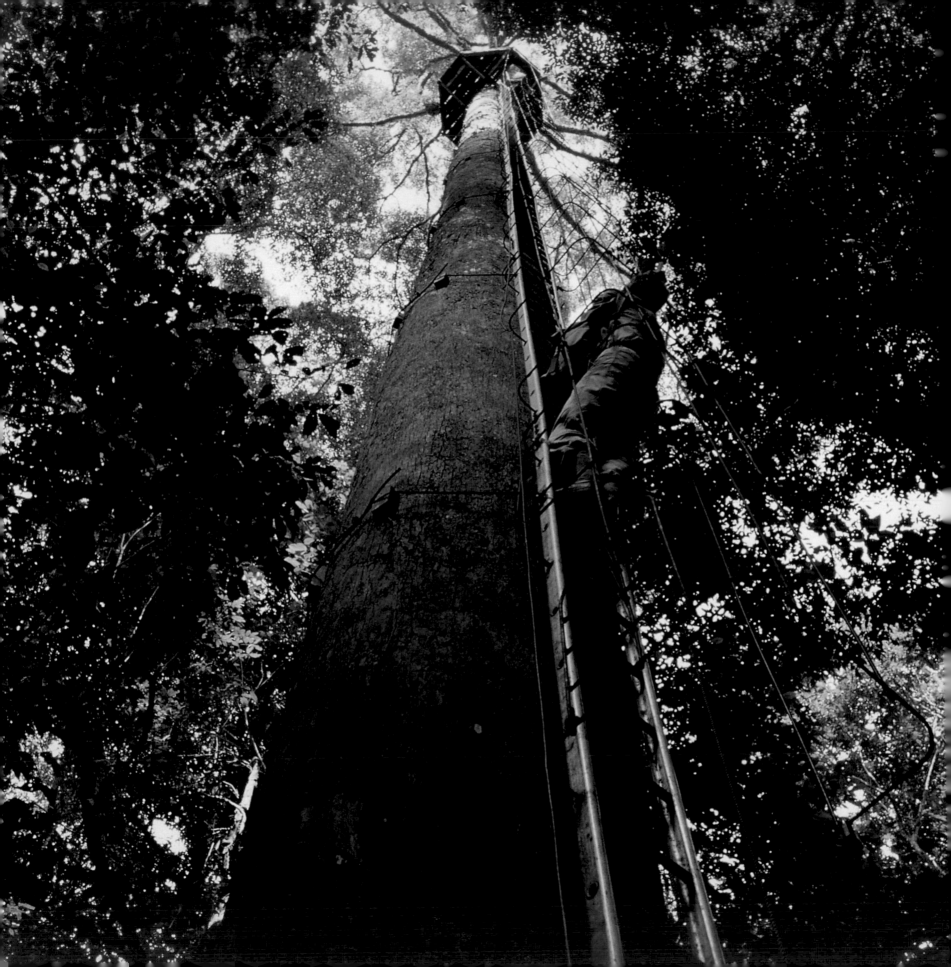

fifths of Madagascar's 10,000 species of plant are endemic, as are its thirty species of lemurs and its two-thirds of the world's chameleons. But, here again, a population explosion – up from five million in 1960, to twelve million in 1995, and perhaps twenty-eight million by 2025 – is threatening every remaining pocket of lowland, montane and mangrove forest. Clearance of rain forests is done by desperately poor peasants, and is 'a tragedy without villains'; but the result is that two-thirds of the original forests have gone, and most of the destruction has occurred in recent years. There have been many international research expeditions on Madagascar, and their work is co-ordinated by a national committee guided by the late great naturalist (and delightful author on wildlife) Gerald Durrell and his wife Dr Lee Durrell.

All the world's natural history museums and botanical gardens send research expeditions into the world's rain forests. The resulting discoveries are magnificent – but they only scratch the surface of the biodiversity and other secrets of these ecosystems. From Britain, the Natural History Museum and Royal Botanic Gardens, Kew, maintain teams of collectors and scientists in many tropical areas; the Royal Society kept a research centre for many years at Danum Valley in Malaysian Sabah; the Royal Entomological Society collected vast numbers of new species of insect on the Indonesian island of Sulawesi; and the Royal Geographical Society organized multi-disciplinary expeditions to Mount Mulu in Malaysian Sarawak, led by Robin Hanbury-Tenison, to Temburong in Brunei under the Earl of Cranbrook, and my own Maracá Rainforest Project in Brazilian Roraima – to

Opposite: *Scientists, such as this one from the Royal Society's Danum Valley research station, use ingenious methods to reach the rain-forest canopy, which contains the earth's greatest biodiversity.*

name but a few. In Indonesia (which has suffered devastating loss of rain forests due to rampant logging, transmigration of colonists and catastrophic fires in 1982–3 and 1997–8) there has been good research by the Bogor botanical gardens on Java, and there are some notable protected areas, such as Dumoga-Bone on Sulawesi, Meru Betiri on eastern Java, or the large Lorentz National Park on Irian Jaya, the Indonesian-occupied half of the island of New Guinea.

As is now well known, plate tectonics is pushing North America westwards away from Eurasia and South America from Africa. The two ancient landmasses meet at the Isthmus of Panama, but this is an unstable land bridge. The south-eastern end of the Isthmus is the Darien Gap, an area of very high rainfall, swampy and forested, and once badly afflicted by malaria and yellow fever. It has never been possible to drive a road through this terrible terrain, to link North and South America in a single Pan-American Highway. (Some conservationists hope that this road will never be built, as it could spread foot-and-mouth disease and other environmental hazards, including the worst of all, human settlement, between the two American continents.) In 1971–2 the British explorer Colonel John Blashford-Snell organized the British Trans-Americas Expedition that was determined to push four-wheel-drive vehicles through 400 kilometres (250 miles) of roadless wilderness of the Darien Gap. The vehicles were two Range Rovers and an old Land Rover. They performed admirably during the rugged drive down the Pan-American Highway, which was mostly unpaved at that time, but broken differentials at the start of the Darien crossing had to be replaced from England. Twenty-five Royal Engineers were in charge of getting the vehicles through, often having to winch them across glutinous mud, slithering

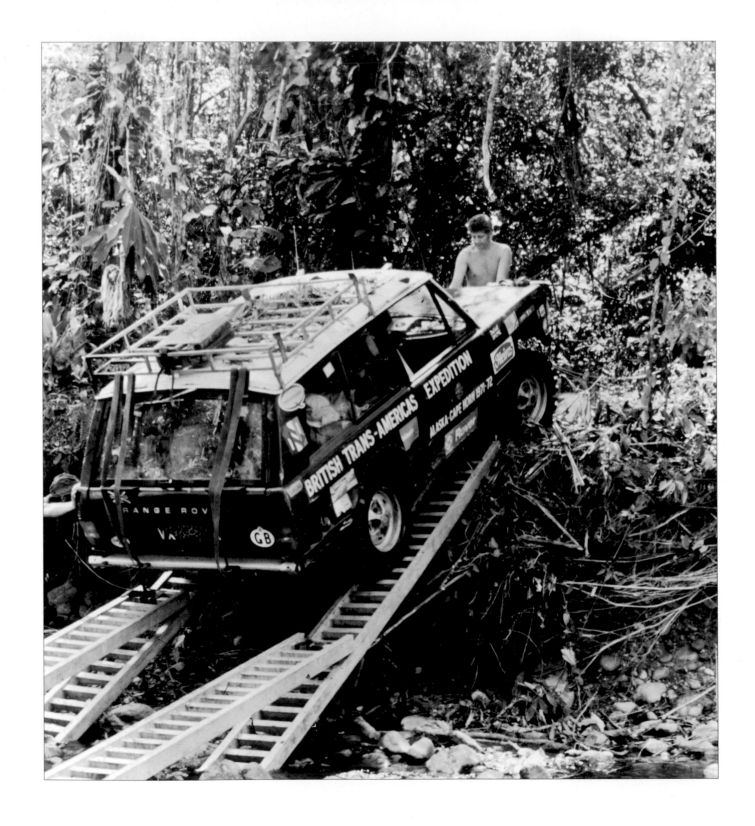

slopes or tangled forests. Rafts and a Colombian gunboat ferried the expedition across the dreaded Atrato Swamp. But the hero of the expedition was 'the wingless, exhaustless, windscreenless, crumpled Land Rover, and those who cut for her, winched her, drove her and cherished her. Where they led, the big cars could follow.'[1]

Explorers have also penetrated tropical rain forests for archaeological research. For the past thirty years, expeditions have cut their way into the forested hills of the Andes in search of lost cities of the Inca. In 1965 the eccentric explorer Gene Savoy found hundreds of ruined buildings buried under deep Amazonian forests north-west of Cuzco in Peru. He identified the remains of Vilcabamba, the final refuge of the Inca escaping the Spanish conquistadors. Subsequently, the English archaeologist Dr Anne Kendall led teams of explorers into the fastnesses of this part of Peru, and further Inca remains were found in a series of expeditions by Vincent Lee, an ex-marine who is also an architect and historical scholar. Meanwhile, in Guatemala, Belize and Mexico's Yucatán, Maya ruins were discovered and sometimes excavated and restored. One pioneer of Maya research is the Scottish scholar-explorer Ian Graham who for forty years, has located site after site in the forests of Central America and has also re-interpreted the glyphs on Maya stelae. Graham always used Land Rovers to approach his archaeological quarry – and to elude the grave robbers who watched his movements. The Land Rover company has also demonstrated the prowess of its vehicles in a punishing tour of forest-choked Maya sites, known as La Ruta Maya.

Opposite: *Range Rovers were the first vehicles to traverse the Darien Gap between Panama and Colombia during John Blashford-Snell's British Trans-Americas Expedition.*

There have been so many expeditions into the world's rain forests in recent years, that it is impossible to mention them individually. Each involved scientists in months of hardship and occasional danger, weariness in the tropical humidity, hunger, insect bites, scratches and even thirst (for during the dry season, forest streams are far apart and water-carrying lianas are rare). There are relatively few dangers. The author has twice suffered the teeth-chattering misery of malaria, has been swept abruptly down-river in swirling rapids, has had log bridges collapse under him, and has confronted the panic of straying from a trail and being temporarily lost in endless unexplored forest. Some researchers succumb to other tropical diseases, such as the incurable Chagas' disease, debilitating leishmaniasis, African river blindness or bilharzia. A few unlucky explorers have endured the agony of stings by hornets, or bites by the common *Odontomachus* ants that lurk in so many logs and trees, or the blindingly painful bites of big black *Paraponera* ants; others (including Richard Mason on an earlier expedition) stepped on a stingray hidden in the sand of a stream bed, and were delirious with pain for many hours; and some, including two of my friends, have been bitten by piranha fish or by venomous snakes – although such wounds are rare, since the over-rated piranha and the various poisonous reptiles tend to be shy of humans. In Southeast Asian rain forests, leeches are common; but they represent no threat beyond a shoe-full of blood. Few of these dangers are fatal. More tropical scientists have been killed in road accidents or air crashes than in the legendary 'green hell' of their forests.

These hazards of the tropics are a small price to pay for the exhilaration of being in the solitude of beautiful forests and learning the secrets of the world's most prolific habitat.

One important lesson from the years of recent research is that the soils under rain forests are devoid of nutrient. Although some trees are deciduous, the system is evergreen. There is no winter, when temperate forests accumulate springy layers of humus. Rain forests are too vibrant. Their biomass is far denser and the rates of growth more exuberant than in northern forests; and the agents of decomposition are also fast and highly efficient. The brown leaf litter that covers a rain-forest floor is thin: scratch it aside and there is a tangle of white threads amid the network of roots. These strands are tree rootlets and mycelia of fungi that suck the nutrient out of decaying litter almost as fast as it falls to the forest floor. The gigantic trees and humble fungi form one of many mutually beneficial relationships that abound in a forest. Bacteria help in the decomposition process. So also do termites, which thrive in their billions in every warm forest. Termites are the great cleaners of forests, able to devour raw cellulose in dead wood thanks to protozoan symbionts in their guts. The triumvirate of fungi, bacteria and termites, as well as a host of beetles, flies and other insects that consume other organic debris, ensure that you never see a corpse in a rain forest: dead animals are swiftly and efficiently recycled, along with nutrients from leaf litter. All this nourishment is recaptured by the millions of seeds and seedlings desperately growing towards the canopy. The result is luxuriant vegetation but impoverished soils.

It seems absurd now, but conventional wisdom used to be that abundant tropical flora meant that the underlying soils could support prosperous agriculture. Adrian Forsyth and Ken Miyata told, in their admirable book *Tropical Nature*, how new arrivals from temperate latitudes 'saw visions of fertility, mirages of fecundity, in the towering forests that covered so much of the land. The lush forests and the thick tangle of riparian vegetation they encountered as they travelled the interior were manifestations of what they thought had to be tremendously productive soil. How else could such an abundance of life be sustained? It was a reasonable yet tragic piece of logic.'[2] The tragedy was that government planners, wealthy ranchers and frontier settlers all thought that they had only to cut down tropical forests to replicate the farmlands of Europe and North America. Right up until the 1980s, politicians of tropical countries argued that they had just as much right to fell their forests as did the northern countries who had long ago destroyed theirs. In those days, politicians gave tax breaks, subsidies and title deeds to any who 'improved' virgin terrain by clearing it of forest. When in 1971 President Medicis of Brazil ordered the building of the 3000-kilometre (1850-mile) Transamazonica Highway across the forests of Amazonia, he declared that he was opening 'a land without people for a people without land'. It was confidently expected that by 1980 a million families would have moved from the overcrowded and drought-stricken north-east of Brazil into the jungles penetrated by the Highway. In the event, only a couple of thousand families had migrated, and their meagre plots were failing. They were defeated by fragile, acidic soils that washed away in the rains and baked into pink 'parking lots' when exposed to strong sunlight, and by the multitude of insects that devoured whatever they planted. It was lessons learned from expeditionary research that put a stop to such folly.

The rate of rain-forest destruction peaked in the late 1980s and early 1990s. During that decade, average annual destruction of rain forests was 150,000 square kilometres (58,000 square miles) out of a world total of eighteen

million square kilometres (seven million square miles). Of this appalling amount, some 62,500 square kilometres (24,100 square miles) were lost each year in South America – roughly forty-two per cent of the world's total loss. Proportionate to the amount of forest, the rate of destruction was even worse in Africa and Asia, particularly in Bornean and other Southeast Asian forests. On average, 36,500 square kilometres (14,000 square miles) of Asian forests were cut down each year out of a total stock of 4.2 million square kilometres (1.6 million square miles): almost one per cent lost annually.

In Amazonia, millions of trees were drowned under hydroelectric dams, which had to flood unacceptably large areas because the Amazon basin is so flat. But the vast majority of the clearance was done to try to convert the underlying soils for cattle ranching or agriculture. Farmers learned an invidious trick from the Indians: to burn savannahs each year and to use fire to open up forest plots. Various plains Indians lit fires to round up game for hunting. Frontier settlers imitated them, thinking that burning helps to clear grasslands of ticks and snakes as well as giving a deceptively green (but short-lived) cover to the ashes on the parched soil. These annual fires cover central Brazil in clouds of smoke, which fills the atmosphere with carbon, and they often rage out of control, destroying great swathes of forest. The same practice in Borneo led to disastrous fires in 1997. These were started by small farmers, transmigrants resettled by the Indonesian and Malaysian governments. But they spread uncontrollably because there had been so much clear-felling of forests by irresponsible loggers. These fires blanketed much of Southeast Asia in thick smog. In 1998 appalling fires destroyed an area of rain forests the size of Belgium. Most forest clearance in equatorial Africa and Madagascar is done by poor farmers, in countries where population growth is outstripping the availability of agricultural land. So the message that removing rain forest to use its soils for farming is a waste of time and money is spreading only slowly.

The only other reason for cutting down forest is to get at the timber in the trees. Commercial loggers have ravaged Southeast Asia to satisfy the appetite for timber of the Japanese (who account for half of the world's international trade in tropical hardwoods) and others. Just as the rate of forest clearance for ranching in Amazonia is subsiding, the timber companies are moving in. There are now sawmills along all main roads in forested areas, and long rafts of logs are an ugly new sight on Amazonian rivers.

For a time, it seemed logical to fell tropical rain forests for logging and then replant them, as is done in the great Canadian and Nordic conifer forests that supply the world's paper. Unfortunately for the tropical countries, this does not work. There are so infinitely many insects, parasites and predators targeted on every species of tropical tree (in the way that Dutch elm disease wipes out temperate elms) that trees in rain forests have to be scattered to survive. A stand of a single species will eventually be wiped out by blight, as Henry Ford found to his cost when he tried to grow plantations of rubber trees (*Hevea brasiliensis*) on the Tapajós river in Brazil. Tropical trees therefore expend much energy on making poisons to protect themselves from parasites, and in growing fruits, nuts, blossoms and other devices to ensure that their seeds and pollen are widely distributed. Also, as noted before, rain-forest soil is too weak to withstand exposure to strong tropical rains and sun. So, if a rain

forest were clear-felled, it could not be replanted for another crop of timber. It would be replaced by a cover of often noxious weeds, which are useless for cattle; and decades would elapse before the lush but bewilderingly complex ecosystem of a mature forest could re-establish itself. All these lessons are now commonplace. But they were not appreciated even a few years ago. They are the product of painstaking field research.

To illustrate the difficulty of commercial use of rain forests, the Director of Kew Gardens, Sir Ghillean Prance, cites the case of the Brazil-nut tree (*Bertholletia excelsa*). Growers would love to create plantations of the trees that bear this valuable nut. But *B. excelsa* are solitary trees that stubbornly resist such farming. Their nectar is produced at the base of staminodes protected by a hood that can be lifted only by a strong bee, such as carpenter bees (*Xylocopa*) or female euglossine bees. Once inside the blossom, the spring that holds down the hood also ensures that the bees' backs are well dusted with pollen. Observation has shown that these euglossine bees can travel for over twenty kilometres (12.5 miles) a day, visiting a line of flowering trees. Curiously, male euglossine bees behave quite differently to their mates. Gaudily coloured, these males are solitary insects that gather aromatic compounds from various species of orchid. They thus help to pollinate the orchids, and once the male bees have gathered enough of the sweet-smelling compounds, they swarm with other males. This attracts the females, and mating takes place. When the Brazil-nut grows, it is in a case so hard that a man can crack it only with an axe. It was discovered that the only animal capable of moving the nuts, which are too heavy for most bats or birds, is the *agouti*, a large rodent that also has

Above: *The Brazil-nut tree,* Bertholletia excelsa, *is dependent upon the powerful jaws of the agouti rodent to crack its nut cases and bury the seeds.*

jaws powerful enough to crack the Brazil-nut cases. 'These capsules, after having fallen to the ground, are opened by agoutis that eat some seeds but scatter-hoard the rest. (Luckily, agoutis have bad memories about precisely where they have hidden nuts.) Later, when they fail to find some of the buried seeds these become available for germination.'[3] Thus, to farm the Brazil-nut, there need to be the right species of bee, the orchids that attract the males of those bees, and the shy and fairly rare *agoutis* that spread the nuts. Each of these species is, in turn, part of other complicated food chains and ecosystems. Destroy any part of any of these systems and the reproductive chain of this one tree species is broken. My description of the pollination and seed-dispersal of *Bertholletia excelsa* is simplified and does not do justice to the weeks of observation that went into discovering the processes involved.

Every one of the tens of thousands of plant species and millions of species of invertebrate in a tropical forest has a different life cycle. A great deal of dedicated research has

revealed much about many thousands of these plants and animals. But the amount still to be discovered seems limitless. To illustrate the diversity of forests: the great American botanist Alwyn Gentry recorded three hundred different species of tree with trunk diameters over ten centimetres (four inches) in a single forest near Iquitos in Peru; Colombian Amazonas has 25,000 indigenous plant species; and it is estimated that tropical forests could hold as many as thirty million species of insect.

Professor Sir Ghillean Prance is one of the leading tropical-forest botanists. Although born in England, Prance spent over twenty years with the New York Botanical Garden, and during that time he devised and ran Projeto Flora Amazonica, an ambitious plan to identify all the flora of the Amazon. Every year, small teams of botanists were sent to different places in Amazonia to collect thousands of

Below: *Professor Ghillean Prance pressing plants during the Projeto Flora Amazonica, a decade of collecting throughout Brazilian Amazonia which he devised and led.*

'numbers' of plants. (A number is when a botanist collects five or six examples of the leaves, fruits, blossoms and seeds of a plant, so that these may be lodged in different herbaria.) Ghillean Prance went on to be a highly successful Director of the Royal Botanic Gardens, Kew. Prance (who likes his first name to be pronounced Ian) is a courteous man with a grey Lincoln-style beard and a wonderful ability to communicate his love of forests in lectures or to students. A tireless and able administrator, he remains at heart a field worker. He manages to return regularly to Amazonia on botanical expeditions. Under Ghillean Prance's direction, Kew Gardens has embarked on a hugely ambitious project that will involve botanists in years of field collection. With a grant from the National Lottery, Kew is building a seed bank and aims to stock it with the seeds of every plant in the world. This should mean that no plant species can be extinguished by disease, pollution or human manipulation.

Field observers have unravelled some of the secrets of rain-forest dynamics. They learned the importance of light. Some twenty to thirty metres (sixty-five to a hundred feet) above ground is the canopy, where trees branch to form a dense umbrella of vegetation. A few giants tower above and are known as emergents. This upper zone is where photosynthesis takes place, where trees blossom and bear fruit. Beneath the canopy is the understorey of younger trees, which creates another filter of light. Every species has a mechanism to reach the life-giving sunlight. Most trees are able to germinate in shade and devote their energies to growing straight up as slender saplings. But some were discovered to be light-seeking: their seeds lie dormant on the forest floor, waiting for a tree to die and expose the ground to a shaft of sunlight. The light-seekers, and low herbaceous

plants, immediately sprout in the clearing – and in turn create a new layer of shade for the next generation of conventional shade-seeking trees.

Scientists have responded to the massive destruction of rain forests with some interesting experiments. One line of research is based on *refugia*. Studies of pollen, fauna, geology and climate history revealed that the Amazon forests have waxed and waned dramatically, particularly during the temperature fluctuations of the ice ages. When the forests shrank, the vegetation survived in separate patches or *refugia*. Organisms separated from one another in this way sometimes evolved into different species, or became extinct. The geomorphologists Keith Brown and Aziz Ab'Saber identified areas of Amazonia that appear to have been such *refugia*, and botanists such as Ghillean Prance also recorded the places where they thought that vegetation survived. Gary Wetterberg and others argued in the 1980s that, if destruction of much of the forest was inevitable, governments must at least protect the known refuges. Maps were produced to highlight these hot spots of biodiversity, and many are now reserves. Tom Lovejoy of the Smithsonian Institution in Washington devised a major experiment to discover another aspect of deforestation: how large must a patch of forest be in order that all the animals and plants of its ecosystem can continue to function? Lovejoy's Forest Fragments Project has been in operation for fifteen years and several hundred scientists have participated in it. Farmers who were clearing forest north of the city of Manaus in Brazil were persuaded to leave fragments of different sizes standing. The disturbance caused by clearing was far worse than had been imagined. Many plant species were upset by lateral winds entering the usually tranquil heart of the forest. Animals suffered when their foraging or reproductive areas were curtailed. Even common small mammals were too frightened to cross narrow open spaces between forest fragments. The intricate web of food chains and ecological relationships broke down, and the result was rapid decline of some species. It was found that to function reasonably normally, a fragment of rain forest needed to be at least 1,000 hectares (2,500 acres) and preferably far larger.

While the Forest Fragments experiment was under way some fifty kilometres from Manaus, the author led a research project 900 kilometres (560 miles) north of there. This was the Maracá Rainforest Project, on an enormous 110,000 hectare (270,000 acre) riverine island near the headwaters of one of the many northern tributaries of the Amazon. Maracá Island is surrounded by fierce rapids and waterfalls, and is therefore uninhabited and largely unexplored. Being near the biographical boundary between the Amazon basin and the Guiana shield, and at a junction of natural grasslands and uninterrupted forests, it proved to have marvellously rich biodiversity. The Brazilian environment secretariat had built a comfortable research station on the island, and it invited the Royal Geographical Society of London to help discover its flora, fauna, geomorphology and other natural history. The first year of the resulting Project involved 150 scientists, mostly Brazilian and British, and a further fifty *técnicos* or skilled woodsmen. It made an ecological survey that recorded thousands of species of insects (including over a hundred that were new to science), new spiders, *diptera* (flies) and butterflies; and it collected or noted

Opposite: A Parrot's-beak heliconia, Heliconia rostrata, *provides rare flash of colour near the ground in an Amazonian rain forest, where most of the flowers and blossoms are high above in the canopy.*

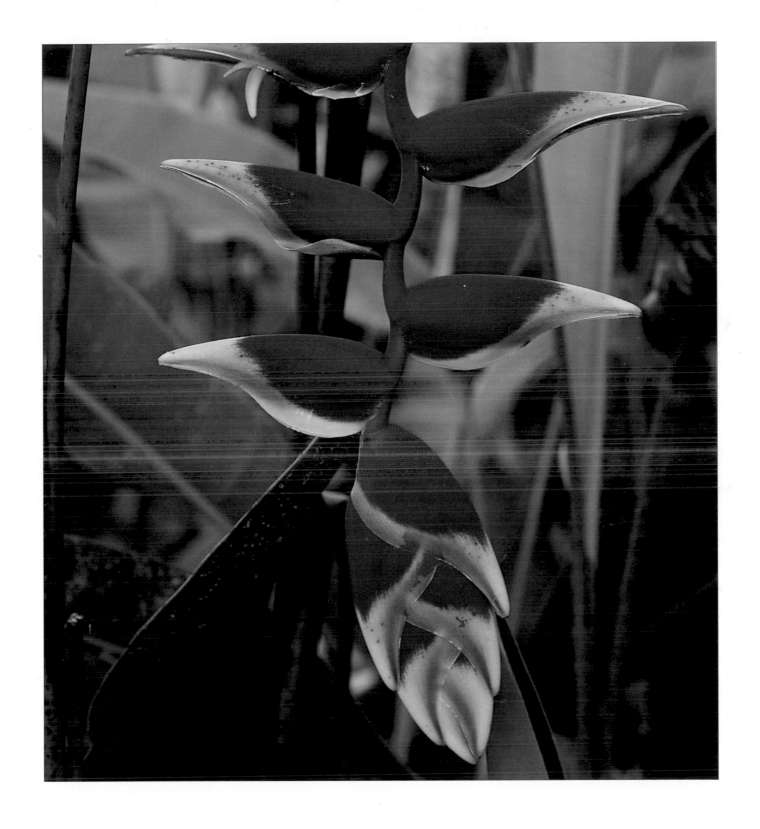

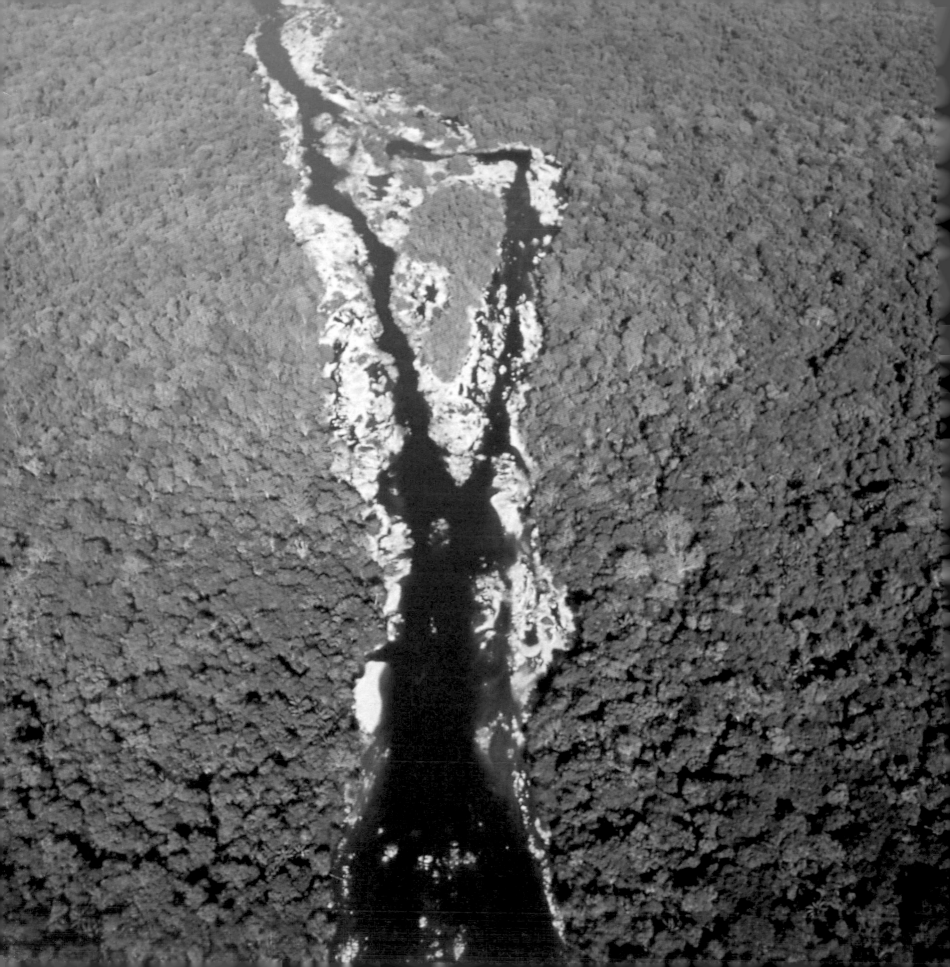

hundreds of species of bird and bat, as well as great plant diversity. This was not primarily a collecting expedition. The scientists erected some nets and traps almost as a sideline. The fact that they collected so many new species is simply an indication of the prodigious biodiversity of any rain forest.

The project also established experiments to try to explain aspects of forest dynamics. One programme was in natural regeneration. This team of scientists observed everything that occurs when felled forest grows again, in a series of artificial clearings as well as in nearby undisturbed control plots. Our forest ecologists were led by John Proctor from Stirling University in Scotland, who has carried out similar studies on expeditions all over the world. Even this experienced team was amazed by the speed of growth in its clearings, which it monitored for several years. The ground was rapidly covered by broad-leaved herbaceous plants; most of their 9,000 tagged seedlings shot up and were soon several metres tall; and light-seeking creepers scrambled up the flanks of the surrounding forest. Forsyth and Miyata described the inspiring flurry of entomological activity in such a new clearing.

'The freshly exposed sap wood of a new-fallen tree attracts noisy syrphid flies and many showy beetles. Long-horned harlequin beetles (*Acrocinus longimanus*) several inches long, striped with geometric patterns of yellow and orange; golden buprestid wood-boring beetles; and large black weevils all alight to sip the oozing sap and to lay their eggs in the massive pasture of wood. Parasitoid wasps interested in the immature stages of the flies and beetles patrol

Opposite: *A branch of the rapid-infested Uraricoera River borders Maracá Island, where the author led one of the largest research projects ever in Amazonia.*

the log, and clouds of fruit flies begin congregating around the fermenting sap. If the gap is large and sunny, vines and shrubs quickly spring into flower. Passion vines lure in butterflies seeking nectar and birds and bats seeking fruit. Morning glories lure bees, while *Aphelandra*, *Heliconia* and other tubular-flowered plants attract hummingbirds, which vigorously defend each flowering patch.'[4]

Another programme at Maracá studied the hydrological cycle, when rains hit the canopy and water drips from branches or pours down tree trunks and is then either absorbed by the living vegetation, stored in the soil and litter mat, or runs off. We wanted to observe the effect of this hydrological cycle if the canopy were removed, or the understorey, or the all-important root-and-litter mat. This proved how essential the roots and litter are in protecting the fragile soil: without that mat, the erosion and degradation of the soil were rapid and devastating. Other scientists sought to explain one of the many mysteries of any tropical forest: why does it sometimes end abruptly and give way to open savannah? On one side is a high wall of forest vegetation; on the other, an expanse of wiry grasses, gnarled low trees and termite mounds. Such a forest-savannah boundary was studied in every possible way — the underlying soil chemistry, water table, vegetation, and soil micro-organisms — and it appeared that liability to seasonal flooding was the single most important factor in causing this sudden change. In the course of all this research, scientists of the Maracá Project frequently plunged into unexplored country, sometimes for weeks on end, and navigated rapid-infested rivers. But these scientists were doing it as part of their work. It would never have occurred to them to boast about the heroics of this exploration.

Much research has been done on epiphytes and creepers. Epiphytes perch on tree branches to get near the sunlight. Most are not parasitic on the host tree but use it only for support. (The exceptions are tropical mistletoes, whose roots bore into the tree's circulatory system.) By being up in the canopy, epiphytes also gain access to the bats, birds and breezes that can disperse their tiny seeds. The disadvantages are scarcity of nutrient food and often also of water, since most have no roots to draw these from the ground litter mat. So epiphytes have been found to develop stratagems to reduce water loss by opening their stomata only at night or by surrounding their roots with spongy dead cells; tank bromeliads have watertight leaves that create tiny ponds; various orchid species have bulbous roots to store water. Nutrient deficiency is overcome by perching in branch junctions that collect falling litter, or by attracting insects and larvae to their miniature pools. Curiously, only Asian forests have the carnivorous pitcher plants, which consume insects that slide into their bellies. As with every family of flora, botanists have discovered most of what we know in recent decades; but every new finding leads to more mysteries about the complex behaviour evolved by each species.

Tangles of creepers or lianes are another striking feature of a rain forest. Ninety per cent of the world's vines are in the tropics, and they come in an exuberant profusion of baroque shapes and sizes. All share the same opportunistic trait of using a tree for support, so that they can have roots in the earth and leaves and blossoms in the sun, but do not need to expend energy on structural tissues. Some lianes climb by catching onto others; many cling to tree trunks; 'scamblers' wait for gaps from fallen trees or streams to clamber into the crests of trees; others are born in the canopy and drop tendrils to the ground. Botanists have observed that Monstera creepers completely change appearance at three stages of the plant's growth. The vine moves along the forest floor towards the darkest shade, which it hopes is that of a large canopy tree; it then climbs, in a beautifully symmetrical ladder of variegated leaves, flat against the bark alternately on either side of a straight stem; once in the light, Monstera's leaves grow into elegant great structures, dark green, with deeply crenellated edges that give this creeper the name 'Swiss-cheese plant'. When they reach the open sky, many lianes greedily spread their leaves, obliterating those of their host, and they drop the now-superfluous lower leaves they needed while growing upwards. The most patricidal are strangler figs. These choke their host tree's trunk with a trellis of encircling stems and obliterate its canopy with their own leaves. The fig flourishes and its stems thicken, but the host is crushed and starved and eventually dies. By then the strangler fig has grown so fat that its lattice seems to merge into a single great knobbly tree, its roots nourished by the decayed corpse of the tree that once supported it but is now lost in its killer's embrace.

Another feature that enhances the exotic appearance of tropical forests is the curiously shaped roots of some trees. Buttress roots look like the triangular fins of a space rocket upended on its launch pad – everyone visiting a rain forest is photographed alongside a mighty buttress, since these are one of the few unusual sights at ground level. But even buttress roots have aroused debate among researchers. The

Opposite: *The view into a dipterocarp canopy, on the Brunei University and Royal Geographical Society's Brunei Rainforest Project of 1991–2.*

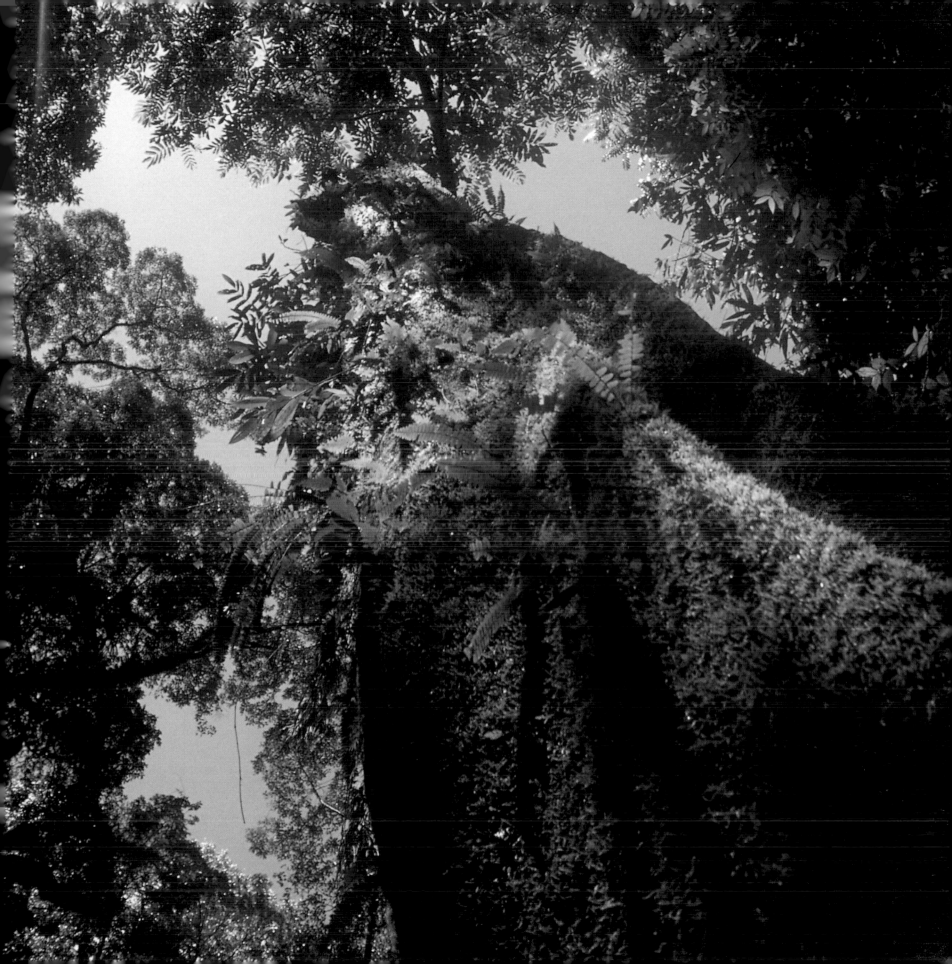

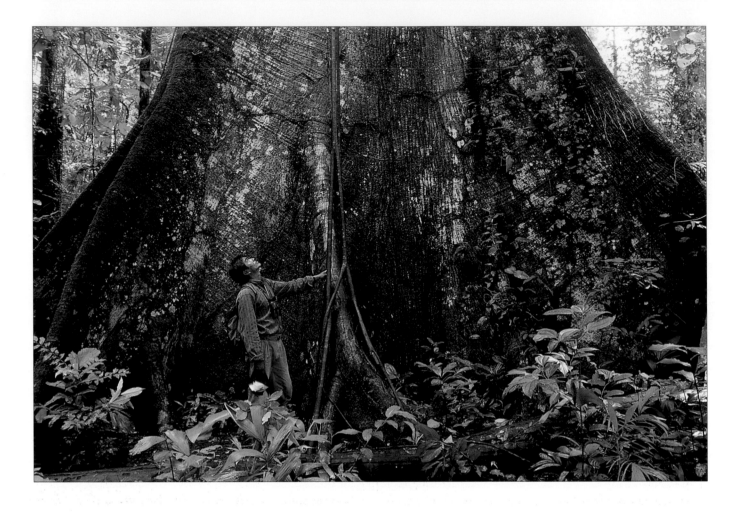

obvious explanation for them is to stabilize a large tree that has horizontal rather than deep vertical roots. But such stability is not very necessary in the still rain forest, where all the trees support one another and are often linked by lianes. So some researchers hypothesize that buttress roots are to inhibit climbing creepers, or to channel runoff water and litter to the roots, or to increase the surface of the tree for oxygen exchange. Equally exotic stilt roots are more easily explicable. They converge like tripods to raise the trunks of palm trees above swampy or flooded ground.

It is obvious to anyone entering a rain forest that most

Above: There are various theories about the purpose of buttress roots on many tropical forest trees. They may be to support the tree, or to channel water and nutrients to its roots.

activity is happening far above the visitor's head. We bipeds are confined to the gloomy world of roots and leaf litter, among the peccary, tapirs and few other animals that cannot climb. Rain forests are easily the most diverse ecosystems on our planet, and most of their biodiversity is in the canopy that receives all the sunlight and rainfall. The problem is how to climb the tantalizing twenty to thirty metres (sixty-five to a hundred feet) to reach the teeming canopy, preferably

without disturbing its inhabitants, and equally preferably being able to move about once we are up there. Scientists have grappled with this problem ever since they became interested in natural history; but, as with most other research, the breakthroughs are being made only now. The crudest way to reach the canopy is to cut down trees to examine their upper vegetation. But this has obvious limitations, since any agile creatures will escape during the fall, and it is hardly correct behaviour for conservationists. Entomologists and zoologists regularly collect specimens by hoisting nets into the trees or by 'fogging' a tree in a cloud of poisonous gas and then collecting all its flying insects when they fall onto sheets or traps that encircle the trunk. But these techniques provide only dead specimens and are useless for observation of animal or plant behaviour. Researchers can climb a single tree by firing a rope over a strong branch (using a catapult, crossbow or native long bow), and then hauling themselves up with mountaineering or caving tackle. I have tried this terrifying method and would not wish to repeat it; but many scientists do. I have also watched the marvellously exuberant American botanist Alwyn Gentry shin up a tall tree using a contraption he called a tree bicycle. Gentry had a metal hoop the size of a bicycle wheel attached below each of his knees. These hoops went round the smooth trunk and Al Gentry had mastered the skill of clambering up in a crouching position. But less experienced users of tree bicycles can easily fall backwards and break their legs. (Alwyn Gentry, of the Missouri Botanical Gardens, was later killed in a light-plane crash in the forests of Peru – a great loss of one of the finest of all tropical botanists.)

Attempts to reach the canopy have a long history. In 1960 the Dutch primatologist Adriaan Kortlandt got pygmies to build a ladder and tree house for him to watch chimpanzees in the treetops of the Congo. Meanwhile, the American botanist Elliott McClure used ladders to climb to a platform forty metres (130 feet) up a tree at Kepong in Malaysia. For three years, McClure observed the flowering, fruiting, growth and decay of the trees, vines and epiphytes around his eerie. With a telescope, he could see two square kilometres (three-quarters of a square mile) of canopy. He also watched the fauna, many of which never descended to ground level. 'Around the railings of the platform large ants patrolled, and a small black-banded squirrel learned to come for a weekly offering of bananas. A flying snake sailed by one day, and each morning by ten a.m. gliding lizards had flown into the tree to search the branches for insects. More than a hundred species of bird, so difficult to observe from the ground, lived out their lives around him.'[5] McClure's tree house eventually fell victim to forest clearance and road building; but not before he had made pioneering studies of what Andrew Mitchell called 'the enchanted canopy' in his book about this elusive realm. Not far away, at Bukit Lanjan in western-peninsular Malaysia, US Army engineers built a 300-metre (1,000-foot) walkway for Malaysian scientists, of aluminium ladders with wooden floors, that projected from a cliff across the crowns of underlying trees. It was a superb structure, but heavy and expensive to construct. This walkway lasted for ten years, before decay of some of its supporting trees caused its demise, and it was the scene of much admirable research. Medical entomologists studying the movements of insect-disease vectors also built canopy perches as far afield as Uganda and Panama. Scientists from the Smithsonian Institution have a 42-metre (138-foot)

tower of builders' scaffolding at Barro Colorado in Panama; nearby, in forests outside Panama City, a tower crane can swivel to explore a 39-metre (118-foot) radius of canopy. Similar structures and platforms have sprouted in rain forests all over the world.

In the early 1980s, the British primatologist Andrew Mitchell and entomologist Stephen Sutton pioneered a light-weight walkway above the forests of Panama. They were on another expedition organized by Colonel Blashford-Snell, who had pushed Land Rovers through the nearby Darien Gap some years earlier. Building the observatory was no easy matter. First a line of spikes was driven up a suitable tree; then a platform was built high in its branches; a line was thrown, with great difficulty and much trial-and-error, to another tree; then that tree was climbed, and heavy-duty jacks were hauled up into it, to tighten rope cables from the first tree; the wooden walkway, prefabricated by British Royal Engineers, was raised up, inched across the gap and painstakingly fastened into place. After five weeks, a Z-shaped bridge was in place, 125 metres (410 feet) long and some thirty metres (a hundred feet) above the ground. Andrew Mitchell described the thrill of being in this unexplored frontier. 'At last it was possible to wander past a flowering tree crown and note how many bees were taking nectar that day, or compare the lilliputian life of one tree-leaf with another further on. The sensations experienced walking amongst these giant tree crowns are hard to describe. Where the walkway passed over a gap, its frail structure seemed as though it could spring apart at any moment and plunge me into the abyss; yet where it touched the tops of trees the fear of falling evaporated, dispelled by the illusion of a thick-piled carpet of green close beneath. As warm breezes blew over the canopy, the trees gently groaned and creaked, moving slightly from side to side.'[6] This swaying caused the ropeway to rise and fall like a ship on a gentle swell.

The challenge of reaching the canopy continues to spawn ingenious solutions. In many forests, scientists shoot (or in some cases, cast with an angler's fishing rod) a line over a branch and then erect their own lianes of climbing ropes and harness with ascenders or jumar clamps and carabiners. Film crews recently used a tower crane to lower the famous naturalist Sir David Attenborough into the foliage of a Venezuelan rain forest, for brilliant footage for one of his television wildlife series. He has also told me how frightened he was on his first climbs up a tree in a mountaineer's harness. On one occasion, Attenborough filmed in the tree house of a British researcher, Andrew Field, at Rancho Grande, also in Venezuela. Field was another of the hundreds of dedicated fanatics who devote their lives to rain-forest studies, but are too modest to boast about their exploits in articles or autobiographies. For years, Field lived in a simple platform on a giant *Gyanthera* tree, sometimes venturing out onto rickety walkways to adjacent trees. He learned much about tree pollination and discovered new species of tree frogs and arboreal beetles. After three years' research, Andrew Field was about to return to Reading University when he decided to climb one more tree. He never reappeared. After days of searching, colleagues finally found his body, which had clearly fallen from a great height.

One of the most famous canopy explorers is Don Perry, a botanist at the Organization of Tropical Studies' research

Opposite: *The Black-handed spider monkey,* Ateles geoffroyii, *is an American forest primate that has only been properly identified in recent years.*

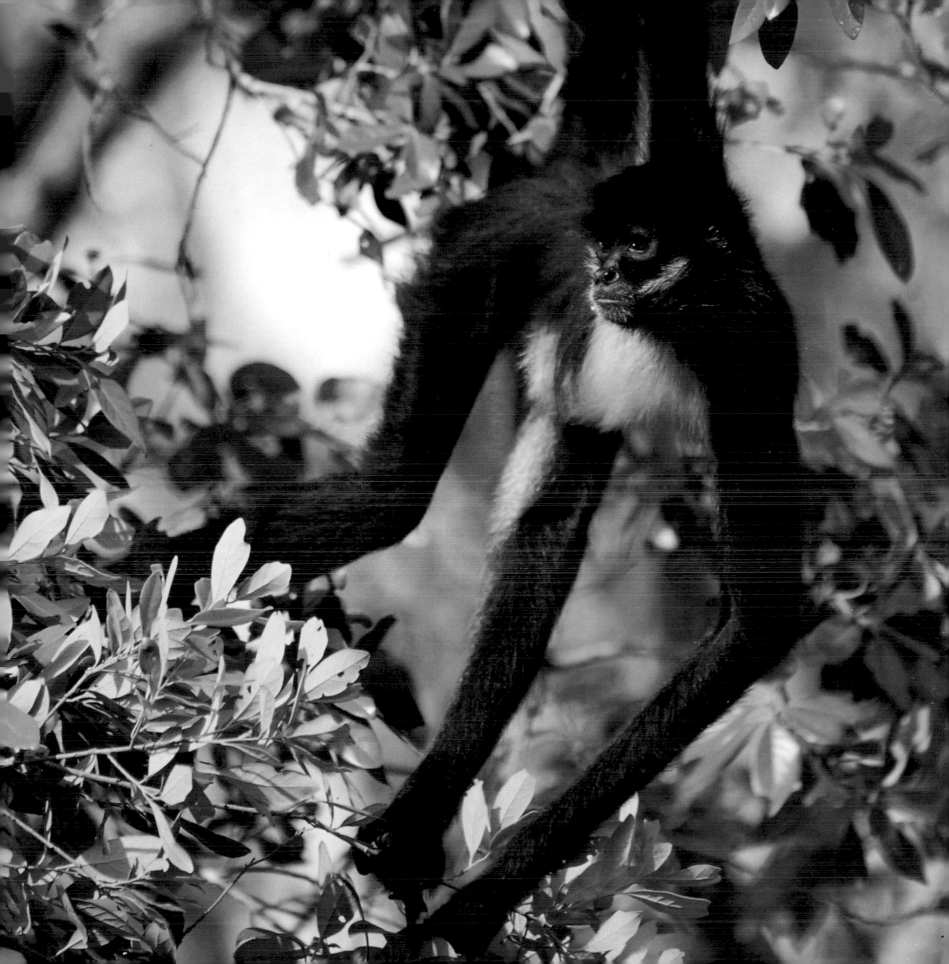

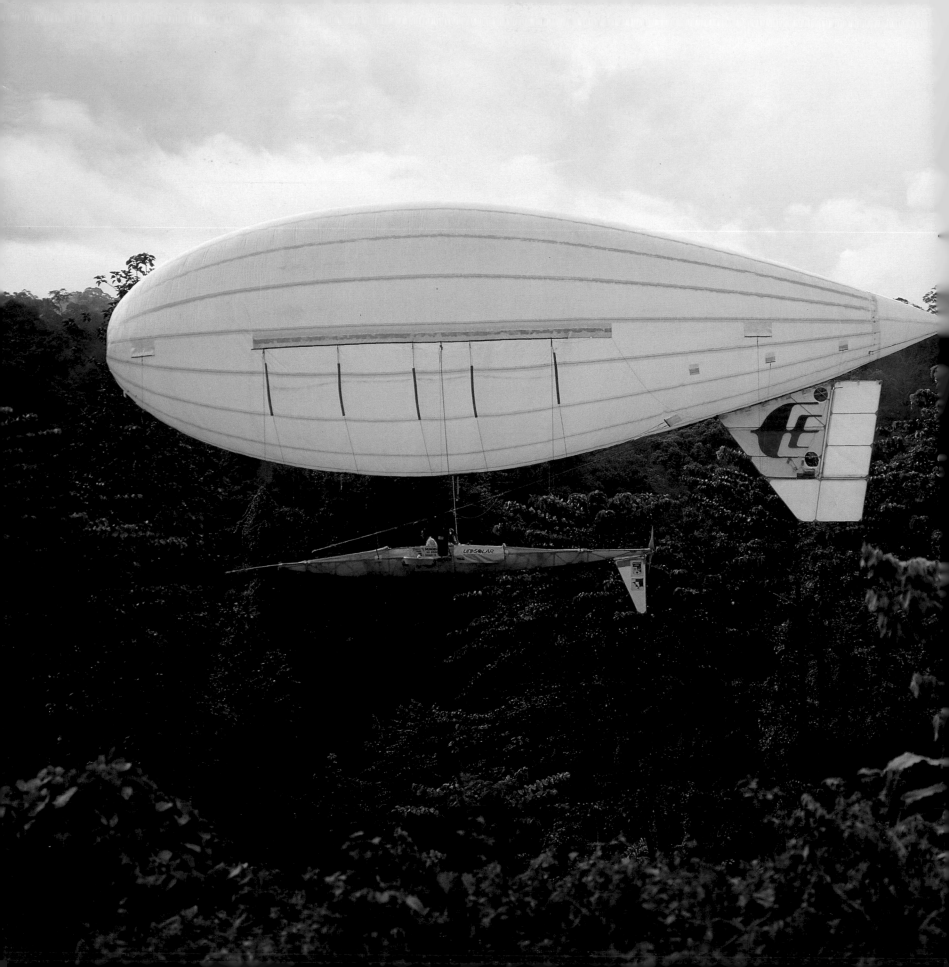

station at La Selva, not far from the capital of Costa Rica. Perry's solution to the problem of defying gravity was to create a triangular web of tensioned ropes between the crowns of tough almendro and monkey-pot trees. Don Perry invented a contraption of an internal rope that ran on wheels along the perimeter guy ropes and could sweep him, bravely dangling from a harness, to any place within the triangle. His invention, first tried in 1978, worked brilliantly and has been in use ever since. It opened new vistas of research.

'Carrying a net on a long pole he could scoop insects out of the air or hang close by a flowering branch and peer into its blooms. Epiphytes on numerous tree limbs were at arm's length, and fruits normally only accessible to an agile spider monkey or chestnut-mandibled toucan were there for the plucking. And more than that, by using a vertical climbing rope and jumars, he could inch-worm his way downwards too, so having remarkable access to a volume of forest almost half the size of a football pitch and thirty metres deep. Such a circus trapeze act is not for the faint-hearted and depends, as do all canopy-access techniques, on a good head for heights and scrupulous adherence to safety standards to ensure that a fatal fall does not occur.'[7]

Another approach to the canopy is from above. Cameramen in microlights have filmed the tree tops. French scientists tried descending onto a forest in Gabon by using a tethered balloon filled with hydrogen. This balloon was also attached above a Land Rover and filmed the canopy as it was pulled across it. Then in 1986 Professor Francis Hallé of

Left: *Professor Francis Hallé of Montpellier, France, invented a canopy raft manoeuvred into position by a dirigible hot-air balloon, seen here in the Danum Valley, Sabah, Malaysia. Once in place, the raft is attached to tree crowns and scientists can live and work on it.*

Montpellier University developed the canopy raft. He has perfected this into a versatile living platform for scientists. The raft is enclosed in air-filled tubes like the sides of an inflatable boat, and the centre is a floor of tough, transparent material with occasional holes through which researchers may reach to collect specimens. The raft is suspended below a hot-air balloon, which moves across the forest with propellers like a dirigible. Highly manoeuvrable, this balloon gently lowers the raft until it rests on top of the trees, and the scientists move about it like children on a bouncy castle. The raft can be as large as a room. It is of course attached to the trees, and the researchers are tethered to it. Professor Hallé's canopy raft has been tested successfully in French Guiana (where, among other tasks, it was used to gather exotic scents to blend in French perfumes) and in equatorial Africa. Hallé himself is convinced that the highest concentration of plant chemicals is found in leaves of the uppermost storeys. He is thus able to collect a new generation of alkaloids and other chemicals for pharmaceutical research.

Opposite: *A narrow-winged katydid,* Tettigonoida, *moulting in Ecuador's Yasuni reserve.*

Below: *Gaudy weevils,* Entimus imperialis, *are one of many insect agents that consume dead wood and help the recycling process.*

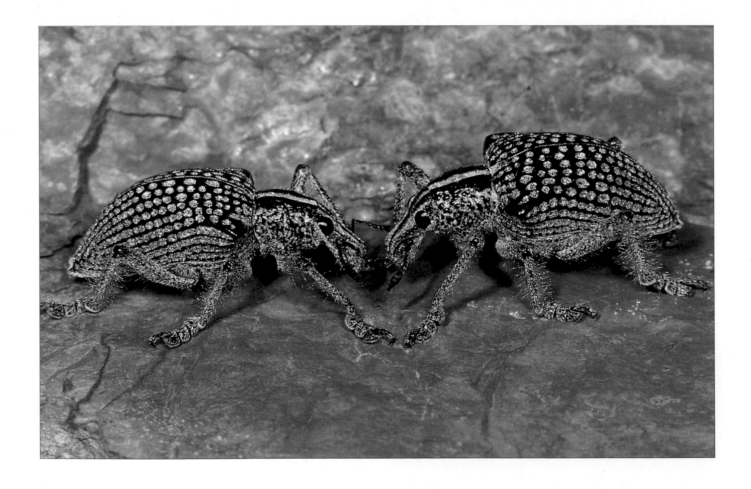

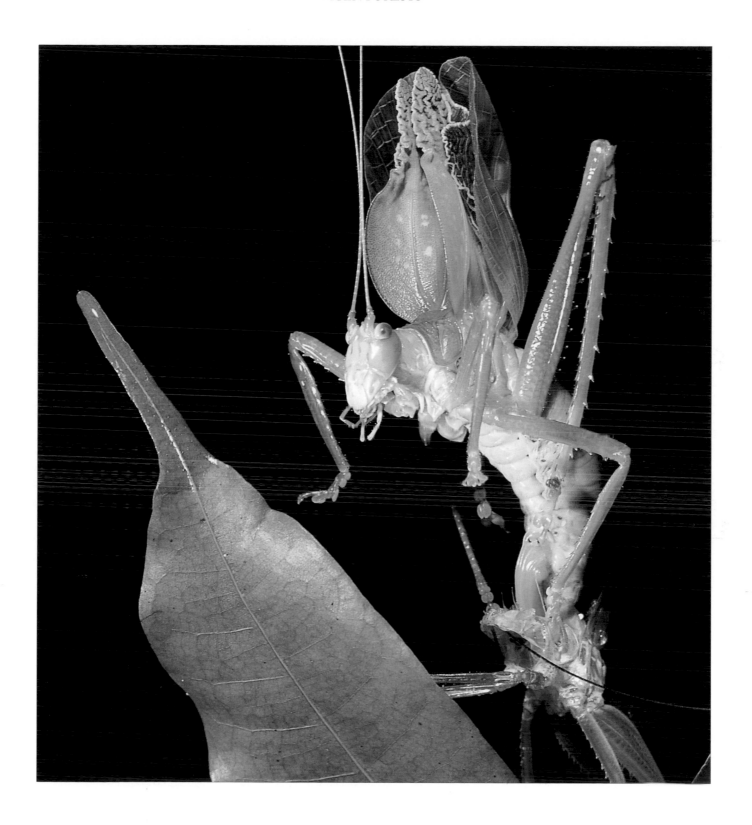

These ventures into the hitherto unknown frontier of the canopy are, in the words of the Harvard entomologist Professor Edward O. Wilson: 'revealing unimagined worlds in the foliage of the rain forest, where chunk-headed snakes with catlike eyes feast on frogs and lizards; where an ant known as *Daceton armigerum*, armed with jaws like a bear trap, rotates its head vertically to snatch flies from the air; and where earthworms wriggle through foot-thick soil on tree branches – ten stories in the air. How do the worms and soil get there? That's one of the questions scientists are exploring. In the process, they are turning up thousands of new species, as yet undescribed by science. They've found a poisonous caterpillar in Peru that looks like a miniature dust mop, and in Papua New Guinea giant weevils that carry miniature gardens of mosses and lichens on their backs. So many new species are being found that it is hardly news any more. The big news is, quite simply, that life is more diverse and more plentiful than anyone had previously known. Of the 1.4 million species of organisms given a scientific name to the present time and those remaining to be studied, many biologists believe the majority are to be found in tropical rain forests.'[8]

All this rain-forest research has started to reveal the secrets of insects. Despite their tiny size, invertebrate arthropods (as insects are known because of their jointed legs) are in such prodigious numbers that they account for over ninety per cent of the biomass in a tropical forest. Professor Wilson wrote 'Every time I enter a previously unstudied stretch of rain forest, I find a new species of ant within a day or two, sometimes during the first hour. On a typical day, the first 40 or 50 colonies encountered might be species already known to science. Then a new species. Then another 20 colonies of established species, and one more new species, and so on in a continuing adventure for many days in a row.'[9] To illustrate the profusion of insect life, he cited a famous study in 1982 by Terry Erwin of the National Museum of Natural History in Washington. This identified 1,200 species of beetles in canopies of the Panamanian tree *Luehea seemannii*, 163 of which were believed to be peculiar to that one species of tree. There are some 50,000 tropical trees in the world. So, if the Panamanian tree is typical, there would be over eight million canopy-dwelling beetle species. Beetles represent forty per cent of insect species, so that the canopies of all tropical forests would contain twenty million species of arthropods. Adding insect species on the ground would bring the total for rain forests to thirty million. Nigel Stork of the Natural History Museum in London made similar calculations based on his own observations, and reckoned that the forests of Borneo contain between five and ten million species of insect.

Every creature in a forest forms part of a food chain, and each species of insect has evolved strategies for survival. Many rely on mimicry. The ingenuity of their camouflage is amazing – there are moths that look just like dead leaves, even with the irregular stains of rotting foliage, katydids that exactly resemble the twigs and leaves of their favourite plants, spiders and moths indistinguishable from tree bark, stick-shaped phasmids with imitation bud scars of the twigs on which they hide, and caterpillars identical to plant shoots or even bird droppings. There are also 'startle displays'. For instance, a silk moth rests on a tree during the day with its large body invisible because of bark-like brown and russet blotches. But if it is touched, it quickly spreads its fore-wings to reveal false eye spots, shining dark blue, and with the

glare and size of an owl's. The large caterpillar of a sphinx moth can, when threatened, constrict muscles to make its body look like the triangular head of a viper, complete with prominent eyes and swaying motion. Other insects adopt the opposite tactic. Their gaudy colouring is so obvious that predators assume that they must be poisonous. Some are indeed dangerous, but others simply pretend to be.

The law of the jungle is omnipresent, with innumerable hunters trying to surprise, trap and devour their victims. But there are also many examples of symbiosis, where one species develops a mutually beneficial partnership with another. One common example of this is ant-plants, where a plant provides perfect nesting places and food for ants in return for their protecting its foliage against foragers and predators. Fast-growing cecropia trees (*Moraceae*) are a common example of this. Their branches are hollow, with chambers and entrance holes easily penetrated by queen Azteca ants. The queen lays her eggs inside, and these eat her secretions as well as nourishment provided by the tree. The leaves have pores that ooze nectar which the ants enjoy. Soon the cecropia is thoroughly colonized. The Aztecas then protect their host by ridding it of caterpillars and even budding epiphytes. A visitor can quickly spot an ant-plant because its leaves are intact, unlike the ravaged foliage of its neighbours. One species is known to Amazon veterans as *pau do novicio*, 'novice's wood', because a greenhorn slings his hammock on the temptingly smooth trunk, only to wake in the night covered in its ant sentries. There is an amazing number of such plants, with bewilderingly many devices for attracting different species of ant. Woodruff Benson writes that ant-plants 'have proved to be structurally and taxonomically the most diverse imaginable. They occur in 16 plant families and 35 genera in America alone. The species total for America now stands near 200, 150 for the Far East and some 65 for Africa.'[10] New symbiotic relationships are constantly being discovered, some of amazing complexity involving several interlocking plants and animals. The author once observed a foraging column of army ants (*atta*) that swept up a tree trunk, killing all the grubs and insects in its bark and clearly hoping to reach a huge and tempting wasps' nest. However, the wasps had a pact with Azteca ants, and these defended their tree against the invaders. A sharp battle ensued, at my eye level, with dead ants falling to the ground. It was all over in a moment: at some command, the army ants decided that it was too challenging. They all retreated simultaneously down that tree and moved on to attack the next.

Another little-known frontier of rain forests is where they meet water, in mangroves on ocean shores or in seasonally flooded river banks. One researcher who has made amazing discoveries in this realm is Michael Goulding, of the American Rainforest Alliance and the Brazilian Goeldi Museum; another is Nigel Smith, a geographer from the University of Florida; and Márcio Ayres, also of the Goeldi Museum, runs the Mamirauá Ecological Reserve with its extensive wetlands far up the Amazon. Studies by these and many others are revealing the extraordinary interrelations between fish, riparian animals, flood-resistant trees and plants that rely on fish for their germination, amphibians, birds, bats and of course innumerable insects. North of the city of Manaus is the national park of Anavilhanas, where hundreds of islands in the Rio Negro have an ecosystem adapted to spending months each year submerged beneath river waters. Some of the plant species are endemic to this archipelago.

Of all the animals in a rain forest, human beings are most interested in our genetic kin, the primates. David Attenborough has no doubt about the most magical moment of all his extraordinary wildlife expeditions. 'The West African forest provides the most haunting experience of all. A trail of broken stems and crushed leaves through thickets of wild celery and giant stinging nettles two metres [seven feet] high may lead you to a meeting with one of our closest relations, a family of gorillas lounging on the ground as they feed on handfuls of leaves, the youngsters inquisitive, energetic and impish, the mother tolerant and gentle, and the whole group watched over by a magnificent, silver-backed male.'[11] On another occasion, Sir David Attenborough gently approached a group of mountain gorillas in the hills of Rwanda, and had unforgettable moments playing with and embracing them.

The Swedish father of animal classification, Carl Linné, coined the term 'primate' for man and the three other species of great apes – gorillas, chimpanzees and orang-utans – that share so many genetic traits, including five digits on hands and feet, opposable thumbs, and having no tails. So, in 1966 the great palaeontologist Louis Leakey sent a young American zoologist, Dian Fossey, to study the mountain

Below: *Sir David Attenborough described the moments he spent with mountain gorillas while filming the famous* Life on Earth *series as among the most thrilling of his life.*

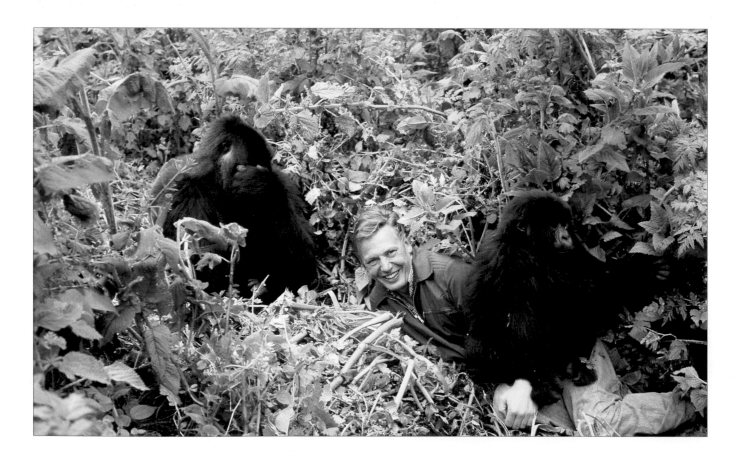

gorillas in the Virunga volcanoes on the borders of Rwanda and Congo. Leakey had made seminal discoveries of fossil remains of early man and human antecedents, so he was naturally interested in the behaviour of other living primate species. At the Gombe Stream Research Centre in Tanzania, Leakey's protegée Jane Goodall showed Dian Fossey how to organize a field camp and undertake ape studies. Fossey then drove half across Africa in the Land Rover of the superb British wildlife photographer Alan Root. She established a research centre at Karisoke in what became the Rwandan Parc National des Volcans and worked there continuously for the next two decades. Her research, like that of so many other expeditioners mentioned in this book, was largely financed by the National Geographic Society of Washington, DC. That Society consistently uses the profits from its excellent and very popular magazine to support scientific discovery. Dian Fossey vividly recalled her first contact with gorillas. First came their smell: 'an overwhelming musky-barnyard, humanlike scent. The air was suddenly rent by a high-pitched series of screams followed by the rythmic rondo of sharp pok-pok chestbeats from a great silverback male. Peeking through the vegetation, we could distinguish a curious phalanx of black, leather-countenanced, furry-headed primates peering back at us. Immediately I was struck by the physical magnificence of the huge jet-black bodies blended against the green palette wash of thick forest foliage.'[12]

One of Fossey's first tasks was a census of the highly endangered 240 mountain gorillas – one of three subspecies of the world's 4,000 surviving gorillas. But her main research was detailed observation of the behaviour of a series of extended families. She modestly described her achievement: 'My research studies of this majestic and dignified great ape

– a gentle yet maligned non-human primate – have provided insight to the essentially harmonious means by which gorillas organize and maintain their familial groups and also have provided understanding of some of the intricacies of various behavioral patterns never previously suspected to exist.'[13] Dr Fossey fought against the destruction of these superb animals. Some were killed for the trophies of their heads or skins, others perished during attempts to capture specimens for cruel exhibition in concrete cages of zoos, some were slaughtered for their meat during the political turmoil and famines that have plagued this part of central Africa, still others saw their forest habitats destroyed by encroaching human settlement (in countries with the continent's highest population densities of a staggering 350 people per square kilometre, 906 per square mile) or by plantations of pyrethrum, tea or coffee. In the end, Dian Fossey was herself murdered in her isolated camp, presumably because she had defended the gorillas too tenaciously.

Genetically, chimpanzees are our closest animal relatives. By 1960 there had been almost no study of chimpanzee behaviour in the wild. In that year the British scientist Jane Goodall started to observe them in the Gombe National Park in Tanzania, and the Dutch Adriaan Kortlandt embarked on years of study in the eastern Congo and then at Bossou in Guinea. In 1965 the Japanese Toshisada Nishida started long-term observation of chimpanzees at Mahale, 160 kilometres (100 miles) south of Gombe. Since then, scientists have learned more about these fascinating animals at other research stations in various West African countries. As so often in science, there has been admirable co-operation between the different researchers. They were assembled for the first time at a conference organized by the Chicago

Above: *In a lifetime of studying chimpanzees in Tanzania's Gombe forest, Jane Goodall greatly increased our understanding of mankind's closest animal relative. She has campaigned tirelessly to save chimpanzees from human cruelty.*

Academy of Sciences in 1986, and there have been similar conferences there at five-yearly intervals since then. Every aspect of chimpanzee behaviour has been studied, from parental relationships to use of tools and vocal communications. Among the many endearing traits of chimpanzees, Jane Goodall discovered one unfortunate similarity with human beings: young males have been known to maraud into the territory of other groups and kill wantonly for no motive other than blood lust.

Dr Goodall, the elegant and eloquent doyenne of chimpanzee studies, recently summarised the mass of data that has been accumulated: 'Two things stand out. First, the behaviour of chimpanzees and [closely related] bonobos differs in a variety of ways from one field site to another. Second, only when data are collected over time on known individuals can we appreciate the range of behaviour in a single social group. This variation — now documented for some sites with respect to ranging patterns, food selection, tool use (objects used and purposes to which they are put), communication postures and gestures, and social structure — is not at all surprising to those of us who know the great apes and are familiar with the inventiveness and resourcefulness of individuals. It would be strange indeed if these close relatives of ours with their complex brains did not show cultural diversity.'[14]

Appalled by human cruelty to these animals, this great researcher established the Jane Goodall Institute in Connecticut to crusade against seizure of chimpanzees from their happier life in the wild for the misery of captivity in some zoos, exploitation as seaside attractions or mockery in anthropomorphic advertising.

Another primate that closely resembles our species is the orang-utan of Sumatra and Borneo. The Canadian zoologist Biruté Galdikas has devoted her life to study and nurture of these 'great orange apes — after humans, the most intelligent of all land animals'.[15] She and her husband

Opposite: *Although chimpanzees are almost genetically identical to man, it is degrading to make them act like humans. Affectionate parents, chimpanzees are distraught when family members are taken into captivity.*

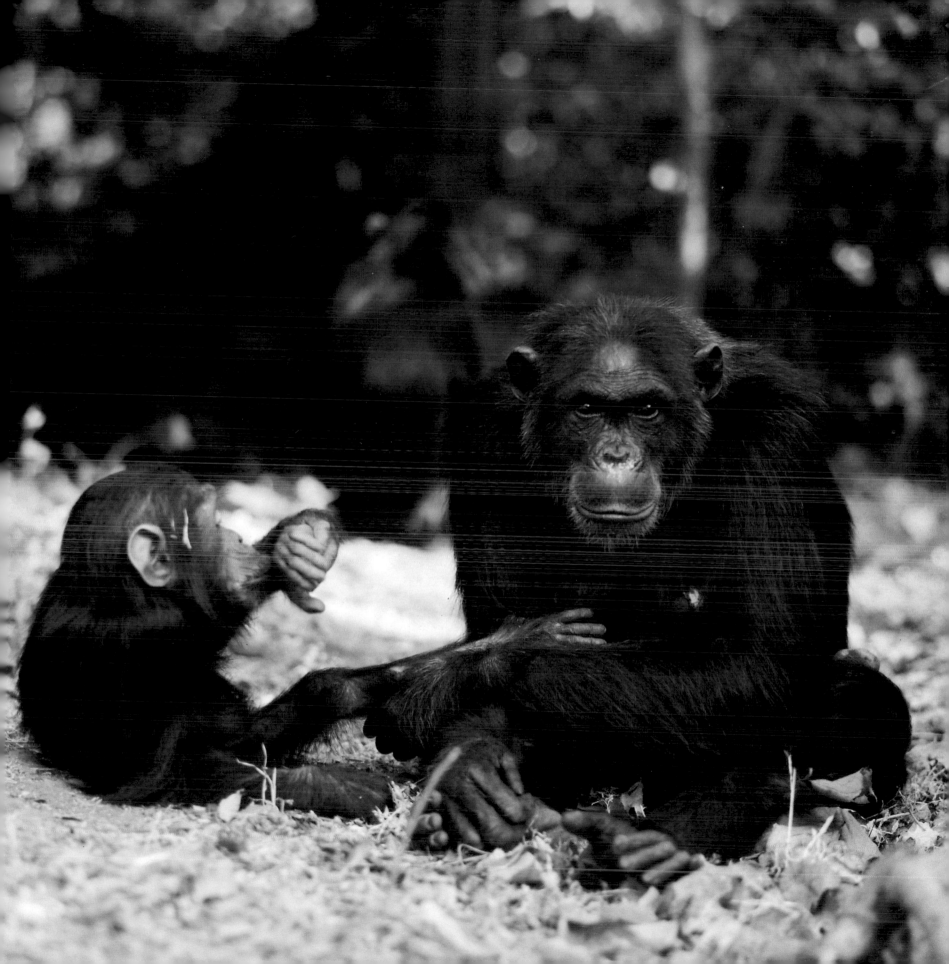

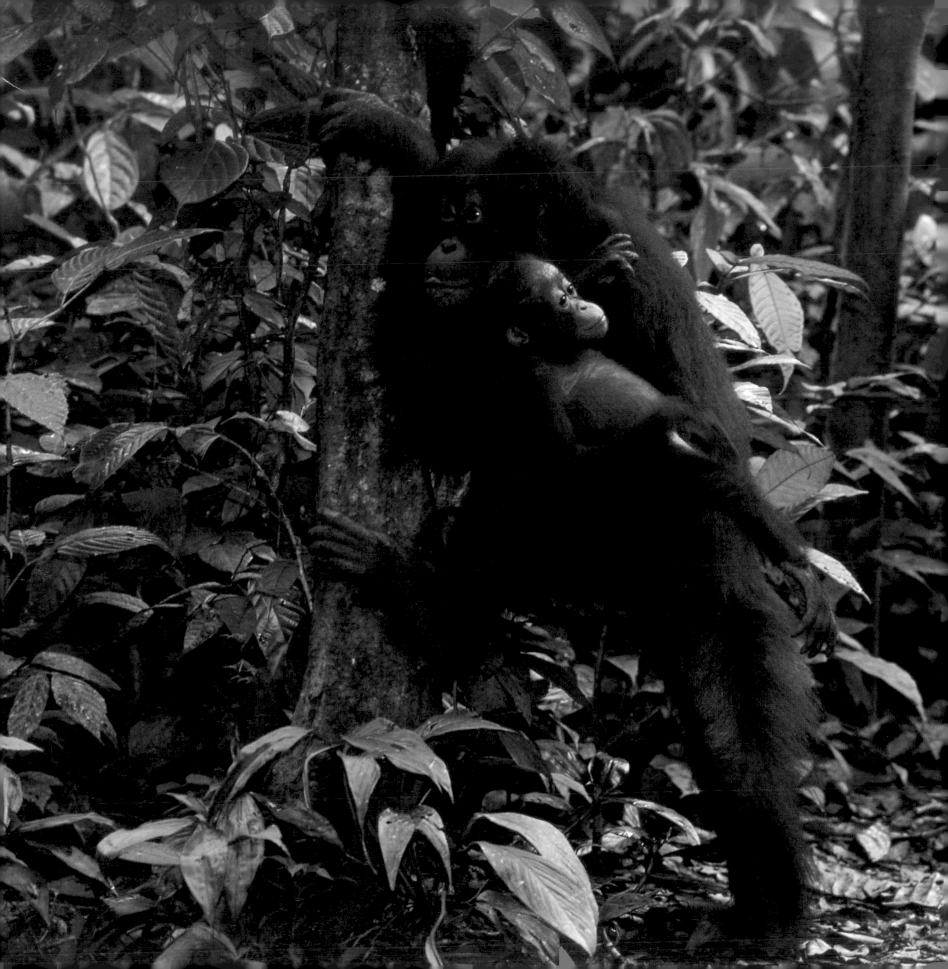

Rod for many years ran the Orang-Utan Research and Conservation Project in central Kalimantan, the Indonesian part of the huge island of Borneo. They even raised their child alongside an orang-utan, to compare the progress of the two infant primates. Dr Galdikas witnessed the first wild orang-utan birth ever, after following a pregnant mother for over a month, sleeping every night below the tree where the female roosted. She and her team of researchers were particularly interested in the diet of these solitary and elusive animals. They recorded them eating 300 types of fruit, bark, flowers and the occasional insect. They also monitored 5,000 census trees, of hundreds of species, in order to establish a catalogue of available food types. Male orang-utans occasionally make 'long calls' that reverberate for kilometres through the forest. These start with a series of grumbles and then crescendo to a powerful bellow that lasts for several minutes. Some males precede their calls by knocking over dead trees, to make an even louder crash that heralds their own performance. Andrew Mitchell particularly liked watching one male who would topple rotten trees by swaying his big orange body on them and then casually swinging to a neighbouring branch just as the first tree crashed to the ground. It is not known whether these great cries are intended to attract females or to frighten off rival males.

A related long-term study is Barito Ulu, a series of annual research expeditions in central Kalimantan, run by Professor David Chivers of Cambridge University and concentrating on gibbons. Chivers can himself make a frightening imitation of the calls of gibbons, 'perhaps the

Opposite: *Orang utan,* Pongo pygmaeus, *female and baby at Sepilok, Sabah, Malaysia.*

most tuneful of all mammals'. The largest of these, the enormous black siamangs of Sumatra, have inflatable throat sacs with which they can make ear-splitting screams, barks and booms. These echo through the forest and attract females, who join in a fortissimo amorous duet.

So, why are tropical rain forests worth saving? The main answers lie in their biodiversity. As has been demonstrated by the florescence of recent research, the forests – and particularly their canopies – are home to perhaps half of the millions of species with which we share this planet. Our species has no moral right to destroy such wealth of natural creation; and our knowledge is insufficient to realize when, by clearing a patch of forest, we may be extinguishing a species or a unique habitat. At a more selfish level, any rain forest may harbour plants that are useful to man, particularly in their reserves of as-yet-undiscovered pharmaceuticals. An argument is often advanced that tropical forests are the 'lungs' of the world, cleaning the carbon dioxide and other greenhouse gases and other pollutants. Scientists are not agreed whether this is happening, since most rain forests are mature systems that emit as much carbon as they absorb. However, their biomass contains a vast reservoir of carbon which, if abruptly released by burning or even by rotting and consumption by termites, would distort the atmospheric carbon balance. Deforestation has a dramatic and damaging effect locally – in changing weather patterns and clogging rivers with sediment. Experiments are under way to measure rainfall absorption and evapo-transpiration from the forest canopy. Large-scale deforestation would result in change to cloud and rainfall patterns. The total elimination of the vast Amazon rain forests might even alter the trade currents and climate all over the world.

THE OCEANS

In occupied France, in the middle of the Second World War, Captain Jacques-Yves Cousteau opened the door for man to explore beneath the oceans. Hitherto the underwater world had been glimpsed only during rapid free dives, by divers in cumbersome suits breathing through a tube from the surface, or from bathyscape submersibles. Cousteau's invention was the aqualung. Its breakthrough came from a valve that enabled a swimmer to breath in and out through the same mouthpiece without inhaling back carbon dioxide. So, in June 1943, Captain Cousteau swam under the Mediterranean with a contraption of three compressed-air cylinders on his back, a goggle mask, and biting the mouthpiece that led to his air regulator. It was a total success. Cousteau was euphoric as he glided across a submarine canyon. 'To swim fishlike, horizontally, was the logical method in a medium eight hundred times denser than air. To halt and hang, attached to nothing, no lines or air pipe to the surface, was a dream. I experimented with all possible manoeuvres of the aqualung – loops, somersaults, and barrel rolls. I stood upside down on one finger and burst out laughing – a shrill distorted laugh. Delivered from gravity and buoyancy I flew around in space. From this day forward we would swim across miles of country no man had known, free and level.'[1]

Of course, it was not all plain sailing. Divers gradually learned about the dangers confronting the human body as it descended into this strange world. One problem came from pressure. Atmospheric pressure roughly doubles with every ten metres (thirty-three feet) descended. Human tissue was found to have an uncanny ability to withstand extreme pressures that would crack the hull of a submarine. But other factors make it impossible for human beings to dive to great depths: gases would be absorbed into tissues and a person could not pass off carbon dioxide. It was found that the layer of water nearest the surface exerts the most exhausting pressure on a diver. Cousteau reckoned that someone who was able to withstand a dive of ten metres (33 feet) could descend to sixty metres (200 feet) without physical

Opposite: *Diver with silversides in an underwater cave. It was the groundbreaking developments of Jacques-Yves Cousteau that allow for such exploration.*

failure. The most important discovery was the agony of 'bends'. If a diver ascends too fast or while holding his breath, he suffers an air embolism – bubbles of air leak into the bloodstream and lodge in the brain or other parts of the body. The bends have to be prevented by gradual resurfacing or time spent in a decompression chamber. The underwater pioneers also learned about the drunken raptures when diving below thirty metres (100 feet). One of them recalled being anxious about his dive line, but 'I really feel wonderful, with a queer feeling of beatitude. I am drunk and carefree. My ears buzz and my mouth tastes bitter. The current makes me stagger as though I had had too many drinks. My eyes are tired. I am going to sleep, but can't fall asleep in such dizziness.'[2] This dangerous euphoria was caused by a build-up of nitrogen in the body.

Another fascinating discovery was that there are three distinct temperature layers in any sea: a thin warm layer, a moderate layer varying down from fifteen to sixty metres (50–200 feet), and then an abrupt crash into a cold layer. 'There is no transition. One can hang in the moderate zone and poke a finger into the cold and feel it as sharply as one sticks an exploratory toe into the sea on the season's first dip.'[3] The first divers found that the undersea is totally silent; the rare noises come from marine mammals – whales, porpoises or men calling to one another, or the sounds of marine motors and other human activity.

Oceans cover seventy per cent of our planet. In 1951 Rachel Carson wrote *The Sea Around Us*, a wonderfully prophetic book in praise of the seas. She appreciated that humankind was on the brink of great discoveries under the marine surface. She challenged scientists to probe the oceans' effect on climate history. 'Day by day and season by season, the ocean dominates the world's climate. Can it also be an agent in bringing about the long-period swings of climatic change that we know have occurred throughout the long history of the earth – the alternating periods of heat and cold, of drought and flood?' *The Sea Around Us* was an influential book, a pioneer of the environmental movement. Rachel Carson ended her text by reminding scientists of the infinite challenges of marine research. 'It took centuries to chart the surface of the sea; our progress in delineating the unseen world beneath it seems by comparison phenomenally rapid. But even with all our modern instruments for probing and sampling the deep oceans, no one can say that we shall ever resolve the last, the ultimate mysteries of the sea.'[4]

The development of the aqualung and concurrent advances in oceanographic submersibles triggered the greatest explosion in the history of discovery. Tens of thousands of divers explored the shallow seas and learned the secrets of marine organisms. There were experiments in which men lived in undersea laboratories. Cousteau himself developed the Conshelf series of dwellings on the continental shelf. In 1965 his own son Philippe and five others lived for a month sixty metres (200 feet) below the Mediterranean; and they talked by telephone to Scott Carpenter in the US Navy's Sealab at a similar depth off the coast of southern California. These explorers breathed heliox, a mixture of helium and oxygen. The French undersea dwellings developed into the more sophisticated Aquabulle and Galathée, while the Americans went on to build deep-sea stations for use at depths of over 300 metres (1,000 feet). These are supplied with controlled oxygen input containing no nitrogen. Now, hydreliox (heliox with the addition of hydrogen) enables men to breathe at amazing depths of over 500 metres

Above: *Offshore drilling platforms in Britain's North Sea are now commonplace, but exploration had 'never previously brought such immediate financial return'.*

(1,600 feet) with no psychological problems.

Industry and science co-operated to make these dramatic advances. The oil industry had an obvious interest in discovering offshore petroleum deposits and then perfecting the technology to drill into the ocean bed, erect platforms, and extract the 'black gold'. North Sea oil, which transformed the British economy, was undreamed of after the War; and offshore reserves have since been discovered in every continent. Exploration had never previously brought such dramatic and immediate financial return, yielding profits far greater than from the treasures of gold, silver and spices brought back by the earliest European voyagers and conquistadors.

Explorers also broke records in dives by submersibles. The concept of a spherical steel shell, with portholes of molten quartz to withstand extreme pressures, had been pioneered in the 1930s by the American scientist William

Beebe and his engineer partner Otis Barton and by the Swiss Auguste Piccard. Their bathysphere was suspended on a cable from a mother ship and linked to it by telephone. Immediately after the War, Barton's benthoscope dived to 1,370 metres (4,500 feet), which was considered the limit for a suspended bell since any longer cable might be snapped by ocean currents.

The problem was to invent submersibles that could float freely at great depth. This was a very dangerous challenge. If the device were stuck or trapped on the bottom, or if its buoyancy chamber leaked, it would never resurface. It had to move at great pressure, and it needed a means of descending and rising again when required. Auguste Piccard doggedly overcame each successive obstacle, inventing a vehicle he called a bathyscaphe. In this, the reinforced steel sphere containing the explorers was flanked by propellers and suspended below a great metal balloon filled with 45,000 litres (10,000 gallons) of extra-light petroleum for buoyancy. The greatest challenge was to weight the chamber for diving and then jettison the ballast – but without making openings in the sphere that would weaken it. Piccard's brilliant solution was to use electromagnets, controlled by a switch that would release iron ballast (rather than non-magnetic lead) as required.

Cousteau accompanied Piccard to the Cape Verde Islands for the first experiments with the bathyscaphe. The two men looked their parts: the French naval officer was lean. wiry and tough, handsome in an Yves Montand manner, while the Swiss inventor had the high domed forehead, wild wispy hair, pot belly and spindly legs of what Cousteau called 'an elderly scientific fanatic'. The usually unflappable Madame Simone Cousteau, who had helped her husband in all his experimen-

tal dives, begged him not to descend in 'that horrible machine. Don't risk yourself in that craziness'. Needless to say, she failed to dissuade Cousteau; but the launch had its moments of panic and farce. After five days of 'bizarre annoyances and delays' the explorers attached a huge battery and tons of iron ballast to the craft, still suspended in the freighter that had transported it. Piccard went aboard for a final check and absent-mindedly wound an alarm clock without noticing the time for which it was set. 'At noon, this weight-tripping clock went off, and tons of metal fell into the ship's hold with a frightful roar.' The first dive lasted for only sixteen minutes, followed by five hours to bring the bathyscaphe back onto the mother ship and release its crew. The hatch was unlocked. 'A high leather boot came out, followed by a bare shank, another boot and leg, bathing trunks, a naked belly, and the bespectacled wild-haired pinnacle of Professor Auguste Piccard. His hand was extended, clutching a patented health drink with the label squarely presented to the cameras. Professor Piccard ceremoniously drank the product of one of his sponsors.'[5] A few days later, the bathyscaphe made an unmanned dive to 1,400 metres (4,600 feet). It suffered some damage, but nothing that could not be rectified by the inventor and his engineers. This was another great breakthrough in humankind's exploration of the oceans.

Improved bathyscaphes saw service with the French and Italian navies, achieving dives of almost 6,000 metres (20,000 feet). With American funding, the Italian craft, the *Trieste*, was given a stronger sphere. Early in 1960 it descended to 7,000 metres (23,000 feet or 4.3 miles). Then, on 23 January 1960, Jacques Piccard (the son of the inventor) and the American Don Walsh touched the bottom of the Mariana Trench in the Pacific Ocean, at 10,916 metres (35,800 feet

or 6.8 miles). The pressure of the water at that depth is a crushing 1,156 bars – where the pressure of the atmosphere at sea level is only 1 bar. Since then, the French navy has developed an even tougher submersible called *Archimède* that is capable of longer dives – if deeper ocean trenches can be found to test it.

These great dives, coupled with a steady programme of hydrographic mapping of the world's seabeds, showed mid-ocean ridges running from north to south in the Atlantic and below all the other oceans. It was the Mid-Atlantic Ridge that finally clinched the theory of continental drift or plate tectonics. The theory had a long pedigree. Francis Bacon in 1620 commented on the way in which the eastern bulge of South America seemed to fit into the hollow on the map of western Africa. Others, in the nineteenth and particularly the early years of the twentieth century, elaborated on the idea that the continents might be drifting apart after the fragmentation of two original land masses: Gondwanaland in the southern hemisphere and Pangaea in the northern. The leading proponent of continental drift was the German meteorologist and Arctic explorer Alfred Wegener. In a book published in 1915, Wegener said that the idea struck him as he watched polar ice floes breaking up. He was the first scientist to link the interlocking of coastlines in a continental jigsaw with geological and palaeontological evidence of the same formations appearing in once-connected land masses. He guessed that the same geological formations, containing fossils of similar land animals, occurred in Africa and South America. An item of evidence came from the geological samples from the interior of Antarctica that Captain Scott and his men were manhauling when they died in 1912. But, although Wegener's theory was occasionally discussed at

Above: *The seabed topography of the South Atlantic Ocean. Surveys in recent decades have revealed mid-ocean ridges in most of the world's oceans.*

learned meetings and in scientific papers, it was not accepted because there is no known force powerful enough to move continents laterally. Scientists had no difficulty with isostasy, the vertical movement of land masses that counteracts erosion and is the basis of so many geological formations, but distinguished geologists continued to ridicule continental drift until the 1960s.

As early as the 1950s, the Canadian geophysicist J. Tuzo Wilson linked Wegener's theory of continental drift with the idea of sea-floor spreading. He further suggested that the earth's crust consists of rigid plates that gradually move over a partially molten lower layer.

Earthquakes are regularly monitored all over the world. A map of such seismic tremors reveals the locations of subduction zones. Wilson showed how the lines of tremors

outline tectonic plates with uncanny precision, 'like the stitching on a baseball'. They corroborate hydrographic charting and geophysical mapping.

British scientists discovered a remarkable feature of the Mid-Atlantic mountain range: a steep-sided valley runs along its centre. In the 1960s came the theory that it was the upward welling of molten material in the mid-ocean ridges that was forcing the continental plates apart. The submarine rift valley seemed to corroborate this. Volcanic activity on all the Atlantic islands, from Iceland to Tristan da Cunha, confirmed that these pinnacles of the Mid-Atlantic Ridge are geologically unstable. Decisive evidence finally emerged from study of the magnetic polarization of rocks of the Mid-Atlantic Ridge. It had been found that magnetically sensitive materials in igneous rocks were permanently magnetized when they cooled. In 1952, P. M. S. Blackett invented a highly sensitive astatic magnetometer that determined the history of the earth's magnetic fields for the past 500 million years. This showed that the magnetic pole, in addition to its constant shifting, has occasionally flipped from the Arctic to the Antarctic and back during those millions of years. The proof came from studying the magnetic polarity of sediments on the ocean floor. Oceanographers found that strips of rock flanking the volcanically active Ridge were polarized in regular patterns. The youngest sediments, on either side of the Mid-Atlantic Ridge, were polarized northwards; the next bands on either side pointed southwards; then north again, and so on until reaching the coasts of South America and Africa.

Evidence accumulated from expeditions all over the globe and from scientists in many disciplines – oceanographers, geologists, geophysicists, palaeontologists, polar explorers, even biologists. Geologists found a perfect match between the ages and positions of similar rocks in Africa and northern South America. Identical fossils of plants and animals were found on different southern continents: these life forms could not possibly have evolved in the same way and at the same time on isolated continents. The sceptics were won over and, by the mid-1960s, the great theory of continental drift was uniformly accepted. It explains much of the behaviour of our planet. It is the greatest geographical theory to gain acceptance in recent times. And it is the product of the recent flowering of exploration and scientific fieldwork.

During the 1970s, the theory was further refined. It was shown that the earth's crust consists of a kaleidoscope of thirteen vast semi-rigid plates and many smaller ones, both on land in the continents and beneath the oceans. These have now been mapped. It is the movement (tectonics) of these plates that causes earthquakes. Plates can press against one another or slide under one another in what was named 'subduction'. This happens on either side of the Pacific Ocean, which is thought to have been the original sea and not the product of fragmenting continents. It produced crumpling of the earth's crust, geosynclines, to uplift as the Andes and Rocky Mountains. These are full of volcanoes and prone to earthquakes, as is the far side of the Pacific. Other plates pull apart or create fracture zones with deep lateral cracks. Uneven rates of sea-floor spreading cause fault lines. These are usually on the ocean bed, but one of them runs into the coast of California in the notoriously earthquake-prone San Andreas fault. Tectonic plates can also move laterally in opposite directions, building up friction that

Opposite: *The upward welling of molten material in the Mid-Atlantic Ridge forces the continental plates apart. This Icelandic eruption is dramatic above-water proof of the Ridge's activity.*

eventually gives way in the most devastating earthquakes.

Echo-sounding sonar was developed to locate submarines during the two world wars. It was then adapted to measure ocean depths. The time taken by acoustic pulses to bounce back to the survey ship gave the distance to the seabed. Of course, such bathymetric depth sounding was not easy. Many factors can influence the speed of sound in seawater – temperature, pressure, salinity, or obstacles such as schools of fish. These problems were overcome as oceanographers grew more skilled in interpretation.

A profile of the ocean floor was recorded continuously on tape as the survey vessel sailed above. Hydrographic charting voyages all over the world used this method to map the oceans in detail; and this mass of data was collated in the 1960s to produce a comprehensive picture. This clearly showed the great ridges in the midst of every ocean, forming a single mountain chain that meanders for 65,000 kilometres (40,000 miles) around the world's ocean floors. Each ridge has central crests flanking a rift-like cleft, with lateral cracks running off under the surrounding seas. The charting also highlighted the great trenches in the western Pacific and Indian Oceans. (Similar phenomena were noted on land, for instance the Rift Valley that runs from the Dead Sea, along the Red Sea and into the heart of East Africa. There are also mountain ranges where subduction is taking place, notably the Himalayas where the Indian plate has spun off Gondwanaland and is pushing against the central Asian plate, and the Alps where a southern range is thrusting under a northern one.) Where the ocean crust is subducted it produces new magma, and when this erupts and hardens it can make arcs of volcanic islands like the Aleutians or Philippines. To learn more about the earth's crust, a group of

nations in 1968 started a Deep Sea Drilling Programme. The Scripps Institution of Oceanography combined with other research institutes to commission a radical new drilling ship, the *Glomar Challenger*, which was capable of penetrating the ocean floor at a depth of 6,100 metres (20,000 feet). This vessel's first adventure came on her maiden voyage. Her scientists decided to drill into the mysterious Sigsbee Knolls: strange, rolling hills that had recently been found in deep water on the floor of the Gulf of Mexico. *Glomar Challenger* had a new positioning system whereby sonar beacons, hydrophones, computers and side thrusters kept the ship in one place, without anchoring, while she dropped her drilling apparatus. This worked perfectly, as did the lengths of piping lowered for nearly 3,700 metres (12,000 feet) to the sea floor and the drill that slid within them. To the delight of the scientists who had worked through the night, perfect cores were brought up. These revealed that, beneath 140 metres (460 feet) of sediment lay a salt dome cap, with traces of oil and gas that are often associated with salt domes.

The *Glomar Challenger* went on to sail in every ocean and make the first systematic global programme of core sampling. This led to fundamental advances in our understanding of the nature and age of the ocean floors, and it discovered the mechanisms that form ocean basins, island archipelagos and mountain ranges. Much was learned about the location and formation of oil, gas and mineral deposits deep on the continental shelves. It was also learned that the oceans are relatively young: some 200 million years old, compared to the earth's 4,500 million years. In 1984 this drilling programme was succeeded by the more elaborate JOIDES (Joint Oceanographic Institutions for Deep-Earth Sampling). This consortium's large and sophisticated drilling ship *JOIDES*

Above: *The sea topography in Australasia shows the destructive plate margins, such as the deep blue linear feature visible in the upper left corner, that give rise to extensive volcanism.*

Resolution lowers a weighted cable and, when this touches ground, it drops a hollow corer into the seabed. When attached to a drill, this can yield cores of up to 1,500 metres (6,000 feet), with information about millions of years of the earth's geology and climate. It was found that oxygen atoms in fossil shells within cores could be weighed to determine the temperature when the creatures died. This gave an idea of climate changes during the past ten million years. In a ten-year programme, the *JOIDES Resolution* gathered core samples from all the world's oceans, at depths of up to 8,200 metres (26,500 feet). It went a long way to answering Rachel Carson's challenge in 1951 to discover the extent to which the oceans have influenced the world's climate.

Recently, satellites have been harnessed to scan the ocean floor. Data gathered by the Geosat satellite in the

Above: *The* Alvin, *commissioned in 1964, was a highly successful submersible that was capable of diving to depths of almost five kilometres (three miles).*

mid-1980s was used by NOAA (the US National Oceanic and Atmospheric Administration) to produce far more detailed maps of the entire ocean floor, published in 1995. From these, tectonic movements can be modelled with accuracy. There are still mysteries to be solved: volcanoes and submarine formations have been discovered that do not seem to correspond to plate boundaries. But, generally, Wegener's brilliant theory of continental drift or plate tectonics has been confirmed. It is now clear that the bed of the sea gives birth to the land, and then gradually rearranges its pieces.

Successors to Piccard's bathyscaphe were used to have a closer look at the ocean floor. The first place they wanted to examine was the Mid-Atlantic Ridge, the final piece in the jigsaw confirming continental drift. In 1974 an expedition

called FAMOUS (French-American Mid-Ocean Undersea Study) explored the Ridge's rift valley south of the Azores. The French bathyscaphe *Archimède* and diving-saucer *Cyane* went down alongside the American submersible *Alvin*. Over 5,000 photographs and many samples of solidified magma all confirmed that it was molten rock in this Ridge that was forcing Europe and Africa apart from the Americas. It was calculated that the seafloor here was spreading at a rate of 2.5 centimetres (about one inch) per year.

The *Alvin*, commissioned in 1964, was a highly successful scientific submersible. Initially, it could dive to almost five kilometres (three miles), but it was later upgraded to descend for a further kilometre. *Alvin* made thousands of highly productive dives. It was joined by a few other research submersibles: the French *Nautile*, the Russian *Mir I* and *Mir II*, the Japanese *Shinkai* and the American *Sea Cliff*, all of which can reach the deepest ocean trenches at a depth of six kilometres (3.7 miles).

But some of the first generation of submersibles have now been scrapped: they were too expensive to run, their equipment was too primitive, and there was too little for them to do. Recently the trend has been to ROVS (Remotely Operated Vehicles). These are cheaper because they do not require the safety precautions and support systems needed for human passengers. Some submersibles can be tethered to a support ship, and they in turn send out small robots. It was a combination of the towed vehicle *Argo* and a small, unmanned, remotely operated ROV called *Jason Jr* that first explored the wreck of the *Titanic*. There are now

Opposite: *The* Deep Flight *submersible, an exciting new mini-submarine, whose creator and inventor Graeme Hawke was also the pilot, seen off the coast of California at Monterey.*

several hundred such vehicles, mostly engaged in routine work for the oil industry and on military missions.

In 1977, the team that had examined the Mid-Atlantic Ridge combined with Mexican oceanographers to explore the Galápagos Rift off the equatorial coast of South America. This expedition made a number of thrilling discoveries. 'Shimmering water streams up past giant tube worms, never before seen by man. Inside the research submersible *Alvin* we watch in amazement. We have dived a mile and a half (2.5 kilometres) into the near-freezing depths of the Pacific, yet our temperature probe now registers 63°F (17°C) as we hover over an incredible community living around a warm sea-floor spring. The unknown creatures and dense communities of life we have discovered living at these vents, like lush oases in a sunless desert, are a phenomenon totally new to science.'[6]

This Galápagos Hydrothermal Expedition was examining submarine vents, where very hot water full of dissolved minerals boils up from small volcanoes. As the earth's crust moves, molten rocks from the earth's core (which is intensely hot from nuclear decomposition) well up into the resulting cracks. This molten rock hardens on the ocean bottom, forming the mid-ocean ridges. Fissures in these ridges are invaded by cold and very dense sea water, and this water in turn spews up as hot submarine springs loaded with gases and minerals leached from the rocks. A typical vent forms a cone of metallic minerals the size of a gigantic hangar. The black gases erupting from this can reach three and a half times the boiling point of water – enough

Opposite: *Viewed from the* Alvin *during an expedition returning to the Galápagos hydrothermal vents in 1979, these extraordinary red-tipped worms grow around the organic-rich vents of deep-sea geysers.*

Above: *The temperature of the underwater hydrothermal vents can reach three times that of boiling water.*

to melt submersibles that drift into them, even those made of titanium.

In 1975 the United States and the Soviet Union agreed to conduct joint studies in the oceans. Eight years later, Peter Rona of NOAA (National Oceanic and Atmospheric Administration) astonished other scientists by finding more hydrothermal vents some 4,000 metres (2.5 miles) down in the Mid-Atlantic Ridge. Other volcano-like geysers are since

being discovered in most mid-ocean ridges. Rona recalled the excitement of approaching this frontier of discovery. 'Billowing black clouds erupt before us. Only a few feet and the acrylic portholes on our (Soviet-built advanced-technology) *Mir* submersible separate me and my Russian companions from a blasting, 650°F inferno. We catch our breath as our pilot braces the craft against a mineral deposit, maneuvering to keep us from being sucked into the roiling geyser.'[7] The reward of their courage and skill was to discover amazing creatures that had evolved in this extreme pressure. These life forms are described in the chapter on marine life. Another reward may be mineral deposits of great purity and in stupendous concentrations. In 1991 Ray Binns on the Australian government's research ship *Franklin* discovered a chain of hydrothermal smokers in waters off Papua New Guinea. One massive chimney, which the researchers called Satanic Mills, was growing a centimetre a day and giving off extremely hot plumes five to ten kilometres (three to six miles) long. These chimneys are only 5,000 metres (three miles) down, and the deposits of arsenic, mercury, lead, copper and zinc surrounding them are of ore quality and constantly renewable. The government of Papua New Guinea in 1998 awarded a contract to a submarine salvage company to try to mine them, at a rate of 1,000 tonnes a day to be commercially viable.

One drawback of bathymetric sonar sounding was that it was vertical, measuring only the ocean immediately below the mother ship. British oceanographers developed an effective side-scanning sonar, in which the pulses fan out on either side of a vessel's course. The returning echoes are difficult to interpret, but once mastered they vastly increase the area of seabed being mapped. This invention is housed in a yellow tube the size of a torpedo; it is towed behind a research ship and uses sonar to survey bands of ocean floor up to thirty kilometres (nineteen miles) wide. It was called GLORIA – a Geological Long-Range Inclined Asdic (the British name for Sonar). Using GLORIA, the United Kingdom was the first nation to make a complete map of its exclusive economic zone (EEZ) or territorial waters. So impressed were the Americans that, when in 1983 they also declared a 200-mile EEZ, the US Geological Survey awarded the contract to map hundreds of thousands of square kilometres of the nation's territorial waters to the British Institute of Oceanographic Sciences and its privatized commercial company. For seven years, research vessels criss-crossed the oceans off 20,000 kilometres (12,500 miles) of coastline of the continental United States, and gloria mapped far more American territory than any previous explorer or cartographer.

GLORIA went on to map the waters around the state of Hawaii, discovering an immense and unexpected field of recent lava flows – by far the largest such formation found under any ocean. In 1988–9, the research ship *Charles Darwin* used GLORIA to map the 400-kilometre (250-mile) Easter Island Plate, off the island of that name in the southern Pacific Ocean. This was the first time that an entire tectonic plate had been mapped, and it was done in a region where the sea floor is spreading most rapidly. A new electro-magnetic underwater surveying technique was developed, to explore this area of hot fissured rocks and superheated mineral-rich seawater. The scientists on board *Charles Darwin* also worked in the seas off the coast of Chile that sometimes suffer the devastating warm current known as El Niño. Every few years, this warm current creeps down the

Above: *The side-scanning sonar,* GLORIA, *housed in a yellow tube and towed behind a research ship, enabled Britain to become the first nation to make a complete map of its territorial waters.*

western coast of South America, between the cold Humboldt Current and the narrow coastal plain at the foot of the Andes mountains. The result is a catastrophic reversal of normal weather patterns, that reverberates all over the Pacific basin since El Niño is simply the eastern extremity of a huge warm-water current across the entire Pacific Ocean. By studying water temperature, salinity and currents, it was found that salinity is the critical factor in changing water density and possibly in predicting the next El Niño.

The deep ocean also contains the wrecks of human ships, the pathetic relics of tragedies that inspire such powerful emotions. Over the centuries, shipwreck has seemed the cruellest fate. When Cousteau and his colleagues started experimenting with aqualungs, they immediately investigated sunken wrecks. They found such wrecks to be as fascinating as they are mournful: encrusted with barnacles and seaweed, home to inquisitive fish, dangerous to divers from their currents and treacherous mangled holds, and full of mystery about their cargoes and the catastrophe that sank them.

Over recent years, innumerable expeditions have explored wrecks in every ocean. Marine archaeologists learned the techniques of ancient shipwrights, and examined the belongings of sailors and the cargoes they carried. There were thrilling finds of Phoenician and Roman cargo vessels. For twenty years from 1965, scuba divers led by Margaret Rule excavated the Tudor warship *Mary Rose*, which sank in 1545 in the sight of King Henry VIII. They were working in the murky waters of the English Channel, in 'a diver's nightmare, ranging at best from a milky haze to something in the order of lentil soup'.[8] In 1961 Anders Franzén led the raising of the magnificent seventeenth-century Swedish flagship *Vasa*, which capsized on her maiden voyage in full view of the people of Stockholm. Treasure-hunters delved in archives to locate Spanish treasure galleons, and a few were spectacularly rewarded. The richest wreck of all time was the *SS Central America*, which sank in 1857 in a hurricane off the coast of South Carolina. Her cargo of bullion from the Californian gold rush was worth a billion dollars. Other divers examine heart-breaking wartime cemeteries such as the British battleships sunk off Malaya or the Japanese fleet lying in shallow waters off the Pacific island of Truk.

The most famous wreck of them all, the *Titanic*, sank in the deep Atlantic Ocean far beyond the reach of divers. Everyone knows how in 1912 this greatest and most luxurious passenger liner of its day, built to be unsinkable, had five of its sixteen watertight compartments torn by an iceberg, and sank on its maiden voyage. *Titanic's* orchestra played 'Abide with me' as she sank; women and children were put first into the insufficient lifeboats; but 1,522 lives were lost in the tragedy, including John Jacob Astor, Benjamin Guggenheim and others of the world's most wealthy people. The discovery of this wreck became an obsession of the American oceanographer Dr Robert Ballard. The search covered a large swathe of the mid-Atlantic, since the records of the ships that finally came to the rescue of *Titanic's* survivors proved flawed. Dr Ballard needed military hardware and funds to pursue his elusive quarry. He worked at the Woods Hole Oceanographic Institution in Massachusetts, the world's leading centre for oceanographic research. Luckily, Woods Hole in the 1970s gave its submersible *Alvin* a titanium hull that greatly increased its diving range to some 4,000 metres (13,000 feet), which was thought to be the depth at which the *Titanic* lay. The US Navy spent lavishly on new sonar, which Ballard himself helped to develop, and this was used in the unmanned submersible *Argo* to film the wreck of the sunken nuclear submarine *Scorpion* in 1985. Later in that year, Ballard joined scientists from the French Institute for Research and Exploitation of the Sea, who had also developed a wide-swathe, side-scan sonar that could monitor a stretch of seabed a mile wide. The team had done painstaking research on all the documentation surrounding the sinking of the liner, but she was not in the presumed location. Ballard recalled those anxious weeks of searching: 'We had done so much research on the wreck that we were very familiar with the disaster surrounding it. We would swing from elation to depression in moments.' Finally, on 1 September 1985, they succeeded. The *Titanic* was located several miles away, and was filmed by remote control lying perfectly preserved in

Opposite: *Divers working on the excavation of the Tudor warship* Mary Rose, *which sank in 1545 in the sight of King Henry VIII. The divers worked in conditions 'ranging at best from a milky haze to something in the order of lentil soup'.*

two huge sections at a depth of 3,810 metres (12,500 feet).

Dr Ballard and two companions then descended in the *Alvin*. The submersible's sonar ceased working and the dive almost had to be abandoned, but a navigator in the surface ship managed to guide them towards the wreck. They were spellbound as their tiny craft sailed along the towering metal cliff of Titanic's hull. Robert Ballard saw that she was 'whole, upright, suspended, and very eerie'. He admitted that 'My lifelong dream was to find this great ship, and during the past thirteen years the quest for her dominated my life.' In eleven dives, the team used a robot camera to take poignant pictures of the stricken ship. On the liner's hull were an anchor crane, cables, parts of a staircase, chandeliers and wooden cabin panelling, and great expanses of ribbing, railings, portholes and bulkheads. There were more intimate objects lying on the ocean floor: champagne bottles, a doll's head, a bathtub, spittoon, serving bowls, and a copper kettle brightly polished by debris in the current. Ballard and his French

Opposite: *The 'swimming eyeball' – the robot* Jason Jr *– cautiously approaches the hull of the* Titanic.

Below: *Rust encrusts a porthole of the emotive wreck of the* Titanic.

co-leader Jean-Louis Michel were scrupulous about not interfering with the wreck in which so many people had drowned, apart from fixing a plaque to her hull. But another French expedition in the following year controversially looted dishes, jewels and other artefacts, which were then exhibited in Paris.

Marine research continues unabated. There are constant improvements in instrumentation, everything from high-resolution television cameras and seismographs to thermometers, pressure gauges, corers and flow meters. A priority is the development of autosubs, free-ranging unmanned robots that use satellites both for navigation and accurate positioning, and to relay their data back to base. Oceanographers have a penchant for irritating acronyms, but their devices' complicated full names describe what they

Below: *Today there are constant improvements in marine research instrumentation. Developments in free-ranging unmanned robots have led to the prototype of* Autosub, *a* DOLPHIN.

can do. DOGGIE is a 'deep-ocean geological and geophysical instrumented explorer'. It works on the seabed close to the mother ship, where scientists analyse its stream of data. DOLPHIN stands for 'deep-ocean long-path hydrographic instrument'. It ranges farther afield, measuring currents, the chemical composition of seawater, and biological formations.

Back in 1951, Rachel Carson contrasted the abundance of biological life in the Arctic with the lack of terrestrial animals in Antarctica. She felt that 'the transforming influence of the sea is portrayed with beautiful clarity in the striking differences between the Arctic and Antarctic regions. The streams of warm Atlantic water that enter the icy northern seas bring the gentling touch that makes the Arctic, in climate as well as geography, a world apart from the Antarctic.'[10] The mass of research since Carson's day has shown that she was only partly right. A hugely ambitious research programme is currently under way to learn more about the great currents that sweep from ocean to ocean around our planet. WOCE (the World Ocean Circulation Experiment) involves research vessels from forty-three nations monitoring the oceans on a global scale. Their data is sent to a clearing house in Britain's sumptuous new Southampton Oceanographic Centre. The large research ship *Discovery* has been rebuilt to give her greater range and greater research capability. The behaviour of currents is revealed by seeding the ocean with radioactive material, at different depths, and then monitoring its movements. This has already shown that the Weddell Sea in Antarctica generates very cold ocean-bottom water, which flows into the North Atlantic and affects productivity of fish and plankton. Recent studies in the stormy waters of the Antarctic Ocean show that its circumpolar current is the passage by which circulation from the Pacific and Indian

Oceans sweeps in and out of the Atlantic. Surface currents plunge deep into the oceans for their return journeys, like an Olympic swimmer making a racing turn. When the warm, upper currents reach the seas off Greenland, they are cooled by Arctic temperatures and sink before flowing south again. This powerful movement is known as the Atlantic Conveyor, and it is one of the engines that drives the circulation of global currents. Simultaneous research on an international scale is learning more about ocean fluxes, studying sea-air exchanges, and discovering the crucial role of marine biology – particularly plankton – on the chemical composition of the atmosphere. We are just becoming aware of the importance of marine biota in cycling nutrients and cleaning up atmospheric pollution.

Much of this data is gathered remotely. Research vessels lower water-sampling devices that bring up water from different depths. They consist of a battery of cylinders whose ends snap shut on a signal from the mother ship. The British marine biologist Sir Alistair Hardy invented a continuous plankton recorder, which looks like a model aeroplane with stabilizing fins and a small propeller. This is towed behind a ship at a depth of nine metres (thirty feet). It collects the organisms on a roll of gauze and immediately passes them into a preserving tank. John Pernetta of the British Institute of Oceanographic Sciences explains that 'Ships, towing these samplers through the North Atlantic over many decades, have enabled scientists to draw conclusions about changes in the productivity of the ocean, the onset of spring blooms of plankton, and the role of water temperature in the annual cycle of temperate seas.'[11] Bottom samples can be collected by dredges towed by the surface ship, or by less destructive grabs whose jaws close around

a sample of mud and sediment. One type of grab works independently: it has weights that drop off when the jaws close, so that flotation chambers bring the sample to the surface. There are now special satellites for oceanographic observation. There is also a wide variety of on-site recorders that can be left suspended from buoys. 'They range from simple reversing thermometers to expendable bathythermographs, which measure a range of variables, including temperature, pressure and salinity. Drifting buoys are extensively employed in studies of current systems. Some float on the surface and their signals, which provide information on the strength and direction of currents, are relayed to satellites. Others operate using floats, which maintain them at a precise depth, providing information on underwater currents.'

However, all this activity is minute in relation to the scale of the oceans and of the problems being studied. As Pernetta concludes, 'Without a greater investment in ocean observing systems, our ability to understand the functioning of the oceans in the world climate system, and hence our ability to plan for future changes which might result from global climate change, remains severely limited.'[12]

Another new line of marine research is using SOSUS, a secret network of hydrophones established by US naval intelligence to monitor movements of Soviet submarines during the Cold War. This array of listening devices, established at a cost of billions of dollars, is now being deployed to measure global warming, in an experiment called ATOC.

Opposite and right: Studies in marine biology have revealed the importance of plankton. Opposite, sea butterflies, Diacria trispinosa atlantica, migrate as part of the plankton. Shown on the right are mixed plankton, North Skye phytoplantiles.

Loudspeakers emit the loudest pure tones ever made by humans. The speed at which these cross oceans can be accurately measured to see whether or not the water through which they pass is warming. A future generation of remotely operated submersibles may be capable of traversing the deep oceans, moving on preprogrammed routes but with sufficient artificial intelligence to vary these if conditions demand, and sending back or storing a stream of data. Thus, more secrets of the oceans will be revealed. But it will be done by machines, without the heroics of the pioneering underwater explorers.

MARINE LIFE

One great benefit of Cousteau's aqualung and Beebe's and Piccard's submersibles was that they introduced man to living fish. By opening the underwater world, these inventions allowed divers to see marine life in its natural habitat. Fish and whales ceased to be only hostile prey, to be hunted, netted, hooked, harpooned and hauled out of their protective seas to die, gasping in the air, and then eaten or rendered down. Suddenly, the shallow seas and deep oceans became a great laboratory. During the past half-century, tens of thousands of explorers have reaped a bountiful harvest of discoveries. Innumerable new species have been recorded. Work continues constantly on their behaviour and the amazing biological and physical properties that each has evolved to ensure survival in this (to us) alien realm. Other research is on a grander scale, investigating the role of plankton in cleaning the atmosphere, or krill, the world's heaviest species in total biomass, as the basis of so many food chains.

Over the millennia, fishermen and sailors developed a blind fear of the monsters lurking in the depths beneath their craft. In *Seven-Tenths*, a beautiful book about the wonders of the oceans, James Hamilton-Paterson pondered why people imagine gods or aliens of higher intelligence in space, but the reverse in the dark deeps. 'Far from being likely to find enlightenment the further down we go, we expect to meet ever-dumber creatures. Moreover — exactly opposite to actuality — we envisage them near the bottom as still bigger, more terrifying in their mindless strength, and uglier. In fact, monsters. To this extent they are remarkably similar to the nightmare creatures of the unconscious: tentacular horrors which enwrap and bear their victims down and down to lairs where, in due time, begins the business of the hideous rending beak and saucerlike eyes. The very gradations of sleep itself seem to suggest a vertical descent into annihilating depths, the deepest levels of sleep being those of oblivion. In any case, by descending into the sea we would expect to meet the monstrous rather than the divine.

Opposite: *Three-dimensional beauty in the underwater paradise of the Australian Great Barrier Reef. Fairy basslets,* pseudanthiasquamipinnis, *swim among technicoloured hard corals.*

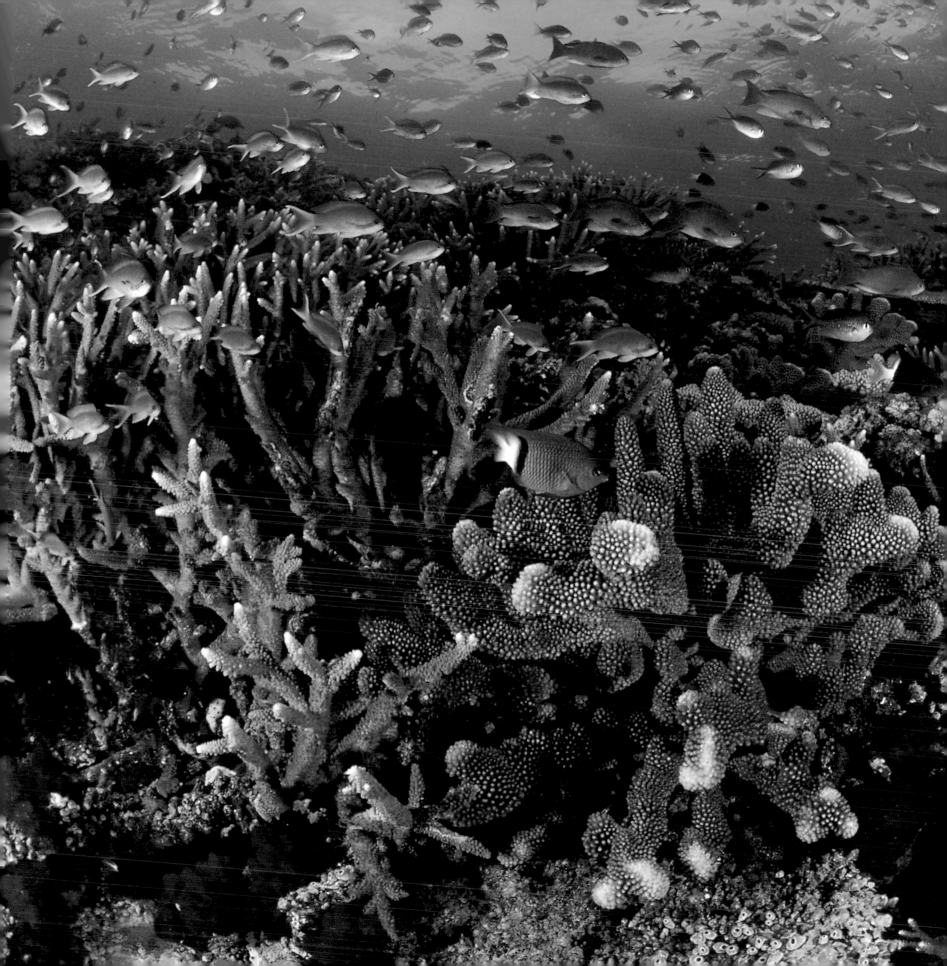

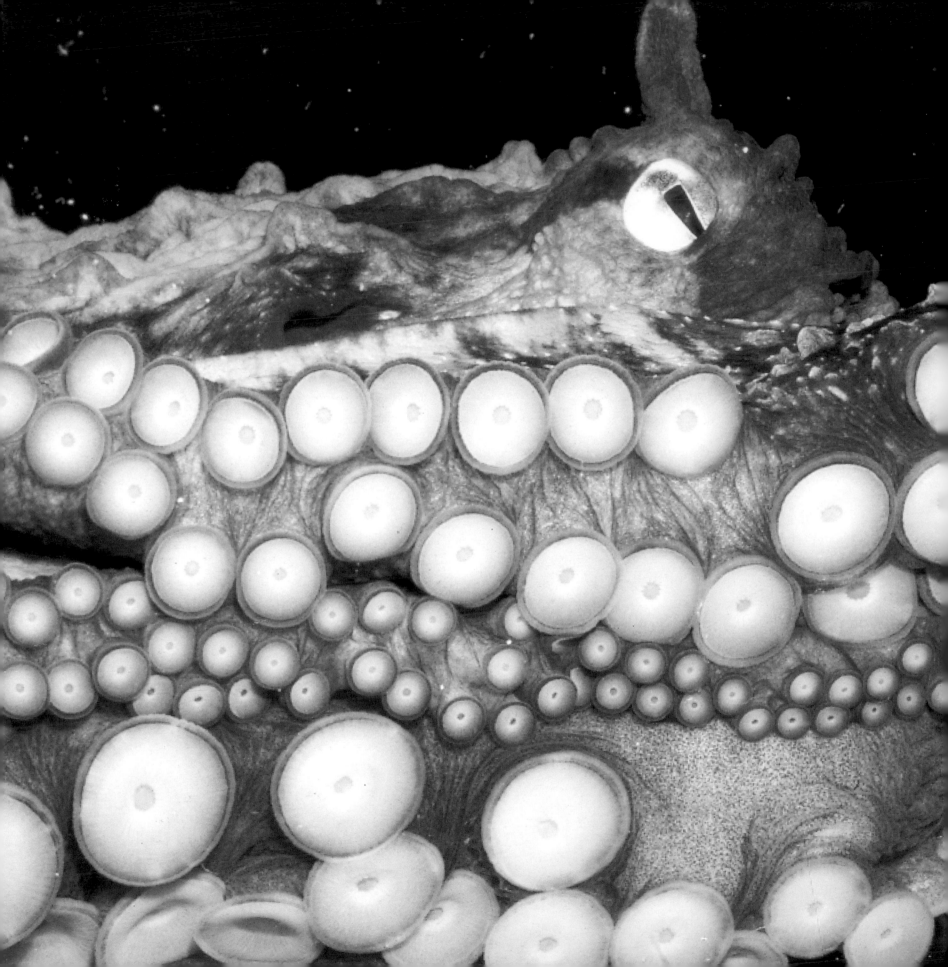

Superior beings are by definition on top, while only the inferior can lurk below. The deeps also remind us of where we suppose we originally came from, what we have left behind. Did we not abandon our ancestral dark by crawling towards the light?'[1]

Jules Verne animated these fears with the denizens of the deep in *Twenty Thousand Leagues Under the Sea*; Herman Melville created the malevolent white whale Moby-Dick; and Victor Hugo wrote a terrifying description of a fight to the death between a man and a giant octopus. 'No fate could be more horrible than to be entwined in the embrace of those eight clammy, corpselike arms, and to feel their folds creeping and gliding around you, and the eight hundred discs with their cold adhesive touch, gluing themselves to you with a grasp that nothing could relax, and feeling like so many mouths devouring you at the same time.' The great French novelist imagined that this monster drinks its victims. 'You enter into the beast. The hydra incorporates itself with the man; the man is amalgamated with the hydra. You become one. The tiger can only devour you; the devilfish inhales you. He draws you to him, into him; and, bound and helpless, you feel yourself emptied into this frightful sac, which is a monster. To be eaten alive is more than terrible; but to be drunk alive is inexpressible.'[2]

Reared on such nightmarish fantasies, the first aqualung divers were naturally apprehensive about octopuses. This revulsion was allayed by finding that their surfaces did not feel slimy when touched underwater. Finally, Cousteau's

Opposite: *The eye of a Giant Pacific octopus,* Octopus dofleini, *off British Colombia, Canada. Research has shown them to be shy animals, with strong parental and domestic instincts, creating homes by moving rocks and shells.*

companion Didier Dumas dared to pull a small octopus from a cliff. He reckoned that he was too large for it to drink. 'If Dumas was timid, the octopus was downright terrified. It writhed desperately to escape the four-armed monster, and succeeded in breaking loose. It made off by slow jet propulsion, exuding spurts of its famous ink.'[3] Dumas tried in vain to get an octopus to fasten its dreaded suction cups to his skin. However, the octopus is an intelligent and adaptable animal, and Dumas found that he could persuade them to dance playfully with him. Contrary to some fears, octopus ink proved not to be poisonous to the skin or eyes of divers. Its purpose seems to be to hang in the water in a blob that looks sufficiently like a phantom octopus to confuse a pursuer.

Cousteau was, of course, diving among small Mediterranean octopuses. Far larger varieties occur in deep oceans, notably between Vancouver Island and the mainland of British Columbia. The largest giant octopus (*Octopus dofleini*) weighed 272 kilograms (almost 600 pounds) and had an arm span of 9.6 metres (31 feet). Most are about a third of this size, but still frighteningly large to a diver unaware of their relatively gentle nature. Now that the species has been well studied, octopuses are known to be shy animals, as intelligent as a domestic cat, and with strong parental and domestic instincts. Octopuses create homes, sometimes moving rocks and other objects to build roofs and walls, and the debris of shells outside these dwellings indicates its owner's preferences. Crabs and shellfish such as abalones are favoured food.

Mike Richmond, a Canadian who is campaigning for a permanent marine sanctuary for giant octopuses, recalled an alarming brush with one. He was diving at seventeen metres

(fifty-five feet), photographing a group of sea anemones. 'Just as I took a picture, something brushed my shoulder. Thinking it a piece of kelp, I ignored it and kept shooting. Feeling another tug, I turned and confronted a giant octopus. By now it held my head with one arm, my shoulder with another.'[4] As Richmond pulled at the creature's arms, his mask was dislodged and filled with water. He managed to clear the mask and replace it. By now the octopus had two arms wrapped around the diver's bright orange strobe light,

Above: *Deep in the oceans are many species of fish yet to be classified. It is increasingly known that there is less life the deeper one descends into the oceans, but fish survive in deep cold and dark trenches, such as this prehistoric-looking angler fish.*

which looked sufficiently like a crab to have attracted it.

There is no mythical kraken, but deeper in the oceans are monsters far larger than the giant octopuses. Fragments of gigantic squids have been recovered, which show that their tentacles grow to nine metres (thirty feet). Sperm

whales have been seen with scars from huge suckers; but we know nothing about the epic submarine battles that inspired the imagination of Jules Verne. These encounters occur at over 1,000 metres (3,300 feet) and involve whales in dives lasting for over an hour. As James Hamilton-Paterson commented: 'The great mass of the oceans remains unexplored, even as the contours of their beds are electronically surveyed. Their waters must hide many species strange to

taxonomy [the classification of species], but this is hardly surprising. The world a mile or more down keeps its secrets well, with neither victors nor victims necessarily leaving the least trace of their lives. As regards the deepest trench faunas, there has been relatively little recent research'.[5] However, it is increasingly known that there is less life the deeper you descend into the oceans. Most of the main families of fish are to be found in these trenches. They survive, adapted to resist great pressure, cold and dark, by feeding on dead organisms that drift down from more productive layers near the surface.

Below: *While the stingray is feared by fishermen for its poison and the powerful sting from its whip-like tail, Jacques Cousteau learned that rays were no danger to his divers and often swam with them.*

Also much feared by fishermen is the stingray. This secretes poison and can inflict an agonizing sting by a flick of its whip-like tail, when it is landed or if someone steps on a ray lying half-buried on the seabed. Cousteau and his companions found a pebbly patch of the Mediterranean that was 'owned by rays: a host of stingrays, eagle rays and skates rested flat on the pebbles. When we glided motionless into the ray kingdom, they remained, rolling their big round eyes and closely watching us. As we swam to them, they rose alertly on their wing tips, ready to flee; and when we closed in, they rose in pairs and fled.'[6] These first scuba divers soon learned that rays were no danger to them. The celebrated sting was not an offensive weapon but merely a reaction to molestation. Didier Dumas found that he could grab a stingray by the tail: it struggled to escape but could not hurt him. Divers also learned that huge manta rays are completely harmless. They glide past the admiring humans, awesomely large, graceful and elegantly streamlined.

Cousteau soon dispelled another myth. He found that barracudas, while voracious, are equally harmless. 'Despite undersea fairy tales, I know of no reliable evidence of a barracuda attacking a diver.'[7] He had often swum past barracuda; but none had shown aggression. The creatures that did alarm Cousteau were far smaller. There was the commonplace sea urchin, whose brittle spines so easily lodge in the skin of any who brush against them and are then difficult to remove. Stinging jellyfish are another menace, particularly the dangerous Portuguese man-of-war, with its long dangling filaments that inflict such a powerful sting. Cousteau recalled diving off Bermuda through a dense colony of men-of-war. But once he had managed to dive below them, he was in no danger and could look up at the threatening ceiling of their poisonous tendrils. Other hazards include fire coral and sea poison ivy, both of which inflict nasty burns.

Of all sea creatures, the one most dreaded by man is the shark. Shipwrecked sailors told of life rafts being circled by sinister black triangles; swimmers on tropical beaches feared an attack that would tear off their dangling limbs. When Commander Cousteau and the earliest scuba divers entered shark-infested waters off the coast of Africa, they believed that they were at greatest risk when entering or leaving the ocean. So for two years Cousteau prepared 'the finest anti-shark defence ever devised by the mind of man and the stout blacksmiths of Toulon. It was an iron cage, resembling a lion's in a sideshow, a collapsible structure which could be erected quickly and lowered into the water. It had a door through which a diver could go in and out underwater and bar himself against sharks.' The divers felt mildly ridiculous as they were lowered over the side of their ship in this 'human zoo'. Once beneath the ocean, the experiment degenerated into farce. The water raised the divers against the roof bars, but they disengaged and floated freely inside. 'The effect was rather like a preposterous underwater bird-cage, with three men tumbling in clumsy flight. The dipping ship's crane bounced the cage up and down, dealing us smart blows on the crown and feet, and swaying us violently against the bars. Our hollow air cylinders smote the bars, giving off loud chimes like bells, which reverberated through the sea. Nine cylinders banging on the cage and against each other sounded like an inebriated bell-ringer saluting the new year.'[10]

Opposite: *One of the smaller ocean inhabitants is the sea urchin. Some are venomous (*Echinotrix calamaris*), secreting poison as well as leaving painful spines in the skin of any who mistakenly brush against them.*

Cousteau's mask was wrenched off and, although the divers signalled to lower their cage to the bottom, they never again used it. They soon discovered that sharks tended to ignore them or swim smoothly away. One elegant grey shark did not behave in this way. It continuously circled Cousteau and his companion Dumas, gradually reducing its circle and watching the divers with hard little eyes. The men tried all the tricks they had been told by naval officers, lifeguards and marine biologists. They gesticulated wildly; they let off a flood of bubbles; they shouted as loudly as they could; and they let off coppery liquid from cupric acid tablets. All to no avail. Then the shark turned and glided straight at Cousteau. 'The flat snout grew larger and there was only the head. With all my strength I thrust the camera and banged his muzzle. I felt the wash of a heavy body flashing past and the shark was twelve feet away, circling us as slowly as before, unharmed and expressionless.' The two men swam to the surface and waved to their ship for rescue. They realized that they were at greatest risk at that moment. 'Hanging there, one's legs could be plucked like bananas. I looked down. Three sharks were rising towards us in a concerted attack. We dived and faced them. The sharks resumed the circling manoeuvre. As long as we were a fathom or two down, they hesitated to approach.'[8] After repeated dashes to signal at the surface, the ship finally saw them and came to their rescue. Exhausted and with their oxygen almost gone, they looked up and saw the hull of the ship's launch that represented salvation. They flopped into the boat, weak and shaken.

Opposite: *Sharks are the most dreaded of all sea creatures. There are seven types known to be dangerous to man: the great white, the blue, the tiger (left), the sand, the hammerhead, the mako and the silver-tip.*

Sharks are formidable animals – big and powerful, streamlined like underwater missiles, swift swimmers in almost perpetual motion but able to manoeuvre adroitly, carnivores armed with rows of sharp teeth that can tear any meat with ease, fiercely territorial and occasionally unpredictable. As expedition after expedition studied their many species, more was learned about these superb fish. Divers learned that they need not fear most sharks. The exception was the great white, bigger and more aggressive than other sharks.

The world learned to be less terrified of sharks through a series of brilliant underwater films. The pioneers and masters of this dangerous cinema were an Australian couple, Ron and Valerie Taylor. Valerie was brought up on the seafront near Sydney and by 1963, while still in her twenties, was three-times women's spear-fishing champion of Australia. She and her husband decided to abandon killing fish and devote their lives instead to filming them. They would whip sharks into a frenzy by seeding the ocean with chum – fish guts – and grew recklessly daring to get sensational pictures. Valerie Taylor, a beautiful blonde with a perfect figure, became the star of shark movies. She grew to love the strong and unemotional fish. She learned that, apart from the great white, sharks rarely bite divers but will ram someone who has strayed into their territory and, if the intruder 'fails to heed the bump, then the shark may well come around for a little nip'. Someone who watched Valerie Taylor filming a melée of sharks feeding from a mass of fish bait in the Coral Sea said that 'with tuna in her arms, she swam into the middle of these animals – now vibrating from side to side with the fury of the feast – and offered her hand-held bait to them. They turned from the speared fish and went for her. She proceeded to tease them, feed them,

Above: *The great white shark is bigger and more aggressive than other sharks. Ron and Valerie Taylor's pioneering underwater films gradually taught us to be less terrified of sharks, although images such as this of a great white attacking the filming cage are everyone's nightmare.*

push them off with the fish and her fists.'[9] For their most dangerous sequences, the Taylors developed a shark suit of chain-mail mesh. Valerie tried this in a place in the Coral Sea called Action Point because its sharks were so abundant and active. One shark bit her on the head. She recalled, 'I felt a tremendous hit. At the same time, the teeth hit the mesh of the suit. There was crunching, grating sound and it was right across my ears. It sounded like it was tearing off my face.'[10]

Her chin was badly bruised and the tips of two shark teeth were lodged in her jaw; but the chain-mail suit had worked.

The Taylors were the chief cameramen on an expedition led by Peter Gimbel in 1969–70 to make a feature film about the rare and fearful great white shark. The resulting film, *Blue Water–White Death*, was a box-office hit. Some of its most electrifying shots were of great white sharks attacking straight at the bars of a steel cage. At one stage of the filming, off Durban in South Africa, Gimbel decided to leave the protective cage and invited Valerie Taylor to swim out with him. The crew were filming some 200 sharks wildly tearing at a whale carcass. Even the intrepid Valerie Taylor thought that she would not survive but, saying her last prayers, she emerged. Three divers swam among the frenzied sharks, beating them off with their cameras or batons; but they found that they soon became accepted, as simply three more marine creatures feeding off the whale.

Another woman pioneer of shark studies was Dr Eugenie Clark. A New Yorker, Eugenie Clark started diving in hard helmets and free diving, before the aqualung became available. She gained her doctorate at the Scripps Institute at La Jolla, California, and learned the skills of free diving from pearl fishermen off the Pacific island of Palau. Dr Clark studied blowfish in the Pacific and poisonous fish in the Red Sea. The success of her first book, *Lady with a Spear*, published in 1953, led to the Vanderbilts financing a marine laboratory for her at Cape Haze in western Florida. For twelve years, Eugenie Clark observed the marine life of the Caribbean; but her main interest was sharks. Her work on over 2,000 sharks added greatly to understanding of the behaviour of this ancient family of fish. She learned that sharks could be trained to differentiate colours, patterns and shapes, and to

remember what they had learned. In the 1970s, Eugenie Clark was led to discover that, contrary to accepted thinking, sharks do not need to be constantly moving in order to breathe enough oxygen through their gills. In 1973 she was shown a cave full of 'sleeping' sharks, on the Isla Mujeres off the coast of Mexican Yucatán. The animals lay still for hours in the cave, but were not hibernating: they calmly watched the intruding scientists. Various explanations were advanced for their strange behaviour: that the water in parts of the cave had an unusually high level of oxygen; or that a mixture of salt and fresh water had created an electromagnetic field; or that an abnormal amount of carbon dioxide had anaesthetized the sharks. Dr Clark went on to see other motionless sharks in Japan, and described her years of research in an important and readable book, *The Lady and the Sharks*.[11]

More recently, Eugenie Clark had the thrilling experience

Below: *Whale sharks are the largest fish in the sea. Feeding on plankton and small fish, they pose no real threat to humans although they are capable of swallowing a man whole.*

of diving with the world's largest fish, the whale shark. Very little is known about this enormous creature, for it is rare and solitary, sometimes basking on the surface, but more often swimming deep in the open ocean. An average whale shark is 7.6 metres (twenty-five feet) long and weighs eight to ten tons; but Dr Clark saw one off Baja California that measured over fifteen metres (fifty feet). Australian oceanographers discovered that the corals off the coast of Western Australia spawn millions of tiny packets of eggs and sperm at the full moon every March. This rich soup attracts some of the largest marine animals: manta rays, minke whales and the elusive whale sharks. So when Eugenie Clark dived in the Ningaloo Reef Marine Park in 1991, her team observed at least twenty of the giants in a single day. She swam as fast as she could, to keep up with one whale shark. 'My hand trails down the massive body, over the thick, hard, textured skin. The shark feels almost inanimate, like a wooden submarine.' She managed to grab the base of its dorsal fin. 'The shark feels my touch and speeds up; I feel the water pressing hard against me. It is as though I am being towed through the water by a bus. I dare not look behind, for fear of having my face mask ripped away.' This thrilling ride lasted for only a minute, before the whale shark dived swiftly away. Watching another, 'I swam alongside the shark, awed by its gracefulness. The clean design of its two-inch-diameter white dots – the most spectacular, yet perplexing, color pattern of any shark – was dazzling.'[12] These leviathans feed only on krill and tiny organisms such as coral spawn. They are harmless to man, although it is easy to imagine a diver being sucked into the huge mouth of a fast-swimming whale shark. This has never been known to happen; but if it did, the shark's digestive system would spew out the large obstruction. It

occurred to Dr Clark that this might, just possibly, have been the origin of Jonah's escape from the whale.

Over the centuries, the marine creature that most awed, frightened and attracted man has been the whale. From Jonah to Captain Ahab, whalers fought the world's largest animal. But during the past century, improved ships, sonars, exploding harpoons and air-compressors to keep carcasses afloat have combined to turn the odds heavily in favour of the hunters. Some species of whale were being slaughtered almost to extinction, so that conservationists had to mount determined campaigns to save these magnificent mammals. Despite hundreds of years of conflict, most of the behaviour and life cycles of whales was unknown until the present day. There are some eighty species of whale – cetaceans to scientists – and these divide into baleen (who strain their food through baleens in their jaws) and toothed whales. The baleens include most of the largest, ranging in size from the mighty blue whale measuring 30.5 metres (100 feet) – far greater than the biggest of all dinosaurs. The greatest toothed whale is the sperm, whose name derives from a clear waxy liquid called spermaceti oil, much prized as an industrial lubricant, which is vital to the whale in regulating its buoyancy during deep dives. The purpose of its teeth is unclear: teeth are hardly used to eat this animal's favourite food, squid. The toothed cetaceans also include dolphins, porpoises and killer whales. Biologists think that the teeth may disappear with evolution. Whales can appear off any coast in the world at any time of their choosing. Marine biologists have plunged into all the oceans to try to learn more about

Opposite: There are some eighty species of whale, divided into baleen, who strain food through baleens in their jaws, and toothed whales. The greatest toothed whale is the sperm whale, seen here off New Zealand.

these majestic creatures. Foremost among the true students of whales is the American biologist Roger Payne. During the first ten years of his working life, Dr Payne conducted experiments on the remote-sensing skills of bats, owls and moths. So when in 1967 he turned from small animals to the largest of all, he worried that he would be bored working with creatures on which he could not possibly experiment. But he of course fell in love with his new subjects, particularly because of their serenity. 'As the largest animal on earth, you could afford to be gentle, to view life without fear, to play in the dark, to sleep soundly anywhere, whenever and however long you liked, and to greet the world in peace – even to view with bemused curiosity something as weird as a human scuba diver as it bubbles away, encased in all that bizarre gear. It is this sense of tranquility – of life without urgency, power without aggression – that has won my heart to whales.'[13] Even after thirty years of continuous observation of whales, Roger Payne admits that human researchers view them only through a keyhole. The bulk of the animal glides past, and researchers struggle to identify its species and guess what it is doing. Much has been learned, but most of the enigmas of whales are still to be decoded. 'In spite of lots of sparks and smoke, we have so far accomplished little more than a small enlargement of this keyhole.' Payne grew to respect the regal slowness of his research subjects. 'Whales are unhurriable. It's one of their most endearing traits.'[14] After a day of difficult and perplexing observation, he concluded that he had only been watching gentle play.

Roger Payne and others have learned much about the metabolism of whales. The hearts of the largest blue whales weigh 1,800 kilograms (two tons), pump almost 300 litres (sixty gallons) of blood with each beat, and pulse at about a tenth the speed of our hearts. The testicles of this whale also weigh two tons. An infant blue whale grows at an incredible 110 kilos (250 pounds) per day, nourished entirely by some 425 litres (750 pints) of its mother's very rich milk. One of a whale's few nuisances (other than murderous humans) is barnacles, which attach themselves in great quantities – the barnacles on the head of one humpback whale weighed 450 kilos (1,000 pounds). To rid themselves of these parasites, whales try to grow and shed their skin faster than the barnacles can burrow their shells into the animal. There are always pieces of sloughed skin floating behind a whale. Shedding barnacles may be an explanation for whales 'breaching' – leaping above the surface, flipping over and diving back in a thunderous crash. Some gulls have learned that there are rich pickings of sloughed skin when a whale performs a series of breaches. Others cruelly pull skin off the sunburned backs of mother whales that have swum into shallow water with their calves to escape attack from below by killer whales. But the greatest natural hazard for the gentle giants is a mass of internal parasites, including long tapeworms and quantities of nematodes in their stomachs.

All whale researchers vividly remember their fear at first entering the water with these vast mammals. Roger Payne knew the power of a whale's tail: he had seen an adolescent whale swat a killer-whale Orca and send it flying out of the water; on another occasion a group of right whales being attacked by orcas defended their calves by forming a circle, heads inwards, with their mighty flukes thrashing the surrounding water in a deadly frenzy. Although Payne knew that whales are by nature gentle, even towards human beings who have persecuted them with hideous cruelty and near-genocide, he worried that a whale distracted by his

Above: *'Most of the enigmas of whales are still to be decoded.' The eye of a southern right whale is certainly enigmatic and mysterious.*

diving companion might carelessly blunder into him like a skittish horse.

'It's crazy; you get in the water with an animal which is at least four thousand times more powerful than you, which is far more manoeuvrable than you, and which can dive to depths that would crush you, and can hold its breath twenty times as long as the average person. The wonderful thing is that the whale does not take advantage of your condition. Instead, it manoeuvres with consummate skill – sometimes missing you only by inches with its flippers or tail – and at the last minute it lifts its flukes over your head so as not to touch you.'[15]

Sylvia Earle, another famous marine biologist, recalled her apprehension when diving off Hawaii amid forty-ton humpback whales. But they lived up to their gentle reputation. 'With magnificent grace the giant swept by, as supple as

an otter and with a dolphinlike expression of good humor. The great eye tilted slightly, enough to suggest that the whale had gone out of its way to look me over.'[16] On that same diving expedition, the petite Dr Earle dived in a thirty-knot storm in a remote channel with powerful currents, to observe Pygmy killer whales (*Feresa attenuata*). A hundred of the aggressive Pygmies swam in formations of three to nine, side-by-side, like torpedoes alongside the huge whales. It was a mystery why these two very different animals moved in unison. While Sylvia Earle was observing this phenomenon, a large oceanic white-tip shark suddenly came up to

her flipper. She kicked the shark away, but it swiftly returned with a mate, to eye her before deciding to swim off. After decades of daring underwater expeditions, Roger Payne came to the conclusion that marine animals are less aggressive than those on land. There seemed to be 'a general amnesty in the sea' that permitted awkward skin divers to swim alongside animals far larger than they. Even wild killer whales showed nothing more than 'a mild curiosity' about

Below: *Killer whales,* Orcinus orca, *attacking South American sea lions off the Valdes Peninsula, Argentina, the main location for Roger Payne's intensive whale studies.*

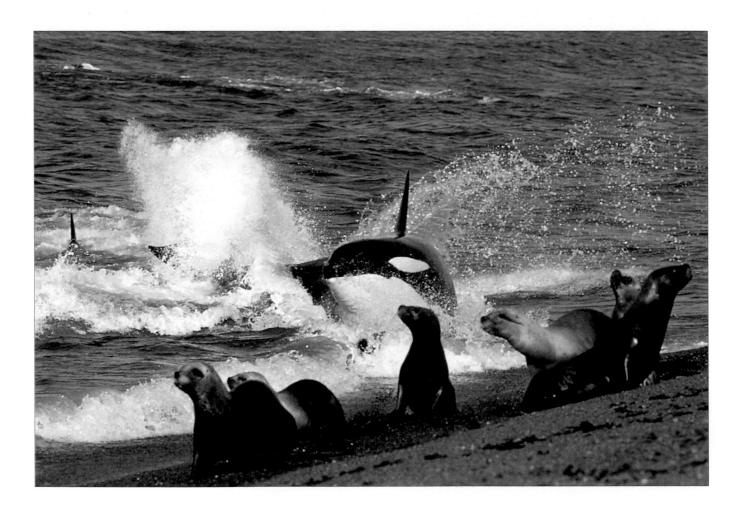

human swimmers. Flip Nicklin, a photographer working with Dr Payne off the coast of Argentina, patted a young right whale. The apparently affectionate animal began repeatedly rubbing its body against Nicklin, 'like a house cat – no, like a 30-ton cat the size of a house'.[17]

Roger Payne's years of observation off the Valdés Peninsula in Argentine Patagonia started in 1970, after a research ship of the US National Science Foundation reported that right whales returned to that location each year. They apparently came to mate and then raise their young. Payne was the first to watch whales mating. 'We found that courtship involved much stroking and hugging of a female by males competing for her.' Skittish when pursued by several males, 'with only one present, however, the female normally was quiet and tender in her acceptance. The pair would hold each other with their flippers, belly to belly, while mating.' The researchers also saw whales apparently resting, with their noses down, eyes closed and tails out of the water for twenty minutes at a time. 'It was delightful to watch the young whales at play. Strands of seaweed dislodged by storms were the toys and newborn calves liked to play with their mothers' tails. They would slide off first one fluke and then the other.'[18]

Orcas or killer whales seem playful and tame when captive in marine parks. But Milton Shedd's research vessel *Sea World* watched a rarely seen attack by thirty killer whales on a young, but eighteen-metre- (thirty-foot-) long, blue whale off the coast of Baja California. The pack of orcas had different tasks in the attack. A pair moved ahead of the prey, another pair behind, while others seemed to prevent the whale from surfacing to breathe. The onslaught continued for twenty hours. The relentless killer whales stripped off flesh, blubber and fins 'as the leviathan tried to flee, trailing a river of blood'.[19] After almost a day of carnage, the orcas suddenly called off their onslaught, perhaps satiated or waiting for the whale to tire before resuming their attack on it.

Roger Payne's main research interest is whale calls. For years, he has recorded (and even issued a compact disc of) the amazing sounds emitted by the largest animals. Sylvia Earle recalled how her whole body throbbed to their 'eerie whelps and low, rumbling sighs'.[20] In the silent millennia before ships' engines cluttered the oceans with noise, whales' calls could carry for thousands of kilometres across water. Even today, researchers have tracked humpbacks acoustically for 1,600 kilometres (1,000 miles). The explanation for whale calls is not known. Roger Payne has surmised that it is to tell other whales about accumulations of food or to find one another for mating. Researchers from the Canadian Department of Fisheries and Oceans guessed that the amazing range of noises – everything from squeaks to grunts – of white beluga whales found in the Arctic was 'an acoustic map' to navigate through a maze of melting sea ice.

Research into whale migrations is equally in its infancy. It is almost impossible to radio-tag whales, since they have no necks or collars, they cannot be tranquillized, and their powerful swimming dislodges most listening devices. One marine biologist is trying to lodge satellite trackers onto whales with stainless-steel sutures implanted like barnacles; but it is very difficult to attach such transmitters to the swimming mammals. Such research may start to explain whales' seemingly random movements over long distances. The Canadian oceanographer Richard Sears is beginning to recognize (by pigmentation patterns) each of some 300 mighty blue whales that live in the Gulf of St Lawrence. Meanwhile, Steve

Katona on the Pacific side of Canada developed a technique for identifying humpback whales by black-and-white markings beneath their tails. James Darling, of the West Coast Whale Research Foundation in California, has accumulated thousands of pictures of individual whales to help pinpoint their movements.

There are places where whales congregate: off the Valdés Peninsula in Argentine Patagonia (the main location for Roger Payne's studies), near the Hawaiian and the Azores Islands, in Alaska's Glacier Bay, or in the Antarctic Ocean to feed. Thanks to researchers' efforts, sanctuaries have been established in whale breeding grounds: in most of the Indian Ocean, off Baja California in Mexico, off Argentina, the Dominican Republic and Canada's Vancouver Island, and in newly discovered calving grounds off the coast of Florida. Years of work are starting to teach explorers more about whales' sex lives. Normally gentle males become agitated and can lash one another with their tails when competing for a female. John Ford, a biologist who has spent years studying narwhals in the Canadian Arctic, observed males sparring in a ritualistic manner with their tusks – the long points once prized as 'unicorn horns'. Other whales apparently court females by displays, which may include their singing calls, and they arouse them by blowing bubbles onto their genitals. Whales seem to prefer to mate in isolated pairs rather than when congregated. Their annual move to the warmer seas off Hawaii may be connected with females giving birth; but about a tenth of whale births take place in freezing Antarctic waters.

One great achievement of all the explorers who study whales is the campaign to stop their slaughter. By telling the public about these magnificent gentle animals, researchers have almost halted commercial whaling. In the first forty years of the twentieth century, some 750,000 whales were killed by whalers; in the next fifty years a further half a million of these mammals were rendered down. In recent years numbers caught have declined dramatically thanks to strict quotas enforced by the International Whaling Commission, created in 1946. Some of the largest species faced extinction and are now fully protected. Blue whales declined from some 200,000 to only 5–10,000; humpbacks from 125,000 to 12,000; speedy fin whales (which used to swim too fast for sailing whale boats) from 500,000 to 120,000; right whales (so named because they were whalers' favourites, the 'right' ones to catch) from 50,000 to 3,000; sei from 250,000 to 50,000; and toothed sperm whales from two million to one million. The traditional whaling nations, headed by Norway and Japan, hypocritically use 'research' as justification for being granted higher quotas. But experiments in Cambridge University may undermine this specious argument, by showing how data on breeding and social structure of whales can be obtained by molecular analysis of skin samples – without having to kill the animals.

The Antarctic Ocean's attraction for whales is krill, *Euphausia superba*, a tiny shrimp-like crustacean that is so fantastically abundant that it is probably the world's heaviest species in sheer biomass. (Man is the second heaviest species, if we have not already overtaken krill in this dubious honour. Our race of 5.5 billion people weighs about 330 million tonnes.) A baleen whale is 'a fiendishly efficient agent of mass destruction' to krill. A whale can fast for eight months

Opposite: *'Whales are unhurriable. It's one of their most endearing traits.' Humpback whales,* Megaptera novaeangliae, *feeding in the Chatham Straits, Alaska.*

until the time when krill are easiest to catch. 'This gives baleen whales access to the greatest food blooms, the most abundant, concentrated, animal food resource on earth – the annual mating swarms of Atlantic Ocean krill.'[21] A whale locates schools of krill by acoustic sonar, and different types of whale use different methods of catching. Right whales skim the surface with their jaws open and heads partly out of the water. Al Giddings watched eight humpback whales feasting on a rich pasture of krill off Alaska's Admiralty Island: 'Hour after hour the eight remained together performing a ballet-like manoeuvre that looked to us like a means of cooperative feeding. There was a thunderous roar as the eight whales in circular formation, mouths agape, lunged for the sky.'[22] Giddings and many other observers have seen whales 'bubble netting' – rounding up their prey in a circular column of bubbles. The whale's baleen plates sieve the krill out of the water, and the tiny animals are then swallowed in mouthfuls through the whale's surprisingly small throat. Many expeditions have studied krill, because this fish is the basis of all Antarctic food chains – in addition to the five species of baleen whales, seals (particularly the most abundant crab-eating seals), all penguins and many fish and seabirds all depend on krill.

This small animal is up to five centimetres (two inches) long, but when not actively feeding on plankton, it congregates in swarms of several thousand to the cubic metre. Millions of krill swim in fantastic parallel alignment, all altering course simultaneously; and water full of them appears red. 'Divers encountering a swarm are enchanted by the experience.'[23] Researchers have tried to estimate the number of krill by echo-sounding and by extrapolating from amounts caught in trawls. Russian scientists recorded a single school

of krill that they reckoned contained a hundred million tons – which is more than the total annual catch of all fish species all over the world. Once a swarm has been located by a fishing vessel, a mid-water trawl can easily scoop up an average of eight to twelve tonnes an hour; but the record is thirty-five tonnes in eight minutes. The trouble is that krill do not always congregate in the same places. There are usually vast concentrations of them around South Georgia in the southern Atlantic; but in some years the tiny shrimps have been swept elsewhere by unpredictable currents. So one expert admitted that 'estimates of the standing stocks of krill vary widely, if not wildly,'[24] from 125 million tonnes to 5,000 million tonnes. To learn more, the Antarctic research committee, SCAR, organized a multi-nation programme called BIOMASS (Biological Investigations of Marine Antarctic Systems and Stocks) which accumulated vast quantities of data, in annual expeditions from 1977 onwards. Surprising discoveries are that krill larvae sink to 600 to 1,200 metres (2–4,000 feet) before hatching, that krill probably live for six or seven years, and that adults can survive for a year without food if the phytoplankton they eat is in short supply.

For a time, it was thought that krill might be the answer to world food shortages. Trawlers from the Soviet Union, Poland, Japan and Germany landed ever greater catches, until in the Antarctic summer of 1979–80 they took an incredible half a million tonnes. Fortunately for the local wildlife, krill paste and krill 'cheese' have limited appeal to humans, and krill is more expensive than fishmeal as animal fodder. Furthermore, unless rapidly treated, enzymes cause krill to go rancid within three hours of being caught, and their shells contain high concentrations of toxic fluoride. These natural deterrents reinforced an attempt to regulate quotas of krill

fishing by the Convention on the Conservation of Antarctic Marine Living Resources, signed in 1980.

It is worth reminding ourselves of the dangers and hardships endured by the uncomplaining researchers who study Antarctic marine life. In the high latitudes of the 'roaring forties' winds lash the earth unimpeded by any land. The Australian scientist Phillip Law described a terrible hurricane hitting the Danish ice-strengthened freighter *Kista Dan*, which was on charter to the Australian Antarctic expedition. (The author sailed to Greenland on this delightful, but small, ship, in the year before Law's adventure on her.) The wind rose steadily, to a terrifying Force 12 (over eighty knots) and then to Force 14, at which the wind is too strong to be measured. The ship was empty of cargo, but it was impossible to pump water in as ballast because the pipes were frozen.

'Soon the captain lost control of the ship and she broached to, lying on her port side, drifting helplessly, pounded by every breaking wave, and rolling from ten degrees to starboard to sixty or seventy degrees to port. In the cabins everything that was not screwed down was flung continuously from one bulkhead to the other. An extreme roll dipped the ship's port side so far that the saloon portholes looked down into green water. There was a great danger that the ship would turn turtle, and over a period of twelve hours it seemed that every roll would be her last. For much of the time it was night, and pieces of ice as big as houses were around but could scarcely be picked out through the spume by searchlight or distinguished by radar from the general clutter of breaking waves. Although steering was impossible, the captain avoided icebergs by going full speed ahead or astern, as best he could. *Kista Dan* survived, and after twenty-four hours the gale moderated to sixty knots.'[25]

It is not only the largest and smallest marine creatures that attract scientists. During the current burst of exploratory activity, tens of thousands of dedicated marine biologists are devoting years to studying the behaviour of individual species and their exotic habitats. Scores of learned journals record this magnificent corpus of research; and the pages of National Geographic are full of photographs that would have astounded earlier generations. However, there are estimated to be 25,000 species of fish; and only a small proportion has been fully studied.

One of the largest and fastest of all fish is the bluefin tuna. Weighing up to 340 to 450 kilograms (750 to 1,000 pounds), these tuna are 'capable of bursts up to 55 miles per hour'. Three-quarters muscle, hydronamically superb, with a powerful heart, ramjet ventilation, heat exchangers, and other special adaptations, the bluefin is built for speed. No predator except the mako shark and the killer whale can catch it. The Canadian biologist Michael Butler studied these 'superfish' in the protected waters off Nova Scotia, admiring 'the power in their streamlined bodies and the grace with which they soar and glide within waves.'[26] When accelerating, they retract all fins and are powered only by large tails. Friendly to divers, bluefins move so fast, in a curtain of bubbles, that they might inadvertently strike a watching researcher. Sadly, the meat of these tuna is the most prized of all for Japanese sashimi and sushi, so that numbers are steadily declining from overfishing.

There has been much work on corals, beautiful creatures that come in a dazzling profusion of shapes and colours and, in Australia's Great Barrier Reef, have built the largest structure on earth made by living organisms. Two British enterprises have done much to advance coral

studies: Coral Cay Conservation, which won an international award for putting teams of volunteers to work each year in monitoring and protecting the corals off the coast of Belize; and Reefwatch at the University of York, which collates data obtained from diving expeditions all over the world and gathered on a standard template.

Sponges are also objects of research. These animals cannot move and have no nervous system or means of defence. Yet sponges exist in a bewildering profusion of species, shapes, colours and sizes, everywhere from the polar icecaps to tropical reefs. They cling tenaciously to rock or coral and are immune to bacterial infection or attack by predators. These properties, that have ensured sponges' survival in all oceans for millions of years, may stem from antibiotics useful to human medicine. Sponges live by passing nutrient-rich water through their bodies. Some sponges change sex regularly, some combine the behaviour of both sexes, and others have distinct sexes. As with everything in the marine world, painstaking research is teaching us much about sponges; but the amount still to be discovered seems limitless.

Biologists study habitats such as submarine kelp 'forests' or the changing altitudinal zonation as divers descend the wall of a continental shelf. The enthusiastic and ebullient Canadian scientist Amanda Vincent dedicates her life to studying tiny sea horses, which have the curious practice of 'pregnant' males hatching eggs in a pouch, but which are endangered because of a belief in oriental medicine that they contain cures to impotence and other ailments. The Australian ichthyologist Alison Reynolds has spent many years combing kelp beds in search of camouflaged sea dragons, which are related to sea horses and pipefish. Eugenie Clark dived in the Red Sea to learn about small 'flashlight fish'

(*Photoblepharon*), which lure their prey with twinkling lights that give an eerie cool glow in the black night sea. It was learned that these fish have pouches under their eyes in which they nurture billions of miniscule light-emitting bacteria. This species is only one of some thousand species of bioluminescent fish. Eugenie Clark noted some of the innumerable 'marvels of adaptation and survival'[27] of other fish in the Red Sea, such as the razorfish that, when threatened, instantly crumples to resemble discarded debris, or the stargazer hidden under the sand apart from two tiny 'periscope' eyes, or the snapping shrimp and Goby fish that excavate a burrow together and then share it. One Antarctic fish, *Trematomus*, has evolved blood and body fluids containing a form of chemical antifreeze that may have industrial applications. These are but a handful of the amazing discoveries about marine life being made by biologists all over the world.

Sylvia Earle, the marine biologist, first dived in 1953 when at university in Florida. Her initial interest was crabs, which she studied for some years; but she then turned to marine algae. Dr Earle explained that algae 'are the producers. Everything on this earth is dependent upon plants, whether above water or below. Everything is from the energy of the sun, which is locked into the food source through photosynthesis.'[28] Her interest in the depth at which marine plants can grow has taken Sylvia Earle ever deeper, so that she has achieved various diving records in the course of her research. In 1970 she formed the first group of women aquanauts to live underwater for several weeks,

Opposite: *The exquisite delicacy and rainbow colours and dazzling profusion of shapes and colours of corals have been the subject of detailed research on the world's reefs. This Gorgonian fan coral was found in Indo-Pacific waters off Sulawesi.*

in the submerged Tektite laboratory off the Virgin Islands. By living in the ocean and emerging for constant exploratory dives, the women 'ceased to be visitors and became residents'. They came to know individual fish that they were studying. In later expeditions, Dr Earle has studied marine plants off the Galápagos and Cocos Islands, joined a 1975 attempt to capture a live coelacanth off the Comoro Islands, and for several years led saturation dives in a Hydrolab. In 1979 she made a world-record solo dive to 380 metres (1,250 feet) off the Hawaiian Islands. This was in a one-man submersible called JIM, that looks like the suit worn by a moon-walking astronaut and keeps its occupant at surface atmospheric pressure. In recent years, Sylvia Earle has gone into private business with a company called Deep Ocean Technology. She and her business partner, the British

Left: *Sunlight seen through a giant underwater kelp forest off the Californian coast.*

Below: *A leafy sea dragon,* Phycodurus eques, *camouflaged relation of sea horses and pipefish, is endemic to south Australian waters.*

engineer Graham Hawkes, have developed a series of small submersibles in which they undertake contract dives, for both scientific research and commercial activities. By any measure, the petite Sylvia Earle is a true explorer, and she has been deservedly fêted and honoured as such.

It was in 1976 that oceanographers discovered the first hydrothermal vents deep on the floor of the Pacific Ocean. These amazing geysers not only explained much about the conversion of the magma of the earth's core into its crust. Almost more surprisingly, they were found to host new forms of life. As the oceanographers John Corliss and Robert Ballard gazed in wonder through the porthole of their submersible, they saw 'shimmering water stream up past giant tube worms, never before seen by man. The unknown creatures and dense communities of life we have discovered living at these vents, like lush oases in a sunless desert, are a phenomenon totally new to science.'[29] The red-tipped tube worms that were fastened to the slopes of the submarine volcanoes grew to over three metres (twelve feet). They have no mouths, eyes or guts, but feed through hundreds of thousands of tiny tentacles that absorb molecules of suspended food and oxygen densely concentrated in these warm waters. Over 200 strains of bacteria were recovered from around the hydrothermals and kept alive at Woods Hole. This isolated food chain also supported hundreds of blind white crabs, thirty centimetres (a foot) long and with surprising red meat. There were octopuses feeding on the crabs, and grenadier fish with hypersensitive eyes

Opposite: *Dr Sylvia Earle in her underwater Tektite laboratory. A marine biologist and pioneer diver, she was in the first group of women aquanauts to live underwater. In 1979 she set the world-record for depth in a solo dive off Hawaiian Islands in the one-man submersible* Jim.

capable of discerning bioluminescence in that total blackness. Clams also flourished in these deep, dark habitats. In places there was a dense blanket of clams covering the pillowy lava formations – another spectacle 'never before seen'; but where one hydrothermal vent had suddenly closed, the seabed was littered with the shells of bivalves that died when the life-giving heat ceased.

In subsequent years, oceanographers from America, Russia, Britain and France have bravely descended into the cold depths and risked their lives if their submersibles strayed over the intense heat of a seabed 'volcano'. They discovered that different species of endemics had evolved in every ocean. One such dive that found geysers, and life, in the Mid-Atlantic Ridge was a joint American-Soviet expedition, using a Russian *Mir* ('Peace') research craft. The American scientist Peter Rona recalled a thrilling discovery: 'Something moves in the path of our floodlights. Thousands – perhaps millions – of shrimp swarm around the black smoker chimneys and feed on bacteria growing near the hot water.'[30] By catching specimens of these shrimp in the *Mir's* grapples, the scientists learned that the blind shrimps had pockets of chemical on their backs that could sense the dim ultra-violet glow of the vents. The animals could thus find the geysers but avoid getting too close to their intense heat. Other 'black smokers' are surrounded by millions of undulating worm-like creatures fastened to the ocean bottom and other exotic, endemic animals. More hot springs are yet to be discovered on submerged volcanoes. Rona commented on their importance. 'More than remote curiosities, these geysers no doubt support a deep-ocean ecosystem where new and ancient life-forms propagate. Indeed, these may be the places where life began.'

DESERTS AND SAVANNAHS

Immediately after the Second World War, in the winter of 1946–7 and then again in 1948–50, Wilfred Thesiger crossed the Rub al Khali, the fearsome Empty Quarter of Arabia. In many respects, his journeys were the end of a heroic era of exploration. Although an experienced colonial administrator in the Sudan and with a fine war record against Rommel in North Africa and behind the Italian lines in Ethiopia, Thesiger chose to travel as the only European with a group of thirteen Bedouin and their camels. Thesiger himself wore Arab dress, for the first time: a loin cloth, a long white shirt, and a head-cloth twisted around his head. Unlike most explorers, he could write eloquently and take photographs of haunting beauty; so that his book, *Arabian Sands*, has always been a classic of travel literature.

Thesiger recalled three days of starvation in the midst of his second crossing. The hunger progressed from a dull ache to a painful obsession. He tried to sleep pressing down on his empty stomach; but the cold of the desert night and his dreams of food kept him awake. They marched through the daylight hours, from dawn to dusk, moving with their camels towards an infinited horizon. At times the desert was beautiful; but it could be ugly, scarred with crusted mud, sand and salt. Thesiger and his companions pressed on mindlessly acrossa landscape that seemed utterly dead. They kept alive by eating some wizened dates. Finally, after weeks of hunger, they ate a camel. Its rank, tough and greasy meat made a wonderful meal. Tall, lean, laconic and very tough, Wilfred Thesiger has looks that can only be described as craggy. He is the epitome of a lone traveller, in tune with the native way of life and deploring all modernization. He felt that his Arabian journey was 'just in time', for oil prospectors and military men were starting to penetrate his beloved wilderness with their machines, and the Bedouin themselves took to using four-wheel-drive vehicles. The author and my friend Richard Mason (who was later killed by the Panará tribe in Brazil) drove a short-wheelbased Land Rover around many Middle Eastern countries in 1955. I remember staying in a

Opposite: *View from Mount Aretain looking across the arid north-east Badia region of Jordan, site of a five-year study programme by various groups including the Royal Geographical Society.*

Above: *Land Rovers are the ideal workhorse for changeable desert conditions.*

Left: *Land Rovers were used to undertake a systematic survey of Wahiba Sands in the Sultanate of Oman by the Royal Geographical Society in 1986.*

large Bedouin encampment in the Syrian desert. Our Land Rover was still such a novelty that our hosts insisted on bringing it right onto the carpet in their tent, with us men sleeping below the tyres; and the sheikh then asked us to spend a day driving him around his people's tents to collect tribute from them. Years later, on Royal Geographical Society expeditions to the Wahiba Sands in Oman in the mid-1980s and then in the Badia deserts of eastern Jordan in the 1990s, I have seen how readily the Bedouin have taken to these wonderful inventions without altering their way of life too radically. Both these Royal Geographical Society research projects were made possible by constant use of excellent Land Rovers. But Sir Wilfred Thesiger would not agree that any good came from such 'progress'.

Other explorers have made fine use of Land Rovers to

Above: Temet sand dunes, in the Tenere desert, Niger, sometimes reach a height of three-hundred metres (985 feet). The imposing natural grandeur dwarfs a Land Rover.

discover the secrets of deserts. In the 1950s, the Australian Barbara Toy abandoned a career in the theatre to travel in her Land Rover, criss-crossing the countries of North Africa and Arabia. On one journey, she retraced the ancient caravan route from the Mediterranean to the Niger. Quite alone, Barbara Toy drove 5,000 kilometres (3,000 miles) from Algeria to Timbuktu in Mali and then back, north-eastwards, along the edges of the Aïr, Tassili and Tibesti mountains of the central Sahara. She found some of the prehistoric rock paintings and engravings that were made famous by the French archaeologist Henri Lhote. This vivid art shows how central-African game animals once grazed on

what is now sands and rock-strewn desert. When Robin Hanbury-Tenison and I crossed that greatest of all deserts in 1966, from Libya to the Tibesti in Chad, we found a record of Barbara Toy's passage written inside a shelter, in charcoal from a camp fire.

When the Royal Geographical Society celebrated its 150th anniversary in 1980, I organized a series of public lecture evenings by the greatest British explorers. Wilfred Thesiger delivered a lyrical account of his crossing of the

Empty Quarter. He praised the lonely beauty of deserts and lamented the ending of the great traditions of camel travel. The next speaker presented a total contrast. Squadron-Leader Tom Sheppard is also an indomitable desert traveller, but he is a meticulous engineer who delights in every advance in off-road vehicle design. Sheppard is as artistic a photographer as Thesiger, in colour compared to Thesiger's

Below: *Squadron-Leader Tom Sheppard led the 1975 West-to-East Sahara Expedition – from the Atlantic to the Red Sea. He took this picture of a 'Dali-esque landscape,' showing a quiver tree and a blue Land Rover, in the Namib desert in 1995.*

invariable black-and-white; but any similarities end there. In 1975 Tom Sheppard led the West–East Sahara Expedition that completed the crossing of the North African desert from the Atlantic Ocean to the Red Sea. He took seven British servicemen in four new Land Rovers and two trailers whose axles could also be powered from the towing vehicles. Early in this five-month crossing, the expedition had to cross another Empty Quarter, the expanse of sands and unmapped dunes between eastern Mauritania and Mali. There were no people or oases in this void. Sheppard's men had to be totally self-sufficient in food, water and mechanical repair

parts. The team tracked its route by sun compass (it was in the days before satellite-based global positioning systems), and Sheppard invented improvements to this method of navigation. The Land Rovers performed admirably, taking seventeen days to cross the 1,600-kilometre (1,000-mile) void, despite frequently sinking into the soft surfaces. The vehicles travelled across the deserts of Niger, northern Nigeria, Chad and Darfur in north-western Sudan.

As in the polar regions, there is a band of explorers who eschew machines and travel in the ancient way, on foot with animals. In 1972 the British writer Geoffrey Moorhouse set out to walk across the Sahara from West to East – the punishing journey that Tom Sheppard had achieved in his Land Rovers three years later. Travelling with a series of local camel-handlers, surviving appalling hardship, loneliness, hunger, thirst and disease, with three camels dying on him, Moorhouse had to abandon his journey after some 3,200 kilometres (2,000 miles). His book of the journey, *The Fearful Void*, is philosophical, exciting and an evocation of the harsh beauty of deserts. The lateral crossing of the Sahara on foot by westerners was finally achieved thirteen years later. The explorers were an improbable couple: Michael Asher, a tough ex-SAS soldier who had become an expert camel-handler and who, with his tangled black beard and hair, described himself as a wild man; and his new wife Mari-antonietta, a very beautiful but tiny Italian official with the UN's children's fund UNICEF. Michael Asher had told her about his dream to complete the crossing, so when she agreed to marry him she knew that this would be her honeymoon. Asher's description of the journey, *Two Against the*

Right: *The eternal and lonely beauty of deserts, photographed by the indomitable desert traveller Tom Sheppard.*

Sahara, tells much about the unchanging ways of desert peoples, but also the politics and the sometimes lawless bureaucracy that often blocked the travellers' progress. The couple overcame physical hardships. Skirting Mauritania's empty quarter: 'We rode across a rolling plain of stubbled grass with the hot wind chasing us. It was the hottest day of the hottest season. The land seemed burning. The wind blew in flame-thrower blasts. My hands and feet were swollen from the roasting; my throat felt like emery paper; my gums were choked with a paste of mucus. The wind rose and fell in gusts. When it hit us it was like being braised with hot, dripping fat. When it fell the stillness of the air brought beads of sweat to our heads. I was glad of the protection of my thick headcloth, swirling shirt and pantaloons, which allowed the circulation of cool air beneath, but nothing could ease my parched mouth or the nausea in my stomach. The sand was too hot to stand on. Even in sandals you could feel the heat cutting through.'[1]

Farther east, approaching Niger, the group travelled over endless interlocking sand hills, constantly climbing from one to the next, with the horizon lost in a grey mist. When they were near Lake Chad: 'We awoke to the noise of a high wind licking out of the night, sucking at the eardrums and scourging us with sand. We trudged on across a fractured land of peaks and ridges, while the sand-rasping gale tore at us, soughing and sighing through the desert, drawing mournfully across the sharp rocks like a violin bow on a lank string. The wall of sound slammed at our heads, drugging us dumb, whispering in tongues, drowning our senses under a tuneless bagpipe haw. It was too cold to sit for long in the saddle, but when we walked the sand-blown grit was worse. We bandaged our heads like mummies and turned, crab-like, away

from the lacerating sand. Soon the texture of the earth changed. The rocks fell away, and we advanced on rippled flats of sand. The wind wheezed out of the erg with its hollow entrails. The camels stopped, sullenly leaning away from the whipping dust.'[2]

On the Ténéré in eastern Niger, 'the desert we walked out into the next day was utterly featureless. It was a vast, endless, sand-sea, the largest in the central Sahara. The emptiness of it was suffocating. It was like walking on a cloud, an unreal nebula that might cave in at any moment. Sometimes its dappling ripples looked like water, a still, untided ocean undulating to every horizion. In all that vastness there was not a tree, not a rock, not a single blade of grass.'[3] The crossing, over 6,500 kilometres (4,000 miles) from the Atlantic Ocean to the Nile, took nine months. Some years later, the Ashers retraced all the journeys of their inspiration, Sir Wilfred Thesiger. Other travellers have traversed other deserts. In 1977, the Australian woman Robyn Davidson walked, alone with four camels, for 2,750 kilometres (1700 miles) across her country's western deserts. Twenty years later, she joined untouchables to cross the Thar desert in India's Rann of Kutch. In 1995, a large British expedition used Bactrian camels and Land Rovers to cross China's forbidding Taklamakan Desert from west to east.

In the following year Range Rovers and Discoverys drove for 2,000 km (1,250 miles) through the soft sands, rocky terrain and gum-tree-studded outback of Western Australia's Great Sandy Desert and Gibson Desert. This was the Calvert Centenary Expedition that retraced the route of a tragic exploration a century earlier, but also included a study of the remote region's geomorphology by Dr Bob Allison for the Royal Geographical Society.

Above: *The Atacama desert in Chile, one of the dry and barren deserts of the south, on the Tropic of Capricorn. Nine months after rain, a lonely flower struggles for survival in the cracked earth.*

Because deserts are so open to human travellers, they have yielded fewer discoveries to modern scientists than the other habitats discussed in this book. No inventions of special equipment opened the deserts to man – as were needed for human beings to penetrate the oceans, the polar regions, caves and mountains, or the rain-forest canopy. Paved roads now cross many of the world's arid regions. Four-wheel-drive vehicles and helicopters have made desert movement far easier; but it can always be done the hard way, on foot with camels or other hardy animals.

Deserts also support less biodiversity. There are fewer plants and animals to be studied when compared with the teeming rain forests or coral reefs. Deserts are nevertheless a highly significant environment. According to the British geographers Tony Allan and Andrew Warren: 'The hot and cold deserts (excluding Antarctica) together cover almost forty per cent of the earth's surface; after the oceans, they are among the most important elements in the global climate system. Desert landforms are extremely active: massive

quantities of boulders, sand, silt and clay are eroded, transported and accumulated by running water and the wind in desert regions. With little or no vegetation, the world's deserts provide particularly striking vistas. The beauty of deserts has inspired the cultures of those who lived there and captured the imagination of those who have visited.'[4]

One major discovery about deserts is why they occur where they do. The world's deserts lie in bands about 30° north and south of the Equator. Roughly along the Tropic of Cancer to the north are: the greatest belt of desert, stretching from the Sahara to Arabia, the Iranian-Pakistani Makran and on to the Thar in India; the Taklamakan and Gobi of Mongolia; the Kyzyl Kum and Kara Kum sands in the heart of central Asia; and in North America the Mojave and Sonora deserts of northern Mexico and the south-western United States. To the south along the Tropic of Capricorn are: the Namib and Kalahari deserts of Africa; the dry lands of the Australian outback; and the Atacama and semi-arid Patagonia in South America. These locations are no accident. They are connected to the earth's exposure to the heat of the sun, and its greatest daily spin at the Equator. A recent discovery is the 'Hadley cell', a circuit of air currents that forms a convection box on either side of the Equator. The sun's radiation causes equatorial air to heat and rise; moisture-laden air is drawn in behind the rising hot air, and discharges its water to create rain forests; the rising air masses are drawn towards the poles in gigantic swirls helped by the earth's rotation; these air currents subside as they cool; and as they near the surface, they become drier, creating high-pressure anti-cyclones and the arid conditions of deserts. Their high pressure also prevents the entry of moist air from the oceans. In some places, deserts are created by cold ocean currents close to land – as along some western coasts of North and South America, and Africa's Skeleton Coast in Namibia. The deserts of the central-Asian plateau are partly the result of sheer distance from any ocean.

Deserts are defined as areas where annual rainfall is less than 200 millimetres (eight inches). Such rains as there are cannot be predicted and are irregular. Years of drought can be broken by heavy rains that cause inordinate damage; and storms can fall on one small locality, often where it is of least use to man. Deserts were defined, by Peveril Meigs of UNESCO, as places where water from rainfall is equalled by that lost through evaporation from the ground or vegetation. Of course, there is a great variety of deserts, differing in degree of aridity and surface cover – ranging from pure sand seas to rock-strewn ergs, and with a profusion of rock formations and weathering patterns. So, geological and geomorphological research concentrates on understanding desert dynamics – how the desert surfaces are formed and what causes their dune movements or erosion. It is now known how the different types of dune were formed. Some result from sand accumulating in the lee of obstructions – anything from a simple bush to a range of hills; others, particularly in Namibia and Australia, are long undulating structures created by prevailing winds from different directions during each year. Crescent-shaped barcans move in the direction of their concave, steep sides, as wind blows sand over their sharp crests. Barcans can travel at from five to fifty metres (15–150 feet) a year, and I have seen them marching across roads as far afield as the Sechura desert in

Opposite: *Crescent-shaped barcans move in the direction of their concave steep sides as the wind blows sand over the steep crests of the Namib Desert.*

northern Peru and in Iraq. Variable and unstable wind patterns can create huge star dunes, in which arms of sand radiate from a central pyramid. Crossing the Murzuq sand sea in southern Libya, our four-wheel-drive truck roared up the steep slope of such a dune. It seemed impossible for it to reach the crest a hundred metres above us, but the surface of the sand was surprisingly hard and the vehicle just succeeded. Over recent years, research teams have described every desert, recording its sand and soil patterns, its geology, the morphology or shape of its surface, and the types of erosion that have created it.

Because deserts have little protective cloud cover, they suffer great changes of temperature. The intense heat of the midday sun can reach temperatures of 55°C (131°F). But the lack of moist soil means that the heat radiates off the ground into the clear air, so that the night-time temperature may drop by 20°C (36°F). Mid-continental deserts can have cold winters, even snow.

With fewer new discoveries to be made in deserts, and because a tenth of the human race lives on or near these fragile ecosystems, desert research has been more directly applied to human needs than has research in other environments. Much fieldwork has gone into combating desertification. As early as 1951, UNESCO set up an Advisory Committee on Arid Lands Research. This in turn generated some two hundred desert research institutes in forty countries, and a thirty-volume series of Arid Zone Research papers. The UN Conference on the Environment in Stockholm in 1972, and a terrible drought in the Sahel from 1968 to 1973, led to the UN Conference on Desertification in Nairobi in 1977. (The Sahel is a 300–1,100-kilometre (200–700-mile) wide swathe of dry-

Above: *As part of the multi-disciplinary Oman Wahiba Sands Project, scientists extensively studied dune dynamics and the weathering of desert landforms.*

lands and poor soils that crosses Africa south of the Sahara Desert.) The Nairobi Conference drew up a ground plan and hoped that governments would implement it and monitor progress. Aid agencies spent billions of dollars in famine relief. There were attempts to plant windbreaks or find crops that would prosper in arid conditions. A decade later, the effort was judged to be a total failure. A growing population was overgrazing the sparse vegetation and consuming water resources. Trees were destroyed for firewood – since

ninety per cent of fuel in Sahelian lands comes from wood, and a cartload of sticks and logs is worth a fortune. Lack of trees in turn diminished rainfall. Rick Gore wrote in the National Geographic magazine at that time: 'Most regions [of the Sahel], with too few trees, also have too many cattle, goats and sheep. The destruction of trees has reached epidemic proportions in the other energy crisis: firewood. As vegetation vanishes, the desert advances.'[5]

In fifty years, the desert had overrun an area the size of France and Austria; and, according to William Ellis of the

Below: *Crop scientists from the arid plants research institute at Safawi in Jordan's Badia desert at work. The University of Arizona has had success in greening deserts with plants such as* jojoba *and* guayule.

National Geographic Society, 'each year man's misuse denudes 65,000 square kilometres (25,000 square miles) of our planet's surface.'[6] By 1987 Dr Mustafa Tolba, head of UNEP (the United Nations Environment Programme), described ten years' effort as 'a harvest of dust'.[7] It was felt that one mistake had been to rely on grandiose schemes, including government efforts to plant water-intensive export crops such as cotton or oil seed. It would be more effective to find solutions at village level and to allow nomads to continue their proven methods of grazing rather than trying to force them to settle. The second world environment conference, UNCED (the Earth Summit) in Rio de Janeiro in 1992, also called for a Convention on Desertification. But little has come of this. A British geographer, Professor Peter Beaumont, writes that 'the future of the Sahel region, perhaps the largest area of continuous semi-arid grasslands in the world, looks bleak. In recent decades drought has devastated the region. Given the high population numbers which now exist, local agriculture is incapable of supplying the food needs. People, therefore, become dependent on food distributed by their governments or directly by international agencies such as the United Nations or the Red Cross. This dependency culture does not bode well for the future.'[8] It leads to population growth too fast for the carrying capacity of the land.

There is a contrary body of scientific opinion that denies the concept of desertification swallowing up potentially fertile land. This theory argues that deserts that spread during drought can be recovered when normal rains resume. The danger in this is that it might lessen efforts to manage dry lands sustainably. It also ignores the looming threat of climate change and global warming.

Recent research has not all been in vain. The University of Arizona and other American institutes have had notable successes in greening deserts with plants such as jojoba and guayule. Israel's Ben Gurion University in the Negev has husbanded every drop of water to yield remarkable growth, and leads the world in desert research. Its Dr Joel Schechter developed trickle irrigation, with just enough water piped to each plant's roots, and it also used expanses of plastic roofing to consume less water and land than open-field farming. An international crop-research institute for the semi-arid tropics (ICRISAT) in Niger improved yields of sorghum, millet, chick-peas and groundnuts, even on soils that were woefully deficient in phosphorus, nitrate or humus. Another arid plants institute near Aleppo in Syria has achieved years of useful research; and Jordanian and British scientists are co-operating at Safawi in Jordan's Badia desert to help the local Bedouin improve their livestock and make better use of any surface water. For many years, French and Tunisian scientists of different disciplines collaborated at Oglat Merteba, to try to understand the causes and measure the effects of desertification. The Chinese have deployed their labouring masses to plant gigantic lengths of woodland to check sand storms. They also restrain and even plant on tracts of arid land by means of grids of rope netting.

One attempt at greening a desert went disastrously wrong. In 1977 the Soviet authorities boasted that they had created 61,290 square kilometres (23,940 square miles) of irrigated lands on the Golodnaya steppe, in what are now Uzbekistan and Tajikistan, by taking water from the Aral Sea. 'In order to increase the output of such products as cotton, rice, fruit and grapes in the Aral Sea basin, it is planned to accelerate irrigation development. The 1976–80 Five-Year Plan assumes an annual addition of 180–200,000 hectares (445–500,000 acres) of irrigated lands, to reach a total of 9 million hectares (22 million acres) by 1990. This will result in nearly full utilization of available water resources.'[9] There was even wild talk of reversing the flow of the Ob and other rivers that drained northwards to the Arctic. In the event, almost everything went wrong. Some engineering works were not completed, the ground was not properly prepared, some places were over-watered and others inadequately. The fragile soil could not stand intensive irrigation, and the result was widespread waterlogging and salinization. As irrigation water evaporates, salts are concentrated in the soil surface or seep into rivers. This phenomenon was well known from earlier irrigation schemes, such as that in the Indus valley in Pakistan. After a few years of increased fertility, salts in the soil rise to cause irreparable salinity. Most disastrous of all was the destruction of the landlocked Aral Sea. Its waters fell by eight metres (twenty-six feet), and its surface shrank from 64,000 square kilometres (25,000 square miles) to 16,000 square kilometres (6,200 square miles) in the last forty years of the twentieth century. The Aral Sea's twenty-four species of fish are almost extinct. Not surprisingly, local weather patterns have also changed. The desiccation of the Aral Sea is an example of fieldwork on a massive scale whose discoveries were radically different to what was hoped.

Apart from efforts to ameliorate the lives of people living near deserts, recent research has made amazing discoveries about survival strategies of desert flora and fauna. The basic problem for desert plants is that photosynthesis (the production of essential sugars using solar energy) requires the intake of carbon dioxide, CO_2, through tiny pores called stomata. However, moisture is lost through

with more strength than the most powerful man. This was on a fine multi-disciplinary project, led by Nigel Winser for the Royal Geographical Society, that studied desert flora and fauna and learned more about dune dynamics and the weathering of desert landforms. Some desert plants as far apart as the Spinifex grass of northern Australia or *Tillandsia latifolia* of the Atacama Desert in Chile have no roots, but roll across the ground in wind-driven balls. Cacti use different ways to protect their chlorophyll pigments from damage by intense heat.

A famous sight in any desert is when it receives rain and suddenly blooms. This is because the seeds of some annual and ephemeral plants, such as poppies and rock roses, can lie dormant almost indefinitely until rain falls. Some mosses also allow themselves to dry out completely. There have been instances of mosses coming to life after hundreds of years in herbarium collections, or of seeds in the mud of archaeological digs flowering after centuries of inactivity. Desert plants have also evolved ingenious methods of seed dispersal, for instance by wind or on the skins of grazing animals; and desert flowers bloom briefly and have to attract pollinators before their reproductive organs are damaged by strong sunlight. Ancient *Prosopis* trees along the eastern edge of Oman's Wahiba Sands were found to derive their moisture from mists swirling in from the Indian Ocean; but they were dying out before scientists found and eliminated a worm that was burrowing into their pods. These are but a few of the discoveries of complex responses that ensure desert flora's evolution and survival.

Findings about desert fauna are equally remarkable. The Californian William Hamilton worked for over twenty years with Mary Seely at the Namib Desert Research Station.

Above: *A Land Rover roof makes a convenient platform to study* Prosopis *trees along the eastern edge of Wahiba Sands in the Sultanate of Oman.*

these same stomata. Desert plants, particularly cacti, tend to have fewer stomata and hence grow more slowly; some grow largely underground; some succulents open their pores at night, but have a system to store the CO_2 as an organic acid for use in the light of the following day. Roots are another adaptation. Some plants have deep roots to draw up water. In Oman's Wahiba Sands in 1986, I saw an insignificant-looking bush whose roots sucked in moisture

They discovered survival techniques in one of the driest places on earth. As in Oman, rare sea fogs from the South Atlantic are often the only source of moisture. Head-standing beetles balance upside-down on the crests of dunes, so that water from the fog trickles down their backs into their mouths. Dr Hamilton wrote that 'in this world of swirling sand live animal species that flourish without ever seeing a living plant. Wind and drifting detritus – plant and animal fragments – activate residents of the dune alps: beetles and spiders, lizards and snakes.'[10] Beetles, scorpions and spiders are all adapted to desert life. The ancient Egyptians

Above: The spectacular sight of flowers blooming in the desert after rain, in the Jordanian Badia desert. Seeds can lie dormant almost indefinitely until rain falls.

worshipped scarab dung-beetles as representing life itself. Desert spiders tend not to build webs, since there are few flying insects: they hunt or ambush their prey.

The insect that causes most damage to humans is the locust grasshopper, and it has therefore received most research attention. It was a locust-research team that first introduced Wilfred Thesiger to the Empty Quarter in Arabia. But despite many arduous expeditions, there is still

much to be learned about locusts: why some are solitary but can swarm with others and become gregarious, what triggers the devastating migrations of millions of these powerful fliers, and where locusts breed. Crowding of locusts appears to occur when a wind from the monsoon coincides with rain. The wind congregates the plague of insects, and the rain creates the plant growth for them to forage and the moist soil needed for egg-laying. Then, according to Allan and Warren, 'the gregarious phase may persist for several years until strong winds and storms disperse the swarm, so that isolated individuals revert to the solitary form.'[11]

Another set of invertebrates depends on occasional rainfalls to create seasonal pools. As soon as such a pool forms, dormant eggs hatch to create a swarm of single-celled protozoa, crustaceans (lobsters, shrimps and crabs), water fleas, tadpoles and other reptiles that need water only for reproduction. Death Valley, an inland desert on the California–Nevada boundary, has extremes of temperature from a scorching 40°C (almost 110°F) in summer to near

Below: *The Namib desert is home to an extremely rich underworld of insects and reptiles, 'residents of the dune alps' adapted to survive desert life, such as the tenebrionid dune beetle,* Onymacris bicolor.

freezing in winter. Its warm springs are host to desert pup-fish that can tolerate such extreme changes of temperature, as can the algae they eat. Across the world in Lake Magadi, in Kenya's Rift Valley near the Masai-Mara, the small *Tilapia grahami* fish exists in a hot spring, with waters at 41°C. Nearby soda lakes cannot support fish, but are home to flamingos. Anthony Smith, author of a book on this part of Africa, ponders: 'One wonders if any portion of the Rift Valley system exists that is unexploited by some cunning plant or animal.'[12] The invention of the aqualung has permitted freshwater biologists to study the ecosystems of African lakes, and to find that they are as complex and fascinating as so many other natural realms. By far the most common fish in Africa's lakes are perch-like cichlids. They account for two-thirds of the fish in Lake Tanganyika, where 140 species of cichlids have adapted to every type of habitat, from rocky cavities to deep water and sandy bottoms. They have the endearing but unusual characteristic of building nests, almost like birds, and then protecting their eggs and young. The largest species of cichlid grows to seventy-five centimetres (thirty inches) in length and its nest is a large cavity in the sand of the lake bed, up to a metre (3.3 feet) deep and 3.5 metres (11.5 feet) in diameter. The females lay 10,000 or more eggs in this depression and the adults then defend their thousands of squirming fry against other fish, reptiles and birds. The few hundred who survive grow to be voracious predators, hunting in well-disciplined packs. Similar research into aquatic life is being made in all the world's lakes and rivers, in this golden age of discovery in which we live.

A response to extreme heat among some amphibians and small animals is to aestivate, which is the summer equivalent to temperate animals' hibernation: spadefoot toads burrow deep into the soil and aestivate for up to nine months with greatly reduced metabolic activity and consequent water loss; ground squirrels and some birds survive summer heat in the same way. Birds are particularly plentiful in deserts, because they can fly in search of water and food, because they can rest during the heat of the day, and because they are naturally able to tolerate very high temperatures. A dazzling variety of survival strategies is being discovered among desert insects, animals and birds. As in every other realm of nature, the true explorers are the dedicated zoologists, ornithologists, herpetologists, entomologists and biologists making these findings.

The most popular research in deserts and savannahs is into the behaviour of mammals, particularly the big-game animals that attract millions of visitors to Africa's national parks. These animals were well known to the Africans who have hunted them for thousands of years and to more recent European explorers – many of whom started as big-game hunters. And yet, observation by modern scientists continues to make extraordinary revelations about the complex biodiversity of the African plains. Such discoveries are occasionally even made on film, when an infinitely patient and resourceful naturalist cameraman or woman captures a hitherto-unknown movement or behaviour pattern.

In 1956 George Adamson, a warden in the Kenya Game Department, and his wife Joy were brought three lion cubs at their outpost in the dry scrub savanna of the Northern Province. They reared the lioness Elsa from a bottle-fed cub to an affectionate adult, who died of disease in George Adamson's arms, but whose offspring were released into the

Opposite: *The colourful sight of thousands of lesser flamingo,* Phoenicopterus minor, *on Lake Bogoria in Kenya's Rift Valley.*

wild of the Serengeti. Elsa's enchanting story, *Born Free*, was a best-selling book and film. Its profits enabled Adamson to create the Kora sanctuary that became a reserve, in an expanse of *Acacia commiphora* thorn scrub beside the Tana river in central Kenya. Here, after Joy Adamson's death, George Adamson and his brother spent twenty-five years providing a haven for lions, preparing those that had been rescued from human captivity for a return to natural freedom. In 1983 Dr Malcolm Coe, a delightful, bearded Oxford zoologist and experienced African ecologist, organized a multi-disciplinary research expedition to Kora for the Royal Geographical Society. The famous palaeontologist Richard Leakey, then Director of the National Museums of Kenya, was co-leader of this project. I visited the expedition and saw the Adamsons' nearby camp. It was like a fresco from Assisi, with the elderly brothers wearing only shorts and sandals and surrounded like Saint Francis by birds, small animals and their beloved lions, amid a bevy of naturalist disciples. Some scientists of the prestigious Cat Specialist Group of the IUCN (the World Conservation Union, which has done much to promote research and conservation in all parts of the world) criticized the Adamsons' experiments with semi-tamed lions. But George Schaller, who spent years studying the lions of the Serengeti and is a foremost authority on the behaviour of carnivores, acknowledged the good that they had done for both the conservation and the scientific communities. 'The Adamsons gave us truths about the species that cannot be found in a biologist's note book.'[15] Observation by zoologists has revealed how lionesses dominate a pride and do most of its hunting, and how exiled young males can return to kill cubs that they regard as rivals.

In the end, the frail and aged George Adamson died in an ambush by poachers, heavily armed Somali *shiftas* who prey on elephants and rhinoceroses for their tusks and horns. Recent research has taught us more about the behaviour of elephants; but, tragically, much work is concerned with their destruction at the hands of poachers.

In 1966 a British zoologist, Iain Douglas-Hamilton, started his doctoral study of the elephants of Lake Manyara in northern Tanzania. He and his Italian wife Oria have since devoted their lives to the greatest of all African animals. Lake Manyara is a beautiful stretch of alkaline water, fringed with dry grasslands and some lush forest, and lying beneath the cliff-like wall of the Rift Valley. Iain Douglas-Hamilton's research involved every one of Manyara's 500 elephants, who, at that time, represented the densest concentration of these mammals anywhere in Africa. He and his wife built up a file of photographs and ways of recognizing each cow, by noting every mark or distinguishing feature. They then conditioned each family unit to accept them, so that they could record its

Below: *George Adamson at home in his Kora Reserve. The Kora Research Project was jointly organized by the RGS and the National Museums of Kenya.*

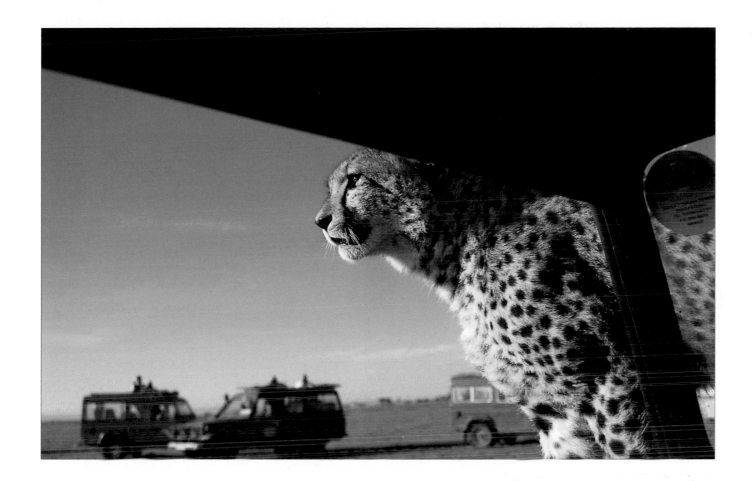

Above: *"Infinitely patient" wildlife film-makers study movements and behaviour patterns for our greater understanding and entertainment. During filming of* Big Cat Diary *in Kenya's Masai Mara, Simon King was befriended by a cheetah cub playing on the bonnet of his Land Rover.*

members' ages, social relationships and movements. Dr Douglas-Hamilton invented a device of a camera and mirrors to calculate the height of each elephant's shoulder, since this was an indicator of age. None of this was easy, since the forest beside Lake Manyara can be dense, and elephants – particularly the cows – can be aggressive. The wildlife film-maker Colin Willock went with Iain Douglas-Hamilton when he was observing the reserve's finest elephant, a forty-five-year-old he had named Boadicea since she commanded a contingent of some twenty animals. 'She never once took her eye off us, and when we approached close in our open-topped Land Rover, charged with a display of ferocity that frightened me very badly. She [shook her ears and then] rushed towards us at great speed, trumpeting and growling, head down, trunk down, tusks lowered to hook the enemy if he did not turn away. "Elephants have spent a few million years perfecting their threat charges," Douglas-Hamilton commented: "they mean them to be impressive".'[14]

Iain Douglas-Hamilton tracked his elephants on foot, in a Land Rover and piloting his own plane. But the best way of

following their movements was to fix a radio transmitter to an animal and locate its bleeps. He chose to do this on young bulls who had just been evicted from a group of cows and calves, but still followed it. To fix this device, the elephant was anaesthetized by a dart fired from a gun; but it suffered if it was not revived by an injection of tranquillizer within at most twenty minutes. On one occasion, Douglas-Hamilton was retrieving a transmitter from a bull. As he was about to revive the drugged elephant, a large matriarch known as Sarah came to its defence, trumpeting and charging out of the bush. She nearly killed Douglas-Hamilton whenever he tried to approach the unconscious bull with his hypodermic.

'Finally, he got back into his Land Rover, drove it into the centre of the furious cows and just had time to inject half a dose of tranquillizer into the bull before Sarah charged, driving her tusks first through the radiator and then up and over the bonnet, demolishing the screen and steering wheel and narrowly missing Douglas-Hamilton. To avoid those tusks he lunged back so hard that he broke the Land Rover's seat from its anchorage, a feat of some desperation, not to

Below: *An African elephant herd, ranging through the generations from young calf to old bull.*

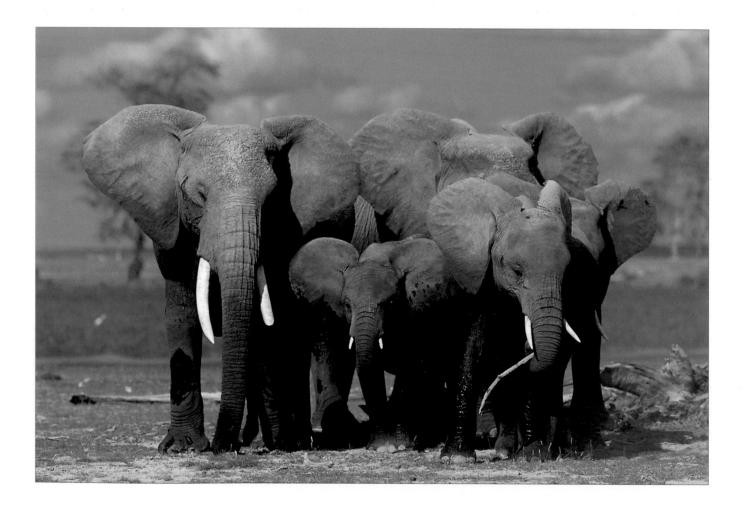

say strength. The vehicle, impelled by Sarah's tusks, shot backwards at around 20 m.p.h. and hit a tree. Sarah withdrew at this point, plainly under the impression that such an application of force had killed her enemy. Iain was still not satisfied and took advantage of her withdrawal to run in on foot and inject the rest of the antidote.'[15]

Elephants are majestic and have many endearing qualities. They can sing and communicate with one another by deep grunts. They teach their young good manners, but are caring parents and affectionate group members who grieve pitifully when one is killed. 'Elephants find private places to make love. They dance, they court, they stroke each other. Elephants bathe languidly and long.'[16] But there are reasons to kill these magnificent creatures — and with modern firearms it is pathetically easy to do so. Ivory is prized for piano keys, billiard balls and oriental carvings. An elephant represents a mass of meat for poor and hungry people: the trunk and heart are delicious delicacies, and the smoked meat from one animal will feed a village for a month. And peasant farmers hate the great animals that trample their crops, smash their fences and uproot their trees. So, the destruction of elephants has been devastating, a demographic catastrophe. During 1976–9 Iain Douglas-Hamilton was engaged by the World Wildlife Fund to attempt the first pan-African census of elephant populations. He worked in thirty-five countries, piloting his own plane for aerial surveys and using a network of scientific informants. He reckoned that 1.3 million elephants survived at that time. The slaughter has continued during the quarter-century since then. For instance, aerial surveys of the Galana ranch in Kenya counted 4,379 elephants in 1972; fifteen years later, similar observation showed only 90 living and 425 recently dead animals. During the same period, the elephant population of Kenya's Tsavo reserve fell from 22,174 to 4,327. In the anarchy of Uganda under Amin and Obote, gun-happy soldiers and tribal people slaughtered almost every elephant in the Murchison Falls and other reserves. The vast and dry Selous Game Reserve in southern Tanzania escaped poachers until recently. But in the two-year period between 1988 and 1990 it is calculated that 20,000 of its 50,000 elephants were slain. If this estimate is correct, the killing averaged thirty a day. And it was indiscriminate: not just large bull tuskers, but any elephants with any form of ivory. The main salvation for the remaining elephants is tourist income, and the protected reserves that they pay to visit. International pressure by conservationists has also helped. This is particularly effective through CITES, the Convention on International Traffic in Endangered Species, by which subscribing countries ban the import or export of produce from animals or plants on an endangered list. Ivory is of course on this proscribed list. While he was in charge of Kenyan wildlife, Richard Leakey caused a sensation by publicly burning a stockpile of tusks worth millions of dollars that had been confiscated from poachers; but he was removed from office not long after. In the elephants' defence is also some Africans' veneration for such noble beasts. The zoologist Malcolm Coe explained that 'the elephant is long-lived, has the ability to learn from experience and demonstrates some of the same complex social patterns as human beings, such as family groups, and so must be wise, just as humans who live a long time are elders or Mzee (literally 'old') and must also be wise. Mzee Kenyatta, the first President of Kenya was, so to speak, the nation's wise elder.'[17]

Rhinoceroses, the worlds' second largest land animal, are

Above: *Richard Leakey's sensational bonfire of elephant tusks, confiscated from poachers while he was head of the Kenyan Wildlife Service, in Nairobi National Park in July 1989.*

also under acute threat from poachers. The sought-after part of a rhino is its 'horn', which is actually densely compacted hair. This horn is prized as a dagger hilt or scabbard in Yemen, where eighty per cent of men used to wear a dagger as a status symbol. It is also thought to have valuable medicinal properties (to cure fever and skin afflictions) in China and is considered to be an aphrodisiac in western India. There are many conservation charities to save rhinos, and many experts doing rhino research. But the man who has done most to save this animal is Dr Esmond Bradley Martin, an elegant young American with a mop of prematurely white hair, who lives with his wife in Nairobi and devotes all his time, energy and fortune to the rhino cause. He explains that rhinoceroses 'are endlessly fascinating because of the great variation of behavior among the different species'. Dr Bradley Martin has been charged by a black rhino. Despite its bulk (sustained by a massive diet of shrubs, herbs and fruit), it can run at fifty-six kilometres

(thirty-five miles) an hour. 'When one of these creatures comes galloping towards you at top speed, its head swaying back and forth menacingly, making a thunderous noise each time its feet hit the ground and snorting loudly, your only thought is how to escape.'[18] But some rhinos fail to complete their murderous charge, apparently becoming distracted or making a mock charge only as an intimidation.

The scale of destruction of rhinoceroses was even worse than that of elephants. In the decade prior to 1983, ninety per cent of the rhino in northern Tanzania were killed; in relatively stable Kenya, the population dropped from 18,000 in 1969 to 1,100 fourteen years later – and the decline has continued since; and in Uganda the slaughter was so bad that almost every rhino has gone. But the crusades of Esmond Bradley Martin and others are making an impact. His efforts in Yemen (which accounts for half the world's trade in rhino horn) were finally successful: in 1997 that country subscribed to the CITES convention, and the Yemenis honoured the man whom they had previously tried to arrest and expel from their country.

Elephants and rhinoceroses are the largest and among the most glamorous of the animals of the African plains. Expeditions or individual researchers have also studied almost all the other animals – from mammals to birds, reptiles to invertebrates – in those rich and easily accessible habitats. At the opposite end of the size scale to the elephants are termites, those ubiquitous insects who clean up the region's dead wood and who create castle-like mounds. The American entomologist Glenn Prestwich, of the International Centre of Insect Physiology in Nairobi, devoted years to the study of *Macrotermes subhyalinus*, one of the world's 2,000 species of termite. He crawled deep inside

termite mounds to learn about their elaborate architecture and to observe the gigantic female, who grew during fifteen years of prodigious fertility to the size of a large white loaf of bread, a twelve-centimetre (five-inch) long mass of blood and ovaries. Dr Prestwich bravely photographed the spectacular nuptial flight of the pregnant female. 'I had prostrated myself beside a mound amid the swarm of ground-clearing workers and soldiers. As I clicked off the first few pictures,

Below: *A black rhinoceros mother and her young offspring in Zimbabwe. The scale of destruction of the rhino is worse than that of elephants, but they are being reintroduced into some game parks to ensure its continued survival.*

through my shirt I felt hundreds of razor-sharp mandibles stabbing into my arms and stomach. The soldier termites clung in a death grip to my pinched and bleeding skin; I tingled under thousands of tiny termite feet protesting my intrusion into their life-sustaining efforts.'[19] Such fortitude is typical of dedicated researchers everywhere.

The dry lands of Africa's Rift Valley were the location of another series of exciting expeditions. In 1967 Richard Leakey, son of the famous anthropologists Louis and Mary Leakey, was on a Kenyan–French–American palaeontological expedition in southern Ethiopia. Flying back to Nairobi over the rarely visited eastern shore of Lake Turkana, Richard

Leakey noticed dark deposits of sandstone. Closer inspection showed that these could indeed be fossil-bearing rocks. So, with funds from the National Geographic Society, Leakey established first a tented camp and later a permanent research base. One day, on a reconnaissance expedition in 1969, he wrote: 'We had left our camels and temporary camp in the cool of the dawn and set out to walk among the fossil-beds, looking for interesting specimens. While I was walking down a dry riverbed my eyes fell on something that made me stop in my tracks: it appeared to be a hominid cranium sitting on the sand. We advanced to the spot to find the ancient bony face of an intact hominid skull staring at us. It was a truly extraordinary moment. The cranium had clearly been embedded in the bank of the stream. Rain and the flow of water along the stream had gradually been eroding the bank away, and the cranium had probably rolled out during the last heavy rain storm. If we had not found it then, the seasonal river would soon have washed it into oblivion. I should say that this kind of discovery is very much the exception. Most finds are the result of many patient months of work, searching in likely deposits of rock.'[22]

After a two-day camel ride back to camp, Leakey showed his magnificent specimen to his mother. It proved to be of *Australopithecus boisei*, two million years old, a type of hominid that Mary Leakey had studied at Olduvai Gorge in Tanzania where she and her husband had excavated for many years.

Five years after Leakey's find, a team of American palaeoanthropologists (students of fossils of human ancestors) was working in the Afar desert of eastern Ethiopia. Their leader, Donald Johanson, wrote: 'At Hadar, which is a wasteland of bare rock, gravel and sand, the fossils that one finds are almost all exposed on the surface of the ground. Hadar is in the center of the Afar desert, an ancient lake bed now dry and filled with sediments that record the history of past geological events. Tom Gray and I parked the Land Rover on the slope of one of its gullies. Then we got out and began surveying, walking slowly about, looking for exposed fossils. (After) a couple of hours, it was close to noon and the temperature was approaching 110. We hadn't found much. There was virtually no bone in the gully. But as we turned to leave, I noticed something lying on the ground partway up the slope. "That's a bit of a hominid arm," I said. "Can't be. It's too small. Has to be a monkey of some kind." We knelt to examine it. "That piece right next to your hand. That's hominid too." "Jesus Christ," said Gray. He picked it up. It was the back of a small skull. A few feet away was part of a femur: a thighbone. "Jesus Christ," he said again. We stood up and began to see other bits of bone on the slope: a couple of vertebrae, part of a pelvis – all of them hominid. An unbelievable, impermissible thought flickered through my mind. Suppose all these fitted together? Could they be parts of a single, extremely primitive skeleton? No such skeleton had ever been found - anywhere. "Look at that," said Gray. "Ribs." A single individual? "I can't believe it," I said. "I just can't believe it."'[21]

But it was almost half a single skeleton, of a young female. Because someone in the camp that night was playing the Beatles' *Lucy in the Sky with Diamonds*, this skeleton was called Lucy.

Richard Leakey described the discovery of Lucy as 'one of the palaeontological surprises of the century'; and then, a year later, 'Don Johanson and his colleagues made (another) find that, even by Hadar standards, was stunning:

they came across a concentration of several hundred bones that represented at least thirteen and possibly more individuals.'[22] These finds were fossilized bones of the earliest known hominids, who lived over three million years ago. They were small creatures, barely distinguishable from modern chimpanzees, except that they walked upright. The lower part of their skeleton – pelvis, knee, foot – was surprisingly modern, but above the neck they were 'incredibly primitive' with very small brains of only 400 cubic centimetres (24 cubic inches). Years of patient research by skilled Africans, Europeans and Americans, much of it along the great depression of the Rift Valley, have revealed many more bone fragments (though nothing as sensational as Lucy's skeleton), footprints of strolling upright hominids, and the floors of shelters that were occupied thousands of centuries ago. Scientists have surmised the branches of evolution that led from *Australopithecus afarensis* (Lucy and her kin, from the Afar desert) and other varieties of *Australopithecus* to *Homo habilis*, then from about 1.6 million to 200,000 years ago *Homo erectus*, and our own *Homo sapiens*. But the discoveries are only tantalizing glimpses over an incredibly long time-span, so that great questions remain unanswered.

Lest we become complacent about our race's domination of the animal kingdom, the zoologist Anthony Smith wrote: 'Even though it is important to emphasise the differences – in species, in genus, in social behaviour, in the vastness of time - between the earliest hominids and the present one, there is another perspective that should not be ignored. If we take a grouping that includes the chimp Pan troglodytes, the pigmy chimp *P. paniscus*, the gorilla *Gorilla gorilla* and all the hominids through *H. erectus* and the sub-species of *H. sapiens* that we call Neanderthal, and throw in *H. sapiens* itself, we have a range of genetic difference that is not as great from one end to the other, from gorilla to human, as between a polar bear and a brown bear. There are some biologists who argue that if we were more honest with ourselves all of the African apes, including us, would be in the same genus. This knowledge comes from the relatively recent techniques of molecular biology. These techniques are now being used to assess the evolutionary relationships of modern peoples throughout the world, and from them two things have been learnt. One is that all humans are very closely related to each other, with a recent origin for modern humans; and the other is that their origin lay in Africa about 100,000 years ago.'[23]

Recent decades have also witnessed a surge in research into dinosaurs. From Alberta to Australia, Patagonia to Pakistan, Montana to Mongolia, palaeontologists continue to discover new species of dinosaur and to understand the world in which they lived. One of the many such ventures was the Calvert Expedition in Australia, sponsored by Land Rover in 1995. Meanwhile, a team under Clyde Goulden of the Philadelphia Academy of Natural Sciences drove Discoverys off-road for a thousand kilometres (600 miles) across Mongolia's desolate Gobi Desert. Their destination was Bayan Zag ('Flaming Cliffs'), the orange-red sandstone outcrops in which an expedition of the American Museum of Natural History had, in 1922, made famous finds of seventy-million-year-old dinosaur eggs and skeletons. But the extinction of the dinosaurs remains a mystery. One theory is that it was caused by a meteorite striking our planet. Satellite imagery has revealed vast concentric circles of such an impact, on the northern coast of Mexico's Yucatán peninsula.

MOUNTAINS AND CAVES

In 1953 serious mountaineering experts argued that Mount Everest could never be climbed. It was felt that at 8,863 metres (29,078 feet) its air was too thin and the summit lay beyond the limit of human physical endurance. There was also a view that the logistics of climbing such a giant, in a remote and roadless part of the Nepal–Tibet border, was too great a challenge. So when the British decided to try to climb Everest their choice as leader was Colonel John Hunt, a mountaineer who was an efficient army officer, rather than the charismatic Eric Shipton, a brilliant climber and hero of pre-war expeditions to Everest and other Himalayan peaks, but a loner who seemed incapable of the necessary organizational effort. John Hunt's planning was meticulous. He proved to be a perfect leader: charming, idealistic, solicitous about his men's welfare, modest and a good listener, but capable of firm decisions when necessary. Hunt welded his British, New Zealand and Nepalese climbers into a harmonious team, with excellent esprit de corps. They spent a month near Everest, acclimatizing and scaling several 6,000-metre (almost 20,000-feet) peaks. The climbers and their many Sherpa porters then progressively moved their camps up the mountain, carrying many tons of equipment and supplies. The first major barrier was the Khumbu ice fall, a hellish tangle of icy crags, sérac ice pillars and crevasses. This was overcome by using lightweight aluminium ladders and rope ladders. Fine climbing pushed the expedition up the Lhotse glacier, to establish its eighth camp on the South Col at 7,900 metres (26,000 feet). One key element in this attempt was the use of artificial oxygen. A Welsh scientist, Dr Griffith Pugh, developed wartime equipment into a breathing apparatus similar to the aqualung, with light oxygen canisters. The President of the Royal Geographical Society, Sir James Wordie, said that the extensive use of oxygen was 'in fact the secret of success'.

A bivouac camp was carried up to 8,500 metres (27,900 feet). John Hunt organized his best climbers into three pairs. The lead pair, Tom Bourdillon and Dr Charles Evans, made

Opposite: Chris Bonington, known for climbing "the hard way", pitches camp 7,300 metres (24,000 feet) up on Mount Everest at Camp IV on the 1975 British Everest Expedition.

the first ascent of Everest's South Summit but their oxygen equipment failed when they tried to press on to the main summit. Despite all the planning, disease had taken a toll: Edmund Hillary of the second pair had to carry a 28.5-kilogram (63-pound) load up to the top bivouac – an astonishing feat. At dawn two days later, the superb New Zealand mountaineer Hillary (by profession a beekeeper) and the leader of the Sherpas, Tenzing Norgay, left the very cold bivouac, where the temperature had fallen to –27°C (17°F) during the night. After a while, they moved along a ridge which, in Hillary's words, 'had narrowed to a knife edge and its friable snowcrust demanded care. The snow was soft and very unstable. I feared the whole thing would avalanche with us on it. Carefully, I packed down the snow as I made each new step'. The pair reached the South Summit and Hillary then laboriously cut steps down the snow on the far side, conscious of giddy drops on either side. The next obstacle was a black rock wall, where they squeezed up a crack. Then came another long slope. 'The ridge seemed to go on forever, its snake-like undulations bearing away to the right, each one concealing the next. For almost two hours I'd been cutting steps now, and my back and arms were exhausted. Tenzing, too, I could see was very tired.' They clambered over a patch of shingle and on to another hump. 'Only then did I realise it was the last bump of all. Ahead the ridge dropped away steeply, revealing, as far as the eye could see, nothing but the barren highlands of Tibet. Above us, to the right, was a rounded snow dome. Just a few more whacks of the ice-axe, a few more weary steps, and Tenzing

Opposite: *The 1953 Everest expedition led by John Hunt resulted in the first successful ascent. Edmund Hillary photographed Sherpa Tenzing in this classic heroic image on 29 May 1953.*

and I were on top of Everest! It was 11.30 a.m. on 29 May 1953. There came no feeling of extreme pleasure or excitement, more a sense of quiet satisfaction, and even a little bit of surprise. Behind his balaclava, goggles and oxygen mask, all encrusted with icicles, I could see Tenzing grinning beatifically. I reached out to shake his hand, but he would have none of it. Instead he flung his arms around my shoulders. We hugged and thumped each other on the back until forced to stop for lack of breath.'[1]

Below: *The second assault party: Tenzing and Hillary getting ready to leave Camp IV for the South Col. The equipment and oxygen canisters seem cumbersome compared to today's more streamlined mountaineers.*

The pair descended carefully, picked up their bivouac equipment, and chipped steps down to Camp VIII. Another New Zealander, George Lowe, went up to greet them with hot tomato soup. "'How did it go?" he wanted to know. "Well, George, we knocked the bastard off!" (Never, for a solitary moment, did I dream that the wretch would broadcast these great words to the world, over the BBC!)

Sir Edmund Hillary went on to achieve more great ascents, a dash to the South Pole, service as New Zealand's High Commissioner to India, and being the inspiration of a generation of explorers. But his proudest achievement was the Himalayan Trust, a charity that he created to help the people of Nepal. As he wrote: 'Nothing for me has been more rewarding in this life than. devoting ourselves to the welfare of our Sherpa friends.'[2] John Hunt became Lord Hunt and also dedicated himself to the service of others, helping young climbers and expeditioners, setting up the Duke of Edinburgh's Award Scheme, and working for the prison probation service. The Queen made both these public-spirited heroes Knights of the Garter.

There are fourteen 8,000-metre (26,250-feet) peaks, eight of them in the Himalayas and the other six in the adjacent Karakoram range. All of them were first climbed in the two decades after the War. Stephen Venables, who later became the first Briton to climb Everest without oxygen and by the difficult east face, commented: 'Suddenly the great giants – the 8,000-metre peaks – began to fall, as though mountaineers had finally broken some intangible barrier. It is hard to pinpoint precise reasons for this.'[3] Superior technology helped, as did careful planning. There was a dash of patriotic fervour – the British were racing against a Swiss attempt on Everest, the French had already climbed Annapurna, the Germans were about to scale 'their' mountain Nanga Parbat, and a year later the Italians conquered K2. But Venables argues that this burst of successes was more fortuitous. Pre-war expeditions had almost succeeded on all these peaks, and massive teams were not the reason. Hillary had learned his craft on small climbs with Eric Shipton, and the American Charles Houston had almost achieved the summit of K2 with a small team.

A group of brilliant French mountaineers had led the way. In 1950 a large team under Maurice Herzog attempted Annapurna (8,075 metres/26,493 feet), the highest point on a vast and fearsome ridge in a very remote, unexplored region of western Nepal. After weeks of effort, carrying in supplies and gaining the crest of the ridge, Herzog and Biscante Lachenal pressed on up a sloping arrête towards the summit, climbing without supplementary oxygen. 'The going was unbelievably exhausting, for the crust of the snow broke beneath our crampons, and we sank up to our knees with every step.' They had to camp on a dangerous and unstable ledge that they had levelled from exposed rocks glazed with ice. They passed a grim night, with a fierce wind piling snow against their tent and threatening to dislodge their pitons and send them sliding into the abyss. The climbers barely slept, and next morning they were too weak to take anything other than stimulant pills. The climb to the summit was 'unbelievably exhausting, every step a struggle of mind over matter'. They reached the summit, the first 8,000-metre mountain ever scaled, at two in the afternoon of 3 June 1950, utterly exhausted and suffering hallucinations. The

Opposite: *Annapurna was the first 8,000-metre mountain ever scaled. Maurice Herzog's 1950 attempt was fraught with accidents. Chris Bonington was luckier, making his successful ascent in 1970.*

peak 'consisted of a corniced crest of ice, and the precipices on the far side, which fell away vertically beneath us, were terrifying. Clouds floated half-way down them, concealing the fertile valley which lay 7,015 metres (23,000 feet) below, almost at our feet.' There were serious accidents during the descent. Herzog's gloves slid down the mountain. 'I knew that their loss meant a race with death. I hurried on, trying to catch up with Lachenal, (but) pausing every few paces to pant for breath.' They reached their camp as night fell. '"We made it!" I gasped. "We're back from the summit." Teray, speechless with delight, wrung my hand. But his smile quickly

vanished. There was a terrible silence, as he saw that my hands were stained violet and white, and hard as marble.' They then found that Lachenal had fallen several hundred feet: 'he was spread-eagled in the snow, frost-bitten and concussed'. Their companions tried to massage the frost-bitten limbs back to life. The descent from Annapurna was appalling, with howling wind and snow, then mist that prevented their finding a camp. They fell into an ice cave and

Below: Nanga Parbat (Naked Mountain) became an obsession for German climbers. It is known as the killer mountain for its wild weather. It was finally conquered by Hermann Buhl in 1953.

passed a terrible night in it. They were half buried by a small avalanche. All four men thought that they would die: some were blinded by snow glare, Herzog was frozen solid and the skin peeled off his frost-bitten hands. Later in the descent, they started an avalanche. 'An elemental force flung me head over heels. My head crashed into the ice. Snow enveloped me, making it impossible to breathe. I was spun round and round like a puppet. As in a kaleidoscope, I saw flashes of brilliant sunlight through the snow that was pouring past my eyes. The rope joining me to the Sherpas coiled round my neck. Again and again I crashed into solid ice as the avalanche swept me down through the séracs. Suddenly the rope tightened, and I was brought to a stop. I lost consciousness. Opening my eyes, I found I was swinging to and fro, upside down, the rope coiled round my neck and my left leg, in a chimney of blue ice.' Herzog somehow managed to crawl up, inch by inch, with his elbows. He discovered that 'the rope had been caught on a ridge of ice, and the Sherpas and I had hung suspended in mid-air from either side of it. If we hadn't been checked, we would have hurtled down another 1,500 feet [460 metres] to certain death.'[4] Once down from the mountain, Herzog's life was saved only by drastic remedies of the expedition's doctor and by heroic Sherpas, who carried the injured men over the passes back to civilization. Both Herzog and Lachenal had gangrenous toes and fingers, all of which had to be amputated one by one. Each of the other 8,000-metre mountains fell to a different nationality.

The obsession of the Germans was Nanga Parbat ('Naked Mountain'). This 8,124-metre (26,653 foot) monster in the western Himalayas is known as the killer mountain because its wild weather, fearsome walls and liability to avalanches have killed thirty-six people on twenty-two expeditions. Hermann Buhl finally conquered Nanga Parbat on a German expedition in 1953. Buhl made an amazing impromptu solo push up the final 1,200 metres (4,000 feet) to the summit, which he reached on hands and knees after sixteen punishing hours, and then had to spend a night in the open at 8,000 metres (26,250 feet). Four years later, Buhl and a small team climbed Broad Peak in the Karakoram (8,047 metres, 26,400 feet) without help from high-altitude porters. A few days later, this great mountaineer was climbing on nearby Chogolisa with Kurt Diemberger. The two were approaching the summit when they were engulfed by low cloud. Hermann Buhl decided that they must turn back before the wind covered their tracks in the snow. They were moving along the crest of a snow cornice and had not bothered to rope-up. It was impossible to see anything. Diemberger recalled: 'Crack! Something shot through me like a shock. Everything shook and for a second the surface of the snow seemed to shrink. Blindly I jumped sideways to the right – an instantaneous reflex action – two, three great strides, and followed the steep slope downwards a little way, shattered by what I had seen at my feet – the rim of the cornice with little jagged bits breaking away from it. My luck had been in all right. I had been clean out on the cornice. Still no Hermann. "Hermann!" I shouted. "For God's sake, what's up, Hermann!" I rushed, gasping, up the slope. There it was, the crest. And beyond it, smooth snow. And it was empty. "Hermann. You! Done for." I dragged myself up a little further. I could see his last footmarks in the snow, then the jagged edge of the broken cornice yawning. Then the black depths.'[5]

In 1956 the Japanese, gaining a reputation as some of the

world's finest mountaineers, finally climbed Manaslu after three previous attempts. This 8,156-metre (26,758-foot) giant, near Annapurna in Nepal, is hidden behind lower peaks and consequently less famous than other great mountains. In 1972, Manaslu took its revenge: fifteen South Korean climbers were killed in an avalanche – the worst disaster in mountaineering history – and two Europeans were killed in a separate expedition during which the Austrian Reinhold Messner reached the top without oxygen.

The mountain that challenged the Italians was K2 in the Karakoram, the second highest in the world, at 8,610 metres (28,248 feet). Italian and American expeditions had been trying to climb K2 since the early twentieth century, but success finally came in 1957 to a team led by Ardito Desio, who was a distinguished scientist of mountain geology as well as a fine mountaineer. K2 was climbed by a big team, highly organized like Hunt's Everest expedition. It established a series of small camps on a high ridge, but was punished by 'forty days of almost non-stop storms'. Desio recalled that 'life in those tiny camps, spread out like eagles' nests on the spur, was terrible. The continuous and violent shaking of the walls of the tents, the difficulty of making even the simplest meal, the prolonged immobility of men confined to a very restricted place, the intense cold: all this was unbelievably wearing both physically and mentally.'[6]

The world's third-highest mountain is Kangchenjunga, 8,597 metres (28,205 feet), on the border between eastern Nepal and Sikkim. This is a difficult and dangerous peak, which had caused deaths on several of the six pre-war

Left: *In 1955 a carefully planned British expedition succeeded in the first ascent of Kunchenjunga. The team was led by Charles Evans, who had been with John Hunt's 1953 Everest team with George Band.*

attempts to climb it. The first ascent of Kangchenjunga was in 1955 by a carefully planned British expedition, with brilliant climbing by George Band (the youngest member of John Hunt's Everest team) and Joe Brown. Dhaulagiri I ('White Mountain'), 8,167 metres (26,795 feet) high, was first climbed in 1960 by an Austrian team that included the legendary mountaineer Kurt Diemberger who, after Buhl, was the next to make first ascents of two 8,000-metre peaks. Dhaulagiri – once thought to be the world's highest mountain, before Everest was measured in 1850 – is part of a remote massif. Its peaks are numbered I to VI, and all were climbed during the 1970s.

Recent decades have unquestionably been the golden age of mountaineering. Easier access (both politically and by transportation) and vastly improved equipment have helped. But the decisive factor has been the skill, fitness and courage of the climbers themselves. All the mountains in the world are being climbed for the first time, and new routes are pioneered up the great peaks that were first ascended soon after the war. In the 1970s, when the highest mountains had

been climbed, Stephen Venables noted that 'people were eyeing the huge untouched steep walls on previously climbed summits. A young British team, led by Chris Bonington, used siege tactics to force a brilliant and difficult line straight up the South Face of Annapurna. The same year [1970] on Nanga Parbat, Reinhold Messner reached the summit (via) the Rupal Face, said to be the biggest mountain wall in the world. Reinhold went on to climb Manaslu by another new "big wall" route, and ultimately to surmount all fourteen of the eight-thousanders, soloing both Nanga Parbat and Everest, and never using oxygen. Messner revolutionized Himalayan climbing.'[7] There was a movement to 'alpine-style purism', whereby ruthlessly lightweight teams move up mountains like flies on a wall, with a minimum of supporting Sherpas, supplementary oxygen or fixed ropes. The achievements of the mountaineers have been prodigious, but at a price of many fine climbers falling to their deaths. Although mountaineering is a sport, its practitioners are also discoverers in the sense of being the first people to tread on and record some of the remotest places on earth.

There has also been expeditionary research in mountain regions. An important target for study is volcanoes, since their eruptions have killed tens of thousands of people. Scientists are fascinated by such awe-inspiring manifestations of the power of nature, which cause destruction and release energy on a scale that dwarfs the most powerful atomic

Left: *Volcanologist Katia Krafft standing above a lava tunnel by the active volcano of Kilauea, Hawaii.*

Opposite: *Volcanoes are the 'crucibles of creation' revealing how our planet was originally formed. A volcanologist stands before the Krafla Lava Fountain in Iceland in 1984.*

bomb. Volcanoes are 'crucibles of creation' that reveal how our planet was formed.

Recent eruptions have all been different. There are 550 known active volcanoes on earth, not counting those beneath the oceans. Many are in a 'ring of fire' around the Pacific Ocean; others lie on tectonic boundaries, often where subduction is causing one plate to slide beneath another. Most volcanoes quietly emit plumes of smoke or the occasional flow of lava. Mount Etna on Sicily is frequently active; and the world's most studied volcano, Kilauea on Hawaii, mesmerizes tourists with its flows of molten lava that pour out at over 1,100°C (2,000°F) and then cool into black swirls and long lava tubes.

A few eruptions are more spectacular. Iceland, like Hawaii, is on a geologically unstable mid-ocean ridge. In 1963 an underwater volcano blew and suddenly formed an island that was named Surtsey, nineteen kilometres (twelve miles) from the south-western coast of Iceland.

Ten years later, at a village facing Surtsey, in the words of Noel Grove of the National Geographic Society, 'the ground opened unexpectedly and hell boiled into heaven. The eruption built a 700-foot-high (213-metre) mountain where a meadow had been, rained black ash on the town and its cliffs, and sent lava creeping toward the (fishing) bay.'[8] In 1969 a dome measuring six million cubic metres (7.65 million cubic feet) collapsed on Merapi, on the Indonesian island Java, sending out a huge pyroclastic flow – glowing clouds of gas and air at great heat that burn and kill anything in their path. The pyroclastic flow of Merapi mercifully missed Java's second city, Yogyakarta. The Merapi Volcano

Opposite: *Nyiragongo volcano in the Congo was first studied by the Kraffts in 1963. It erupted again in 1967, with fresh eruptions in 1982.*

Observatory constantly monitors the build-up of water and other gases, to try to predict another explosion.

Some volcanic research is routine observation and prediction, in a series of institutes of volcanology and seismology that have been developed in countries most at risk. Other work is literally 'fire-fighting', when volcanologists rush to watch an eruption in progress. The father of modern volcanology is Haroun Tazieff, a big, handsome Frenchman with exuberant vitality and an insatiable appetite to learn more about his field of science. Tazieff's first ventures, soon after the war, were in the Nyiragongo volcano in the Congo. At that time, very little was known about the composition of volcanic gases. On Tazieff's third expedition, in 1959, his team used the latest mountaineering skills to descend onto a lava terrace that had been exposed when a viscous, burning lake within the crater had subsided. Wearing masks against acidic fumes and heat-resistant clothing, the scientists managed to collect gas samples that proved vital in understanding volcanic eruptions. Fourteen years later, Tazieff's pupils Maurice and Katia Krafft returned to camp beside Nyiragongo's boiling, 400-metre- (1,300-foot-) long lava lake. They also used climbing tackle and wore the latest protective clothing. Once on the rim of the crater, the Kraffts studied its stucture, the geology of its rocks, variations in temperature of the magma, and the sulphuric gases bursting from its surface. They were lucky. Four years later, the mountain exploded, with lava bursting from the crater's walls and a wave of molten rock, 1,000°C (1,900°F) hot, pouring down to bury the surrounding countryside. Rushing to the scene of the catastrophe, the Kraffts found an 800-metre- (2,600-foot-) deep smoking hole where they had previously studied the lava lake. They saw 'Waves of molten

rocks (that had) spilled out from the twisted crater like a torrential river, tearing out huge chunks from the edges of the blowhole. Enormous, rugged scoriae are carried on the river of lava, in a sea of fire.'[9] Then, in 1982, there was a fresh eruption. Nyiragongo's boiling lava welled up towards the crater's rim. The Kraffts were there once again to observe this phenomenon.

One of Tazieff's most arduous expeditions was a Franco-New Zealand study of Mount Erebus, a 3,794-metre (12,450-foot) volcano in Antarctica. Camped high on the mountain, the scientists were lashed by a blizzard in temperatures that dropped to –60°C (–76°F). 'They descended the frozen walls of the crater to an active vent in which they saw a lake of lava. The volcanologists used a windlass to position their equipment for taking samples of eruptive gases that escaped from the seething magma. But the risks of the operation were multiplied by constant explosions, and by projectiles that shot out suddenly from the dense smoke. The scientists made seismographic investigations, studied the fumaroles (vents that emit hot gases and steam) outside the crater, and took geological samples.'[10] Even the dashing Tazieff had to abandon that expedition because the explosions were so frequent and menacing. But he returned to Erebus in 1978 and used new techniques to isolate the gases without risking his team's lives in the crater.

In 1980 came the gigantic eruption of Mount St Helens in the American state of Washington. Magma had been constantly rising in St Helens' core, and the attendant earthquakes unexpectedly caused the mountain's northern flank to collapse. Noel Grove wrote that: 'In such events the debris rolls farther than physics would seem to predict, perhaps fluidized by snow or groundwater caught up in the churning movement. Debris from St. Helens flowed 15 miles [24 kilometres] down the Toutle River. Thirty-five hundred vertical feet [1,066 metres] of material slid nearly 80,000 feet [24,000 metres] horizontally! The collapse was followed by a pyroclastic blast that scythed down trees 17 miles [27 kilometres] away. Some 60 people died.'[11] This spectacular event in the United States focused research on the destructive threat of the collapse of volcanic cones. After Mount St Helens, geologists all over the world were able to identify relics of similar bursting of ancient crater walls. However, warnings by volcanologists went unheeded by people living near the Nevado del Ruiz in Colombia in 1985. There had been ten months of activity during which this mountain threw out blocks of lava and ash. Then, it erupted. A murderous torrent of lava, mud, trees and rocks poured down the volcano's slopes at thirty-five kilometres (twenty-two miles) per hour. At first cold, this flow later became scaldingly hot. The town of Armero was buried beneath eight metres (twenty-six feet) of mud, ash and debris; 22,000 people lost their lives.

In April 1991, the Kraffts and the American Harry Glicken went to observe activity on Mount Unzen in Japan. All three were highly experienced and popular in the small coterie of international volcanologists. Suddenly, there was a loud crack. Lava broke from the top of the mountain and rolled down its slopes. But it was a boiling cloud of gas and ash, a pyroclastic flow roaring with hurricane force that instantly killed the three volcanologists, as well as thirty-eight farmers working nearby. In June of that same year,

Opposite: *In 1991 the side of Mount Pinatubo was blasted out, blackening the sky with ash and falling debris, and lethal pyroclastic flows raced down valleys and into villages.*

there was a powerful eruption of Mount Pinatubo, a short distance north-west of Manila in the Philippines. The country's largest island, Luzon, is in fact composed of fifteen ancient volcanoes, and Pinatubo lies in the midst of a caldera, so the Philippine Institute of Volcanology and Seismology was closely observing activity around the mountain. When there was a build-up of steam eruptions, followed by shallow earthquakes, sulphur-dioxide emissions, and the rapid growth of a lava dome, the evacuation of nearby villages was ordered. Loss of life was thus greatly reduced. Scientists think that they know what events inside Pinatubo's magma chamber triggered the eruption. A lava dome, that had acted like the cork of a champagne bottle, was blasted out and rose in columns of ash forty kilometres (twenty-five miles) into the atmosphere. Shortly afterwards, the side of the mountain was blown out, blackening the sky with ash and falling debris. Lethal pyroclastic flows raced down neighbouring valleys; and when it rained, villages were smothered by lahars – rivers of soaking ash.

In the past decade, scientists are learning more about the dynamics of volcanoes and are increasingly better able to predict when eruptions may occur. Seismic tomography uses the principle of powerful X-rays to probe over thirty kilometres (twenty miles) into the earth, to try to locate a build-up of magma. Laser beams are used within some calderas to measure the slightest movement of their underlying magma. Methods of prediction are improving, but it is never easy. A leading Italian authority, Franco Barberi of the University of Pisa, debated whether to remove the population of an area of volcanic activity near Mount Vesuvius. 'We have all these factors to look for – seismicity, deformation, gas changes – but volcanoes show individuality. So it is very difficult to make a decision about evacuating [people] from an area – perhaps for nothing.'[12]

Glaciers are another powerful mountain phenomenon that can threaten human beings. Scientists have for centuries been studying glaciers in the heavily populated Alps. But, as in so many realms of science, most of what we know about the composition and movement of glaciers has been learned from observation during recent decades. A glacier is a vast mass of ice, in high mountains or polar regions, that is formed when snow falls faster than it melts. New snow compresses the ice beneath, and when the thickness exceeds some thirty metres (one hundred feet) the mass starts to slide down a valley. Immensely powerful, a glacier gouges a great rounded valley. It eventually reaches a point where the ablation (melting or evaporation) exceeds fresh snow falls. Below this point, the glacier's surface is a layer called névé or firn. Farther down, the glacier carries boulders and moraine to form a snout where the ice melts or ablates into streams, at a lower and warmer altitude.

Research has shown how all glaciers have a similar structure, with the same component layers and stages of transition from source to snout. But the speed at which glaciers move varies widely, and scientists are still baffled by their advances and retreats. For instance, the Black Rapids Glacier in Alaska advanced at a record thirty metres (over a hundred feet) a day at one time earlier this century, whereas the Columbia Glacier, also in Alaska, started to retreat in the 1980s and is expected soon to reveal a fjord up to forty kilometres (twenty-five miles) long. Alaska contains the world's longest glaciers outside the polar regions: Hubbard is 120 kilometres (seventy-five miles) and Logan only slightly shorter. In 1986, Larry Mayo of the US Geological Survey

watched the Hubbard Glacier advance at terrifying speed. A tributary glacier called Valerie surged, at a rate of forty metres (130 feet) a day. This caused the Hubbard to break a dammed lake, releasing a mass of ice fifteen times greater than the Great Pyramid, which poured out at a rate of 100,000 cubic metres (3.5 million cubic feet) a second – thirty-five times the flow of Niagara Falls. Dr Mayo was awed by 'a roaring and booming, punctuated by the explosive sound that icebergs make. I don't know if I'll ever again see anything like that much energy released at one time.'[13] Meanwhile, as if to show the perplexity of glaciology, the nearby Columbia glacier was retreating.

Another range with magnificent glaciers is the Karakoram mountains of northern Pakistan. Its Siachen Glacier is seventy-two kilometres (forty-five miles) long, and the Hispar sixty-one kilometres (thirty-eight miles). In 1980, to mark the 150th anniversary of the Royal Geographical Society, Keith Miller, an ice engineer from the University of Sheffield, led an international British–Pakistani–Chinese expedition to the Karakoram. Professor Miller was pioneering

Below: A shot of Mount McKinley from the air showing glaciers on the southern side. Bradford Washburn was a pioneer climber of this peak.

the use of nuclear probes to measure ice thickness. Andrew Goudie, later Professor of Geography at Oxford, led a group of geomorphologists to study and re-measure the bases of glaciers that had been surveyed fifty years previously. They used conventional theodolites and plane tables, but also a new instrument called a distomat for calculating distances to targets. In the early days, 'they found walking up to the glaciers carrying their relatively heavy equipment unexpectedly tiring. They, like every other member of the expedition, had to pass through the acclimatisation barrier.'[14] Some of the glaciers they studied had moved dramatically. 'The spectacular advances and retreats of the Hasanabad Glacier, which is on the northern side of the Hunza river, make it one of the most extraordinary glaciers on the face of the earth.'[15] It had advanced by some nine kilometres (5.6 miles) in a single year at the turn of the century; had then retreated by seven kilometres (4.5 miles) during the next half century; and in 1980 was advancing again. This Karakoram Expedition also studied the carrying capacity of glaciers and how to determine past movements by examining and dating differences in moraine deposits. The expedition was but one of countless efforts to learn more about glaciers.

The International Karakoram Project 1980 used versatile Land Rovers to move up the newly cut Karakoram Highway, in some of the world's most unstable landscape – where seismic tremors are a constant occurrence, and the rough road repeatedly crashed down thousands of metres of crumbling mountainsides or was blocked by landslides and cascades of boulders. One research aim was to re-survey

Opposite: *The impressive peaks of Pasu overlook the Karakoram Highway and the Hunza River at Gulmit. Land Rovers covered the mountainous terrain on the RGS International Karakoram Project.*

the gorges of the upper Indus, measuring plate-tectonic movement over a fifty-year period, since the Karakoram is a region where the Indian plate is pressing against, and sliding under, the Central Asian plate. A later Royal Geographical Society project is examining the effect of deforestation on erosion of the banks of rivers that rise in the Himalayan hills of Nepal. This study, like so much research in mountainous regions, is also powered by Land Rovers. The prowess of these vehicles was tested in the Great Divide Expedition of 1989. Nine Range Rovers drove off-road for 1,800 km (1,100 miles) criss-crossing the continental divide in the Rocky Mountains – a feat of endurance that included climbing the continent's highest pass. Six years later, examples of Land Rover's different models from Defenders to Discoverys and Range Rovers – were driven across the Alps from France to Italy in the Hannibal's Trail venture. They managed to follow the most likely route taken by the Carthaginian leader in 218BC, with his army of 26,000 men and thirty-seven elephants.

Inland from Alaska's glaciers lie ranges of mountains that include Mount McKinley, at 6,194 metres (20,320 feet) the highest in the United States, and Lucania, the highest in Canada. Dr Bradford Washburn was a pioneer climber of these remote peaks, both before the War, while still in his twenties, and again in 1961 when he organized a series of assaults on McKinley by new routes. In one of the latter climbs, the outstanding Italian rock-climber Ricardo Cassin scaled the mountain's sheer south face, which had been known as 'the impossible wall'. Later in life, Brad Washburn turned his energy and skills to meticulous mountain surveying, first of the McKinley region, then of the Grand Canyon, and finally in 1983–6 a definitive survey of the summit of

Mount Everest. This feat began with some remarkable diplomacy, when the charming and tenacious Dr Washburn obtained permission from the King of Bhutan and then from the Chinese authorities to photograph Everest from the air. In 1983 the space shuttle Columbia flew over Everest and made a series of overlapping infrared images from an altitude of 250 kilometres (156 miles). A year later, with funding from the National Geographic Society and Washburn's own Boston Museum of Science, a Learjet flew over the world's highest mountain and took photographs of amazing clarity with a special German mapping camera. During the next two years, Swiss and American photogrammetrists and computer experts converted these images into a beautiful contour map at a scale of 1:50,000. Washburn wrote, with justifiable pride: 'The base maps are so detailed they depict 12-foot (3.6-metre) boulders and are so accurate nothing is more than 30 feet (nine metres) out of place. Using software developed by the GeoSpectra Corporation, the stereo-photographs were digitized and converted into three-dimensional data. A computer can tilt or turn the data to make amazingly realistic images'[16] of Mount Everest from any angle. This digitizing also meant that extremely detailed contour models of the top of Everest could be cut from plastic foam, to any size. One such model was erected under a tent in the garden of the Royal Geographical Society, and was admired by an assembly of Sir Edmund Hillary, Lord Hunt, Chris Bonington, Stephen Venables and other heroes of Everest mountaineering.

Mountain regions provide another, very different source of scientific and adventurous discovery. They contain the cave systems that challenge speleologists to descend into their black depths. As with so many other forms of exploration, speleology was in its infancy in the 1950s. It has since blossomed into a major sport and has earned its place among the earth sciences. There have also been amazing discoveries of animals and plants that evolved to live in the darkness of caves. In 1961 the French speleologist Michel Siffre spent two months below ground in the Scarasson chasm near Nice to study a unique phenomenon of a subterranean glacier. Some cave scientists have plunged underground for geological research; others specialize in applied research, such as locating subterranean aquifers or rivers so that they can advise people in arid regions where to drill for water.

European cavers have steadily explored their own underground systems, particularly in the Picos de Europa on the north coast of Spain, where large teams return every year to continue their discoveries. A recklessly daring branch of speleology is cave diving, whose practitioners combine skills of mountaineers, potholers and aqualung divers – but with special oxygen containers or very long breathing tubes so that they can still wriggle through crevices. These people have to overcome dangers of climbing, claustrophobia, cold, drowning, loss of air supply, and even decompression. They have to wear specially insulated wet suits, and some have perfected relays of divers who replace used canisters of the lead diving pair. This technique enabled Patrick Penez to achieve a world depth record in 1981. Penez and his companion dived for six hours under two sumps to a depth of 1,455 metres (4,770 feet) in the Jean Bernard chasm in French Savoy. A year later, an Australian team advanced underwater and underground for seven kilometres (4.3 miles). In 1998 four British potholers gained a new world record depth of 1,610 metres (5,256

feet) in the Gouffre Mirolda in the French Alps south of Geneva. This feat involved some 6.5 kilometres (four miles) of climbing and crawling, including the claustrophobic 'Ami noire': two rock ledges a chest-width apart, down which the explorers had to squeeze for one hundred metres.

Other cave divers work beneath the oceans. America's William Stone and Britain's Rob Palmer are the acknowledged leaders in this dangerous activity. They operated for

Below: *Cave diving is a recklessly daring form of speleology. It combines the skill of mountaineering, potholing and aqualung diving, needing special oxygen containers.*

years in the Blue Holes and other submarine caves off the Bahamas, and established records in the depths of their speleological dives. They experimented with new mixtures of gases and re-breathers in order to prolong the time they could spend underwater. On one occasion, when Rob Palmer was swimming into a cave tunnel, he encountered the body of a diver who had disappeared there the previous year and remained trapped in the submarine grotto.

Among many speleological milestones was the 1971 descent for 716 metres (2,350 feet) into the Ghar Parau cave in Iran's Zagros Mountains by a team led by David

Judson and the outstanding cave scientist Dr A.C. Waltham. Tony Waltham was later on the Royal Geographical Society's expedition to Mount Mulu in Sarawak in 1977–8. This was a multi-disciplinary study of rain forests, but it yielded another, unexpected bonus of discovering a vast cave system beneath Mulu's limestone formation. Waltham described how, at one point: '500 metres of energetic rift passage led to a series of massive chambers, remarkable for their variety of decorations. One of these we named Gua Ajaib – Wonder Cave. Massive flowstone walls and towering stalagmites vied with sparkling crystal floors and screens of stalactites to make the most splendid scene. The smaller formations include beautiful gypsum flowers and tangled calcite spirals up to a metre in length. In addition the chamber contains a hitherto unknown type of cave deposit. Delicate calcite fans, each the size of a cupped hand, appear to be formed by cave water splashing and spraying down from the cave roof, and occur in great tiered banks.'

Another wonder was a one-kilometre- (3,300-foot) passage that they called Deer Cave. 'It is so vast that it defies comprehension. At its downstream end it is 170 metres (560 feet) wide and 120 metres (390 feet) high. Everything about it is on a magnificent scale. Its bat population approaches a million. Sharing the cave with the bats are thousands of cave swiftlets, and between them bats and swiftlets have accumulated vast amounts of guano. This guano supports an enormous population of smaller cave animals – beetles, giant earwigs, millipedes and white crabs. And these in turn support a population of predators, mainly huge hunting spiders, but also long-legged fast and highly poisonous centipedes; there are also cave snakes, many of them more than a metre long.'[17]

Robin Hanbury-Tenison, leader of the Mulu Expedition and an intrepid explorer, described what it was like for a non-speleologist to enter this system. The cavers took him along a silted-up underground river where, 'for perhaps 400 feet (122 metres) the height between floor and roof is no more than two or three feet, so that we eased our way along like woodlice under a plank, except that we knew the rock was solid for maybe 3,000 feet (910 metres) above us. It was a most exhausting and confusing way to travel, half crawling, half stooping, but we were rewarded by eventual escape into black space again. We knew that no human foot had trodden there before during the million or so years since they were formed. It is an eerie and subduing feeling.'[18] One of the many dangers in cave exploration comes from sudden flash floods. A team underground has no way of knowing about rain on the surface. Moving into unknown territory, the explorers often had to swim under rock arches, or tred water while deciding which way to go. Two of the Mulu speleologists were surveying riverine caves when 'We noticed water suddenly start to pour in through the roof. The stream on the floor increased in flow and changed to a turgid brown torrent. Realizing it was flooding we set off out – downstream. A few yards down, a new river was pouring out of a passage which had been dry five minutes earlier. Then there was a lake – waist-deep water – and the current. The water became too strong, but we just reached the vital junction and, now wading against a strong torrent, reached the entrance.'[19]

One of the finest cavers on the Mulu team was Andy Eavis, a Yorkshire businessman, who went on to explore and map cave systems under other Southeast Asian limestone formations. Eavis and his colleagues discovered caves on

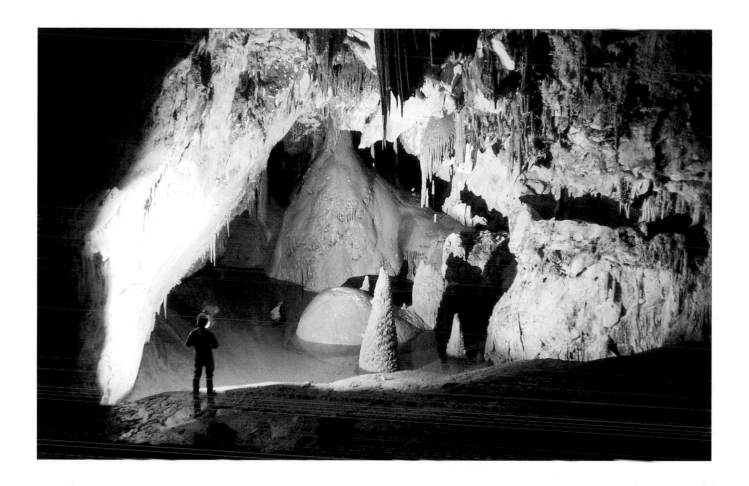

Above: During the 1971 RGS Mulu Expedition, led by Robin Hanbury-Tenison, a vast cave system beneath the rain forest was discovered, including the magnificent Wonder Cave. Andrew Eavis' photo shows a crystal pool at the end of the main passage.

Papua New Guinea's island of New Britain, on an expedition that involved penetrating rapid-infested forest rivers. French speleologists under Jean-François Pernette had, in 1980, found the world's largest chasm in the Lusé sinkhole on that tropical island. His team then hacked through rain forest to reach the Vuvu caves, where they explored kilometres of hitherto-unknown galleries. Andy Eavis later led a series of projects with Chinese speleologists. They explored amazing caves beneath the famous limestone pinnacles that are so admired by tourists along the Luoqing river at Guilin. Eavis and his team also developed three-dimensional cave photography, organizing simultaneous flash lighting along the length of spectacularly beautiful chambers. Gallant cavers are exploring their underground frontier in all parts of the world, moving on from caves of Europe, Canada and the United States to new systems in such countries as Mexico, Peru, Vietnam and the republics of the former Soviet Union in central Asia. They are probably too busy penetrating unexplored caves and establishing new records to consider that we are also living in the golden age of speleology.

THE POLAR REGIONS

Antarctica – vast, empty, cold, windswept, high and desolate – is a scientist's paradise. Here was the empty canvas on which researchers could devise grand experiments. The southern continent offered unlimited space, time constrained only by cost and no human interference. It also emerged that isolation and extreme climate create remarkable conditions for study. Antarctica's pristine purity and refrigeration can preserve specimens perfectly. Lessons learned in this cold laboratory explain phenomena throughout planet Earth.

Two events in the 1950s combined to launch a scientific programme that is unique in many ways. Its international co-operation transcended Cold War politics, the tensions of the British–Argentine Falklands War, and rivalries between the developing and developed worlds. Perhaps it is the harsh conditions that attract tough and dedicated characters to Antarctica. Research stations are full of humorous signs and nostalgia for sunny places, and there have been plenty of practical jokes in Antarctic exploration. But that same camaraderie has produced a fine record of mutual support,

particularly during crises. Antarctica also became uniquely the world's largest area dedicated exclusively to scientific research, and by far the biggest protected nature reserve.

It could easily have been different. Before the Second World War, various countries had claimed segments of Antarctica that tapered to the pole from a stretch of uninhabited coastline. Immediately after the war, the United States Navy started aggressive exploration and testing of men and equipment; and the Soviet Union responded with its own research station. But the two superpowers refused to recognize other nations' territorial claims, and they gradually came to favour pure research. In 1955 the Americans established an airstrip capable of taking large cargo planes and a headquarters village of ugly huts at McMurdo Sound, close to Amundsen's and Scott's starting points on their race to the Pole in 1911. In the following year, an American admiral landed at the Pole itself – the first man to stand there

Opposite: Chinstrap penguins on a very rare blue iceberg of ancient, compressed ice, Antarctica. This award-winning photograph by Cherry Alexander shows the extraordinarily three-dimensional quality of ice.

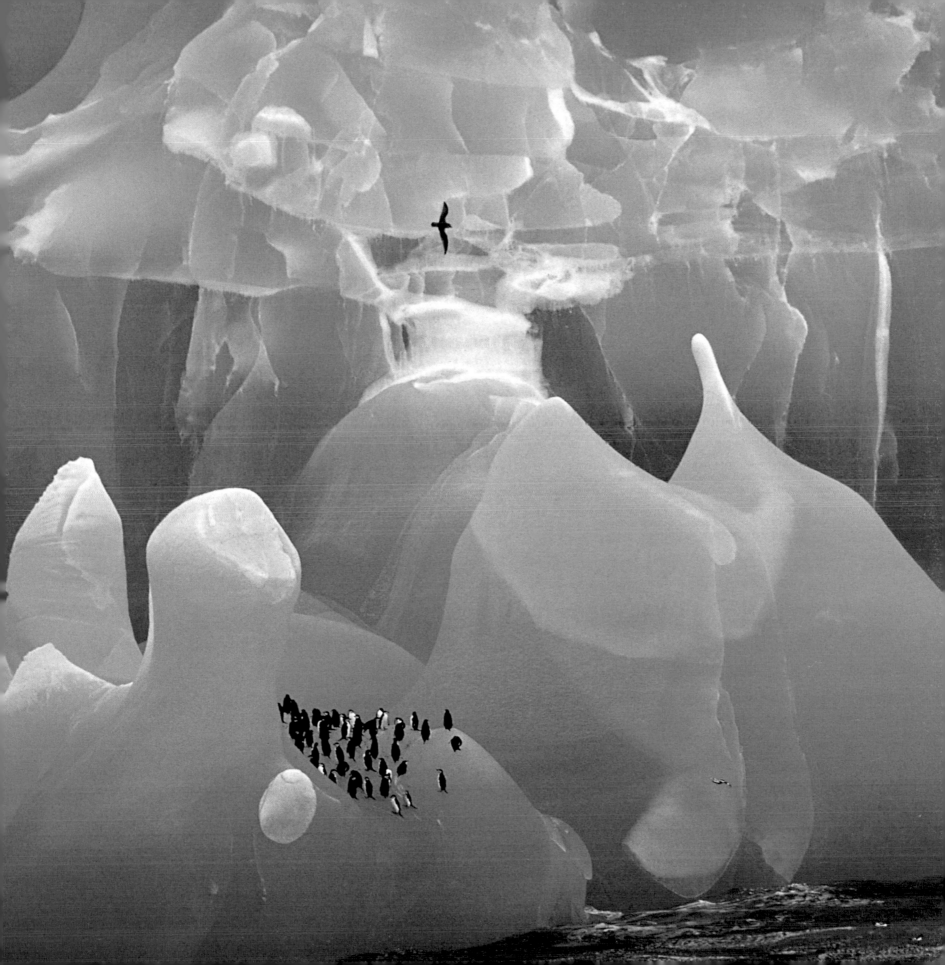

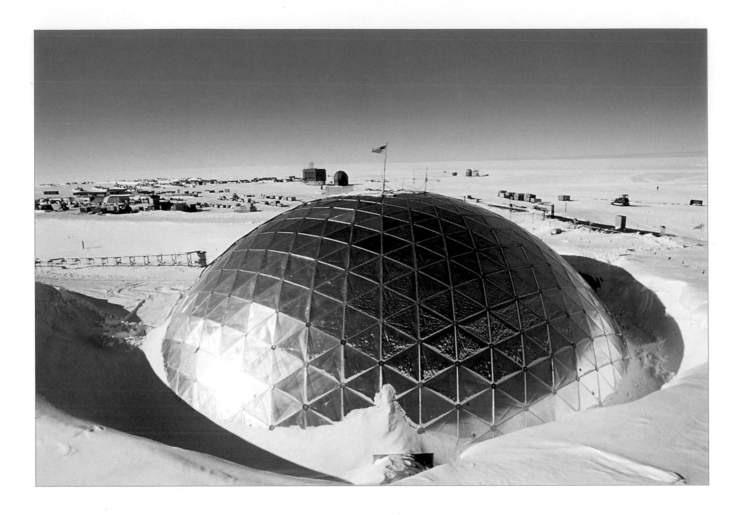

since Scott's party – and another permanent research base, Amundsen-Scott Station, was built at the world's southern most extremity.

The drift towards political confrontation was broken by a marvellous idea called the International Geophysical Year. Actually, it lasted for eighteen months, from mid-1957 to the end of 1958. The Americans led the way with a massive scientific input; Soviet scientists, liberated by the death of Stalin, participated, as did both Chinas; and, in the end, 64 countries took part. They gathered a vast corpus of climatic and other data from some 4,000 stations all over the world.

Above: The South Pole has become a hive of scientific activity in the last fifty years – this is a shot of the Amundsen-Scott South Pole Station, showing the Dome from the meteorological tower.

The greatest effort was in Antarctica, 'a region of almost unparalleled interest in the fields of geophysics and geography alike'. So the scientists fanned out from bases dotted around the continent like fleas on an elephant, for Antarctica is larger than Australia or western Europe. They worked from forty-seven stations on the continent and eight on the surrounding islands, and their findings greatly increased human knowledge of the ionosphere. Scientists are not

political animals. The nations working in the empty southern continent co-operated so well during the International Geophysical Year that it led to the creation in 1957 of SCAR, the Scientific Committee on Antarctic Research. This admirable arrangement and an Antarctic Treaty signed two years later have, with only a few rumbles of discontent, successfully kept 'Antarctica open to all nations to conduct scientific or peaceful activities' to the present day.

The other event that stimulated Antarctic research was Vivian Fuchs' first crossing of the continent, in 1957–8. This

Below: *Several supply ships were involved in transporting equipment and supplies some 16,000 kilometres (10,000 miles) from London to Antarctica, enabling Fuchs' team to successfully cross the continent.*

was a Commonwealth expedition, for men from three nations of the southern hemisphere – New Zealand, Australia and South Africa – joined those from the United Kingdom. The expedition was tough and dangerous, but it was not all pure adventure. The leading personalities in this expedition, the British Vivian Fuchs and the New Zealander Edmund Hillary, are both quiet, gentle men, but with powerful inner strength and determination. A friend described Fuchs as 'like the profile of the continent itself – tough, flat, unchanging, dogged'. At that time both were slim, but the gangling Hillary, fresh from his first ascent of Mount Everest in 1953, towered over Fuchs. (Hillary has now broadened into a bearlike giant with tousled hair and bushy eyebrows.)

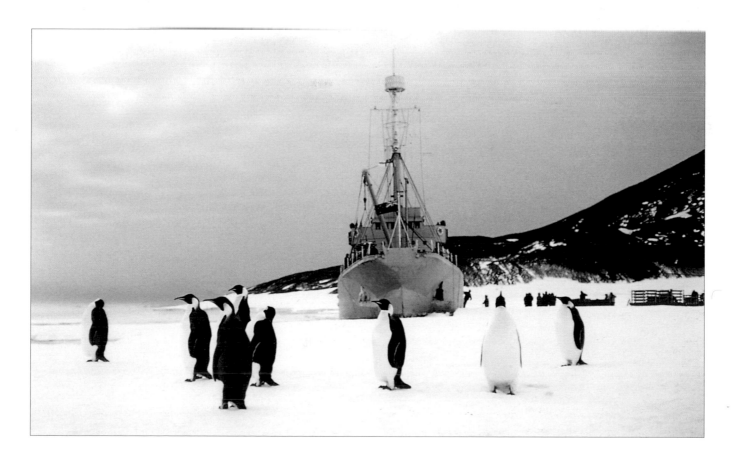

tracked cargo carriers and Snocats through a tortured landscape of crevasses towards the plateau of South Ice. The vehicles were roped together but frequently fell through snow bridges. It was highly dangerous and involved hours of delicate manoeuvring to extricate each fallen vehicle. On one occasion, Fuchs' Weasel was suddenly suspended over an abyss, held only by its rear tow-bar and one forward track. Vivian Fuchs coolly commented: 'I climbed out safely enough, after the others had taken the photographs they wanted.' At another time, the snow collapsed under the team's surveyor, leaving him suspended only by the ends of his skis. This group discovered a range of mountains that they named after Shackleton. They were helped on their way by a forward base established by a light plane flying twenty daring supply flights. That base had been occupied throughout the previous winter by three men, who managed to make glaciological and meteorological observations in the

Below: *Edmund Hillary meets up with Vivian Fuchs at the new American base in the Antarctic in January 1958: 'It's damn good to see you, Ed.'*

Above: *Vivian Fuchs' crossing of the continent in 1957–8 on the Commonwealth Transantarctic Expedition. Although the Snocats were roped together, Fuchs' 'Weasel' was dangerously suspended over an abyss, held only by the rear tow-bar and one forward track.*

The plan was for Fuchs' main party to set out from the Filchner Ice Shelf (south of the Atlantic Ocean) while Hillary's New Zealanders prepared depots and scouted a route from the destination on the far side of the continent. They started from the Ross Ice Shelf (south of New Zealand) moving inland from their Scott base near the Americans' McMurdo. Fuchs took a reconnaissance team of

perpetual Antarctic night, at temperatures dropping to −57°C (−71°F) and with punishing wind speeds of over thirty knots. Once up on the plateau, Fuchs' vehicles made good progress southwards, averaging fifty kilometres (thirty miles) a day. They took regular seismic soundings, using the shock waves of controlled explosions to measure ice thickness and a gravimetric profile of the underlying rock.

Meanwhile, Sir Edmund Hillary and three companions used modified farm tractors to move inland from the Ross Shelf. Everything went well. The tractors performed excellently, moving up a glacier and then just able to overcome the soft snow and thin air of the plateau. The depots were all laid before schedule, so Hillary decided to push ahead to the Pole. He was there, at the new American base, to greet Fuchs on 19 January 1958. There is no substance to rumours that the two explorers clashed over Hillary's unauthorized 800-kilometre (500-mile) dash to the Pole. Fuchs greeted him: 'It's damn good to see you, Ed.' The crossing was completed six weeks later. It had taken ninety-nine days to drive the ungainly red vehicles for 3,473 kilometres (2,158 miles) across Antarctica.

In 1958 Soviet scientists made an epic expedition into the unknown heart of East Antarctica. The snow is soft on this relatively calm but high plateau, so the Soviets had to develop tractors with wide treads and air compressors to give engines greater thrust in the thin air. Ten tractors pulling twenty heavy sledges set out from a Soviet station on the Indian Ocean shore of the continent. One party pressed inland for hundreds of kilometres to Vostok, a station newly established at the South Magnetic Pole. The others, led by Vitali Babarykin, moved towards the Pole of Inaccessibility. They had a grim time, overwintering in appalling cold and at

an altitude of 3,600 metres (11,800 feet). To work outside, Soviet scientists had to wear electrically heated suits, and even their paraffin congealed. Their measurements showed that the ice under this remote, unexplored plateau was 2,900 metres (9,500 feet) thick, whereas precipitation of new snow was almost non-existent.

Work on ice thickness revealed that eastern Antarctica is a continental shield, whereas the ice on the western part lies on a chain of islands. Much was learned about the thickness of the ice shelf – thousands of metres deep and weighing so much that it is reckoned to have depressed the underlying rock by around 1,000 metres (3,300 feet). It was discovered, surprisingly, that snow is accumulating over the continent at a rate of millions of tons of water per year. Although icebergs are always breaking off ('calving') from the great marine ice shelves that surround Antarctica, and great quantities of snow are blown into the sea by fierce winds, there is still an annual accumulation of billions of tons of ice.

Measurement of Antarctic ice has continued ever since the pioneering research of the Commonwealth Trans-Antarctic Expedition, the Soviets and the more important International Geophysical Year. One scientist who worked for forty years, with teams of different nationalities, is Dr Charles Swithinbank of the Scott Polar Research Institute in Cambridge. Some of Swithinbank's research has been on the speed of movement of the mighty glaciers that flow into the oceans around Antarctica. This involved planting markers in the glacier's surface. The teams often moved across unexplored terrain, and they developed techniques for surviving areas riddled with millions of crevasses. Large crevasses were easily visible and avoidable, except in a 'white-out', but

smaller snow bridges could not be detected. These scientific explorers used small motor sledges pulling a train of two or three cargo sledges. It was too dangerous to sit in the leading sledge, in case it plunged into a chasm. Instead, Swithinbank and his companions skied far behind the vehicle and steered it by long ropes. 'The advantage of being sixty feet behind the machine through this maze of crevasses was that we were always ready to let go the ropes if the machine should drop. On the other hand, once the vehicle was across a given hazard and we ourselves were approaching it, we hung on for dear life with the intention of being pulled out if our skis broke through.'[1] The annals of Antarctic exploration are full of accidents in crevasses. Scientists found themselves suspended by their skis, or had to haul themselves or their dogs out of an icy abyss. And there were deaths, particularly during white-outs, when everything is enveloped in a blinding dazzle. Caused by multiple reflection between cloud and snow, a white-out diffuses daylight into a glare that obliterates shadows, terrestrial features and horizons. In 1963 two British scientists with dog teams were photographing ice cliffs. An unexpected strong wind caused all-enveloping drift. The two men separated in the blinding blizzard. One finally returned to base, only to find to his horror that his companion was not there: he and his dog team had fallen to their deaths, over the invisible ice cliff into the icy sea below. It was almost certainly a white-out that caused Antarctica's greatest human tragedy, when in 1979 an Air New Zealand plane slammed into Mount Erebus killing all 257 tourists and crew

Opposite: *The interior of a deep cave in a tabular iceberg in Graham Land fjords in Antarctica showing the differences of ice thickness.*

Above: *Charles Swithinbank with an ice core, Ross Ice Shelf, Antarctica, in November 1960.*

on board, and in 1997 experienced freefall parachutists were so confused that they crashed to their deaths on the ice at the South Pole.

Vivian Fuchs described a tragedy in 1965 when men of the British Antarctic Survey were starting a new project to sound ice depth using radio-echo equipment developed by their colleague Dr Stan Evans. One party of four men travelled into the Tottanfjella mountains with a Muskeg tractor, two tractor-sledges and a dog team. They took a day to overcome terrain of dangerous ice falls, and were then making excellent progress across open snow. A scientist called John Ross was on a sledge with the dog team, being pulled by the vehicles. His sledge suddenly stopped. He saw: 'the leading sledge tilted up over a yawning hole, and there was no sign of the tractor which hauled it. Anchoring himself with rope, he rushed forward and peered down to see the

Muskeg jammed in a crevasse more than a hundred feet below. There was no immediate response to his continual shouts, but twenty minutes later he heard Bailey's agonised voice crying out that both Wild and Wilson had been killed, while he himself was badly injured and could not survive. Poor Ross lowered a rope but Bailey ceased to answer his calls. Darkness was falling, and even if Ross had attempted to go down into the crevasse, there was little hope that he could have got out again unaided. That nightmare of a night he camped alone at the scene quite distraught, trying frequently to make contact again but there was never any response. By morning he had to accept that his three companions had died.'[2]

Parts of Antarctica are riddled with crevasses, some as deep as a ten-storey building. The open ones can easily be seen and bypassed. 'Snow-bridged crevasses, on the other hand, are sometimes invisible. Visible or not, there are millions of them, and you have to cross them. Snow bridges can be thick enough to support a tractor or, at other times, thin enough to give way under the weight of a man on skis. The only way to find out is to dig or probe through the bridge to establish its thickness. But doing that, we would get nowhere because of the time involved.'[3] So risks had to be taken. Whenever a sledge slid into a crevasse, it had to be unlashed and unloaded box by box – a dangerous and delicate manoeuvre that demanded the steadiness of a bomb-disposal crew, for one false move could plunge the sledge into a disastrous fall. It was slow and icy work, like so much Antarctic science.

Charles Swithinbank recalled a moment of panic, when he was reconnoitring ahead. 'A snow bridge collapsed under the middle of my skis. The ends of the skis – front and back

– were on safe ground, but I myself was poised over a menacing black hole. Momentarily unbalanced by the sudden sag in the middle of the skis, I steadied myself with ski poles. Now that I was bridging the crevasse, the problem was what to do next. Lifting one ski would put all my weight on the other, which might break. Very carefully, I put weight on one ski pole placed on the far lip, and more weight on the other placed behind. Transferring the least possible weight from one ski to the other, I slid forward onto the far side. Then I put all my weight on that ski and brought up the other. I was swearing, and in shock – but I was safe.'[4]

Other explorers died in plane crashes. When researchers were working within helicopter range of a base, they could be supplied by these versatile vehicles. Charles Swithinbank had many adventures with helicopters. Pilots always keep their rotors turning during temporary stops. So if a helicopter rested on the ice, with scientists planting markers or taking soundings close to it, and the helicopter suddenly sank into a cavity, the men knew that they would be sliced like salami. An alternative was to winch the researcher down from a hovering copter. Dr Swithinbank recalled an occasion when he was lowered to the surface and had to slip out of his harness to drill a hole and plant a tubular survey marker into it. The helicopter manoeuvred sideways towards him. He took a step forward, but his feet disappeared through a snow bridge. Luckily, Swithinbank's ice drill straddled the crevasse and he clambered out. 'At that point [the pilot] threw me the end of an alpine rope. I had to take off both gloves to tie it round my waist. Fortunately there were few witnesses to the spectacle of a shaken scientist advancing on

Opposite: *A crevasse on Fleming Glacier, Graham Land, as recorded by Charles Swithinbank in 1972.*

hands and knees at the end of a rope belayed to a doorpost of the helicopter. With relief I clambered aboard to relative safety. Sharp ice crystals had lacerated my hands. First aid consisted of putting on gloves to hide the blood.'[5]

At a more mundane level, polar explorers endure much hardship that they rarely complain about. In the intense cold and biting wind chill, the body craves as much fat and protein as carbohydrates; but it was some time before those preparing rations realized this. Some expeditions sleep in boxlike shelters of tarpaulin around a wooden frame mounted on a sledge, cramped but cosy. Others choose different types of tent. The best are double-skinned ones made only in Britain; thin American tents can be very cold at night. Other bodily functions present a challenge. Swithinbank recalled: 'How did we handle the call of nature? The short answer is "As rapidly as possible." We generally walked fifty yards downwind, dug a shallow hole in the snow and squatted over it. It helps to hold on to a shovel. There is no difficulty on a sunny day, but blizzards reward a slow performer with pants full of snow. There is a risk of frostbite in awkward places. The worst form of purgatory is when a dangling penis, desensitized by cold, freezes to the ground. An ice axe may be needed to free it. Returning to the warmer shelter, melting snow leaves soggy underwear.'[6]

The years of dangerous and gallant work on ice and glaciers has gradually taught us about this important medium. The temperature of ice was found to be constant fairly near the surface, but to fall with depth – contrary to a theory that geothermal heat might have warmed it nearer the bedrock. Much difficult research has been done on ice dynamics. Three types of movement were distinguished:

sheet flow, when the ice sheet moves generally outward; stream flow in the faster-moving glaciers and ice streams; and ice-shelf movement by the great floating ice sheets. But the sliding and lubrication of glaciers is not yet fully understood. It was recognized that, under great pressure, ice behaves similarly to sediments being converted into rock. Professor Tony Fogg listed the many ways in which ice was studied. 'During IGY, investigations of Antarctic snow and ice covered density, permeability, porosity, crystal structure, bubble structure, visco-elasticity, ultrasonic wave propagation, radio wave transmission, seismic wave velocity in relation to temperature and density, strength and deformation under a variety of stress and temperature conditions.'[7] In later years, with more scientists and more sophisticated equipment, such research intensified. It became possible to drill hundreds of metres into the ice, and these cores taught more about changes in ice crystals or air bubbles with depth.

All over the world, glaciers have been surging and retreating alarmingly during recent decades. So the study of Antarctica's great glaciers, that flow majestically for hundreds of kilometres, took on added significance. The snows and ice of Antarctica hold the majority of our planet's fresh water. There is concern that global warming might cause the vast West Antarctic ice sheet to collapse, with catastrophic consequences in sea-level rise and climatic change. It therefore became important to understand the flow of ice in this sheet. It comes partly from glaciers, but also from mysterious ice streams which move as fast as surging glaciers along channels in the surrounding ice that are apparently unrelated to the underlying rock. No one understands their sliding or lubrication. The behaviour of the ice sheets in general has been described as glaciology's grand unsolved

problem. Years of painstaking research have built up a history of the Antarctic ice sheets. Among other lines of enquiry, this included study of submerged wave-cut platforms and sea caves, by brave scuba divers working in glacial waters. It emerged that the ice sheets spread to their present size roughly twenty-five million years ago. This was after the huge southern landmass Gondwanaland had split, and the continents drifted apart sufficiently for the circumpolar current to isolate Antarctica.

Techniques of drilling ice cores have improved steadily since the first Antarctic core was brought up in the early 1950s. The Americans undertook a massive programme of drilling. But it was a collaborative effort by the Russians and French that yielded a record 2,200-metre (7,200-foot) core from the Soviet base Vostok isolated in the heart of the East Antarctic plateau, close to the Pole of Inaccessibility. This was achieved by electrically heating a ten-centimetre- (0.4-inch-) diameter tube so that it melted ice around the core, then ensuring that the melt water was recovered before it refroze, and using non-freezing alcohol to balance glaciostatic pressure at great depth. The resulting core represented 160,000 years of snow and ice deposit. Its analysis revealed that mean temperatures had fluctuated by an amazing 11°C (20°F) during this period. Between the last two ice ages, Antarctica was about 2°C (4°F) warmer than at present. This core also showed that the amount of carbon dioxide in the atmosphere had varied, and higher concentrations of CO_2 seemed to relate to warmer periods. The relevance of this to the 'greenhouse' theory of global warming is obvious.

Research has also gone into every possible aspect of the floating ice shelves. In Professor Fogg's words, 'these included accumulation rate, strain rate, ice thickness, sub-glacial water depth, gravity, temperatures, rate of movement, seismic and radio-wave velocities, electrical resistivities and radar polarization'. It is often dangerous work, for camps can be on ice that splits and starts to float out to sea or, worse, can suddenly turn turtle like a capsizing iceberg.

One reason for studying Antarctic glaciers is because the southern icecap is known to play a crucial role in the circulation of the earth's atmosphere and oceans. The melting and freezing of the icecaps must have an effect on the timing and intensity of global warming. Conversely, new research seems to show that warming of the Southern Ocean might unexpectedly thicken the ice shelf. A team from the British Antarctic Survey used hot water to drill 800 metres (2,600 feet) through the Ronne Ice Shelf. They found that the formation of sea ice made the ocean circulate beneath the shelf and controlled the melting of its base. Thus, if less sea ice were formed, the ice shelf might thicken.

North polar scientists have also learned how to drill ever deeper into the snow and ice. An electromechanical drill recently penetrated for over 3,000 metres (almost 10,000 feet) through the highest point in the Greenland ice sheet and brought up samples 250,000 years old.

The conventional way of measuring ice thickness was by seismic bangs, but this involved crews travelling across the hostile surface and then undertaking the difficult and dangerous task of fixing the charges. The veteran American radio technician Amory Waite noticed that Very-High-Frequency radio waves could penetrate icebergs, so he tried making soundings in Antarctica from a sledge. It was then discovered in 1960 that a plane flying over an ice sheet could pick up two radio echoes: one from the surface and a second from the glacier bed. But simple radio soundings

Above: *A scientist working inside a crevasse at Signy, Antarctic.*
Crevasses are one of many dangerous locations for the essential study of
ice dynamics and crystals.

could measure only shallow ice. The Scott Polar Research
Institute in Cambridge developed a device for measuring by
pulsed radar and, to its scientists' delight, it was found that
this instrument could penetrate far deeper and it also
worked from a plane. The mapping of Antarctica's ice and
underlying geography was transformed. Charles Swithinbank,
one of the pioneers of seismic measurement, commented:

'Imagine our feelings on finding that from each hour of flight,
while admiring the scenery from a comfortable chair (in a
plane), we could carry home an almost unbroken cross-sec-
tion covering a hundred miles or more of this icy
landscape.'[8] Gradually, the immense continent was surveyed
in this way. By 1982 more than half Antarctica had been
radio-sounded, in a 50- to 100-kilometre (30- to 60-mile)
grid, through half a million kilometres (over 300,000 miles)
of flight tracks. Now, remote sensing from satellites is also
used, to show both the surface elevations of the ice and its
horizontal distribution. Recently, David Drewry of the
British Antarctic Survey developed a computer model to
estimate the shape and behaviour of the entire ice sheet.

Of all the discoveries emanating from Antarctica, the one
that has made the greatest public impact is the discovery of
the hole in the ozone layer. The British meteorologist
George Dobson discovered, in the 1930s, by observing
meteor trails, that some fifty kilometres (thirty miles) above
the earth's surface is a thin bubble of ozone that helps to
protect our atmosphere from ultraviolet radiation.
Instruments invented by Dobson were used during the
International Geophysical Year in 1957 to start systematic
measurement of this ozone layer – this was done because it
could help to trace atmospheric circulation at high levels. It
was found that most ozone was produced near the Equator
and in high latitudes only during the polar summers. In the
1970s it was noticed that artificial CFC (chloro-fluoro-car-
bon or Freons) – much used in refrigerators and aerosols –

Opposite: *The Byrd Glacier (right) and the outflow of Darwin*
Glacier (top left) as seen from space. The Antarctic coastline runs
diagonally across the frame. Many characteristic features of glaciers are
seen here, such as the ridges running parallel to the direction of flow.

was accumulating in the lower atmosphere. It was known that the chlorine in CFC destroys ozone. Scientists then realized that CFC, which is virtually indestructible, would, when transported into the stratosphere, yield chlorine, which in turn would destroy the ozone layer. The United States in 1979 launched a polar-orbiting satellite with an ozone system that produced daily maps of all ozone over the sunlit parts of the globe. However, this satellite was pro-grammed to ignore very low values, which were presumed to be due to instrument error. But in 1984 the British Antarctic scientist Joseph Farman, using Dobson's ground-based spectro-photometers backed by balloon-borne

instruments, found that there had been a catastrophic thirty per cent decline in the ozone layer over Antarctica during the quarter century since the IGY. This caused a sensation. The Americans' reaction was 'immediate, massive and effec-tive,'[9] with a series of National Ozone Expeditions that involved the space agency NASA and Antarctic scientists of six nations in a co-ordinated space-, air- and ground-based investigation. The alarming hole in the ozone layer was con-firmed, and it was found to be worst over the southern

Below: *Ozone distribution over Antarctica as seen in false colour image over two four-year periods, 1979–82 and 1989–92. Reds and oranges indicate high ozone concentrations.*

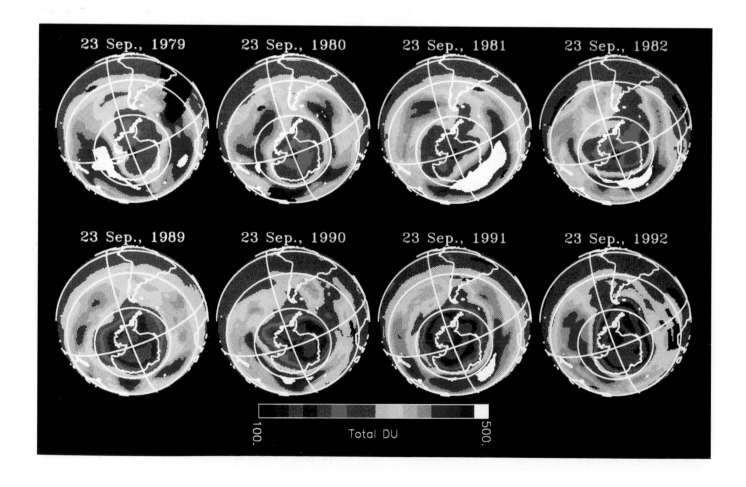

hemisphere. During the Antarctic spring, molecules of chlorine, blown south from industrial centres, adhere to ice crystals in clouds formed in the vortex of cold winds that blow around the South Pole. This triggers a catalytic reaction when the sun warms those clouds. The chlorine atoms then destroy up to half the ozone over Antarctica.

People in Australia and New Zealand covered their skin and their children and pigs from exposure to the ultraviolet rays in direct sunlight. Perhaps more alarmingly, it is feared that these ultraviolet rays will destroy phytoplankton, which is the main food of krill and the base of many marine food chains, and which is also a crucial agent for cleansing atmospheric carbon dioxide. Politicians reacted with exemplary speed and cohesion. At Montreal in 1987 thirty-five nations agreed to phase out the production of CFCs. This was relatively easy, since chlorofluorocarbons were only recently invented; but it was a momentous first concerted bid to check pollution. And it was a triumphant justification for much arduous Antarctic research.

Scientific studies in Antarctica are not solely physical. Many explorers study the flora and fauna of the southern continent. Only three per cent of Antarctica is not covered by perennial ice and snow, so that vegetation has few growing areas. Plant life is also limited by the low temperatures, isolation, poor and impoverished soils, and lack of rain water. Nevertheless, hardy biologists are learning about the region's tough herb tundra, mosses, lichens and algae. Botanists have a far richer field for study in the mass of plants that flower in northern Greenland and elsewhere in the Arctic summer.

The research stations dotted around the shoreline of Antarctica tend to be on ice-free rocks, so that they are often near colonies of penguins and seals. Different species of seal are found in all parts of the world, including monk seals in the Mediterranean and near the Hawaiian Islands. There are four types of seal in Antarctica, all distinct and each successful. Nigel Bonner of the British Antarctic Survey comments that 'the crabeater seal is one of the most remarkable, though least known, of the mammals of the world. Its population probably numbers between fifteen and forty million animals, making it one of the most abundant large mammals.'[10] Over half the world's seals are crabeaters, and they are big animals: females grow to two metres (6.5 feet) and weigh up to 225 kilograms (500 pounds). This species is difficult to study, because it lives on drifting pack ice or swims far out to sea in packs resembling schools of porpoises.

More has been learned about fierce leopard seals, so called because of mottled spots on their silvery flanks. These streamlined killers can attain 3.5 metres (11.5 feet) and weigh 500 kilograms (1,100 pounds). Leopard seals prey on penguin, but they can attack a swimming man. Despite this danger, intrepid cameramen and marine scientists often enter Antarctic waters, and have filmed seals seizing penguins. In 1986 a photographer got too close to a leopard seal on an ice shelf. The animal grabbed him round the ankle and started to drag him to the ocean. The photographer desperately beat at the leopard seal with heavy camera equipment, but it hung on. Another man grabbed the photographer, but both were pulled sliding across the ice. They got to the edge and were about to be dragged into the sea, when the second man managed to hammer the seal's head with an ice axe. It let go, and the men collapsed exhausted on the ice; but the seal attacked again and was driven off

Above: Colonies of penguins and seals are often found near the research stations in Antarctica. The crabeater seal however lives on drifting pack ice.

only by a concerted battering by both desperate men. When one of these ferocious seals catches a penguin in its massive jaws, it shakes the bird out of its skin before swallowing it. Diving penguins are elegant swimmers who fly through the water at thirteen knots; but when landing – or fleeing from leopard seals – they accelerate and shoot vertically out of the water. A familiar sight in some penguin colonies is a crowd jostling one another at the ice edge until one falls in; the rest then peer over to see whether it is caught by a leopard seal. Leopard seals are now the main predators of king penguins. In the past this dignified bird was slaughtered by man for its blubber and plumage. Now all penguins are protected, and there have been many expeditions and research projects to learn more about these delightful

Opposite: Part of the vast king penguin colony (Aptenodytes patagonia) *at Salisbury Plain, South Georgia. Brown chicks segregate into groups.*

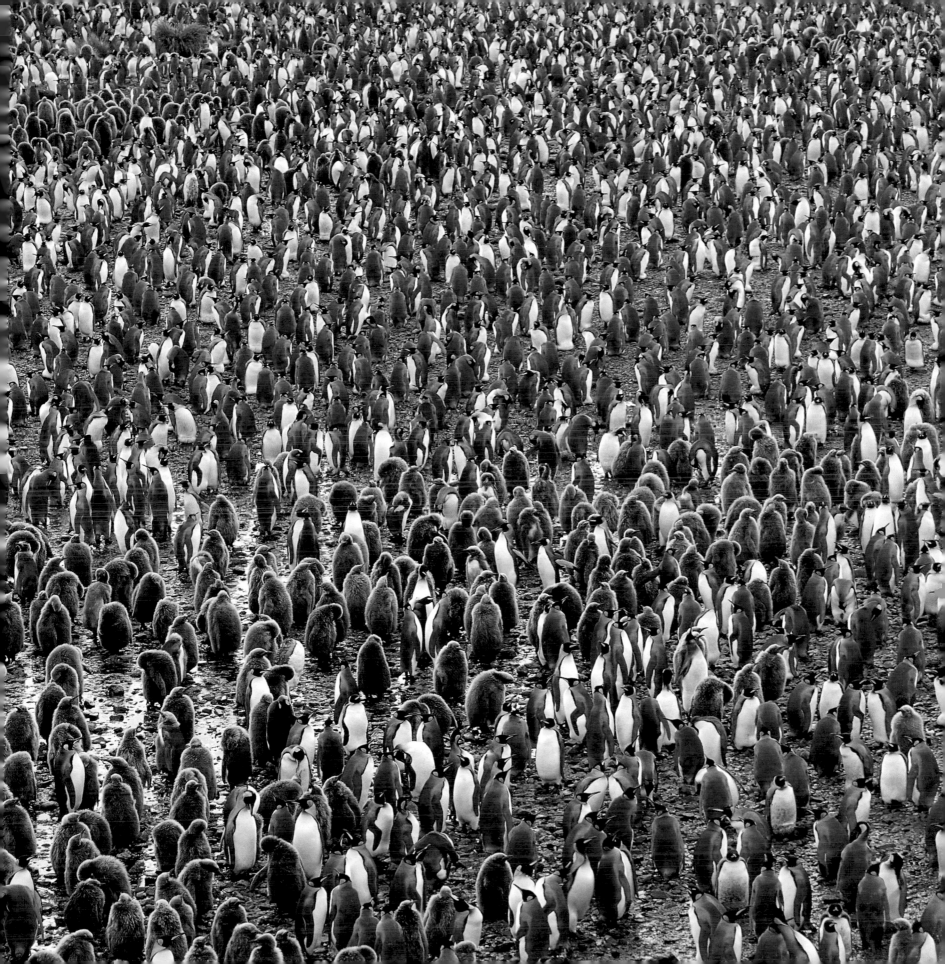

symbols of Antarctica. The British base Halley Station is isolated on a waste of ice shelf in the Weddell Sea. Its main justification is as a geophysical laboratory: the discovery of the hole in the ozone layer was made at Halley. In biological terms, the ice shelf is a desert, apart from a nearby colony of 10,000 breeding pairs of emperor penguins. Professor Fogg writes that: 'these splendid birds are the largest living penguins, standing up to 1 metre [3 feet] high and weighing up to 46 kilograms [100 pounds]. They have a blue-black back and wings and a white shirt-front shading into yellow above with orange ear-patches. In demeanour as well as appearance they are truly imperial; their movements are deliberate and stately – it would be easy to choreograph them into the entry of the peers in *Iolanthe* – contrasting with the noisy bustle of those slum dwellers, the smaller penguins. With human beings they are unafraid but aloof.'[11]

Ornithologists have learned how emperor penguins can dive to great depths in search of their favourite squid and fish. Because food on their ice shelves is plentiful only in summer, they have to incubate their eggs during the freezing winter. The male does this, balancing a single egg on his feet and covering it with a fold of abdominal skin. Much has been learned about how emperor penguins withstand temperatures as low as –48°C (–54°F), by layers of special feathers, by thousands of birds huddling together, and by minimizing heat loss from their flippers and organs.

One problem in studying penguins is that they are really aquatic creatures. On land they shuffle awkwardly but, as the penguin expert Bernard Stonehouse wrote, 'at sea they swim with the effortless ease of dolphins'. The smaller penguins, such as gentoos and adélies, feed near the surface and can dive for only a couple of minutes; but larger emperor and king penguins dive very deeply, for up to a quarter of an hour, to catch squid and bottom-living fish. 'It has been estimated that the five million adélie penguins distributed among the colonies of a single island in the South Orkneys require up to nine thousand tonnes of krill and larval fish per day to feed their young at the height of the breeding season.' To catch this huge quantity, they forage for up to sixteen kilometres (ten miles). 'Penguins spend much of their lives in the sea, on hunting excursions and migration. Individuals of any species may be immersed for several days at a time; migrating penguins remain at sea for several weeks; and the crested eudyptid penguins (including macaronis and rockhoppers) are seldom found ashore during the four to six months between breeding seasons.'[12]

Two inventions above all others revolutionized polar exploration: planes, particularly those adapted to land on ice; and motorized sledges – all the variants of skidoos. A breed of explorers mounted a Luddite reaction to these machines. They feel that travel in polar regions has become too easy, so they revert to the heroic days of skis and sledges hauled by men or dogs. The pioneer of this return to basics was the British explorer Wally Herbert. Herbert was a seasoned polar scientist. On one long sledge journey, with dogs, his team surveyed down the central plateau of Grahamland on the Antarctic peninsula. Returning in 1962 for more seasons in the southern continent, he explored the Queen Maud Range, sledging from the head of the Beardmore Glacier along the 'infernal plateau' and then down the very difficult icefalls that Amundsen had traversed during his discovery of the South Pole in 1911. During this epic journey, Wally Herbert made first ascents of Mount Nansen (4,050 metres, 13,300 feet) and other peaks, and surveyed and mapped a

large area. But Herbert, a romantic traditionalist, was disgusted by 'the new polar men, scientists "on a picnic" with their "thundering machinery"'[13], who could not form the deep human bonds derived from living with dogs and challenging the elements. The author recalls the burly, bearded Herbert appearing before the expedition screening panel of the Royal Geographical Society, seeking approval for his plans to be the first person to travel and drift across the surface of the North Pole. He spoke with passion about his determination to cross the northern ice with dogs rather than motors, and using sledges that could act as makeshift boats to cross stretches of open water. We told him to come back after he had tested his equipment. He did this, reluctantly; but later told me that he was grateful that we had made him do it, as the sledge-boats would not have worked.

The four man British Trans-Arctic Expedition of 1968–9 took fourteen months to travel some 2,000 kilometres (1,250 miles) from Point Barrow in Alaska, across the North Pole, to Spitsbergen (Svalbard) in the north Atlantic. The first major obstacle was to cross an 130-kilometre (eighty-mile) belt of fractured young ice off the coast of Alaska. They scrambled up the first pressure ridge, a six-metre (twenty-foot) wall of ice blocks. The view from the top was bleak. 'As far as the eye could see there was chaos. It was like a city razed to the ground by a blitz or an act of God, an alabaster city so smashed that no landmarks remained. It was a desolate scene, purified by a covering of snow that had been packed down by the wind; dazzling bright yet horrifying.'[14] It took months to cut their way through this, building ramps to heave the sledges over the tortured ice. Once past, much of their movement came from camping on floes that were carried in the desired direction by prevailing currents. But

the team also drove their dog sledges for long distances across terrible terrain. Apart from the physical hardships of extreme polar weather and jagged ice formations, the greatest dangers in the Arctic come from the breakup of ice floes and from polar bears. Herbert's team left the North Pole with forty huskies on 7 April 1969. But by late May they were unable to reach the coast of Spitsbergen because the ice was rapidly breaking up into a dangerous mush. Men and dogs were lifted to safety by a 'thundering machine': the helicopter of HMS Endurance.

The first man to ski solo to the North Pole, the Japanese Naomi Uemura in 1978, was almost killed by a polar bear. The animal ate some of Uemura's supplies, and then smelled the explorer. 'Turning to the tent, he begins ripping at the flimsy nylon with his great claws and grunting loudly as I literally hold my breath. A new terror seizes me as the tent wall bulges inward and I feel the bear's nose thrust against my back. "Now it is surely over", I think. "I'm finished."'[15] But the bear inexplicably went away. When it returned next day, the explorer shot it. Uemura used a dog team to make the heroic 766-kilometre (476-mile) journey from Ward Hunt Island off the north coast of Ellesmere Island.

In September 1979 a ship sailed out of London on another great polar adventure. This was Sir Ranulph Fiennes' Transglobe Expedition, which aimed to make the first circumnavigation of the earth from Pole to Pole, roughly following the 0° and 180° meridians. After crossing the western Sahara and the swamps of Northern Nigeria in two doughty Land Rovers and a Range Rover, the expedition landed at the South African research base in Antarctica in January 1980. Some supplies were flown inland by the brilliant Antarctic pilot Giles Kershaw; others were hauled by

Above: *In 1992–3 Ranulph Fiennes and Mike Stroud skied unsupported to the South Pole and across Antarctica. Firing the public imagination, this was at considerable physical cost as they suffered muscular loss, frostbite and exhaustion.*

three skidoos driven by Fiennes and his companions. There were the usual hair-raising escapes, as the team crossed the 'hinge line' where the floating ice sheet joined the mainland, and in the inevitable crevasses and snow bridges. The Expedition overwintered, from March to late October, in a base it constructed, 530 kilometres (330 miles) inland on the plateau. Conditions in the Antarctic are extreme, because even in summer the mass of snow reflects heat straight back to space and the ice cools the air above. Thus, the temperature averages –65°F (–55°C) throughout the year and drops as low as –129°F (–90°C). Sudden blizzards can raise the wind to the highest speed recorded on earth – almost to 320 kilometres (200 miles) per hour – while fierce katabatic winds sweep downward to maintain a speed of eighty

kilometres (fifty miles) per hour for days on end. So the Transglobe Expedition hunkered down in its relatively warm huts and snow tunnels, clearing snow drifts from the exits on a daily basis. Fiennes recorded that in Antarctica 'Midwinter Day, July 21, is celebrated fiercely in each and every lonely base camp by the few hundred men and handful of women from a dozen nations who form the transitory population of the whole vast continent. Radio messages of fraternal greetings zing back and forth between the multi-national scientists, all of whom feel the same joy that the longest night is over and the sun is on its way back.'[16] Ranulph Fiennes's wife Ginnie, who was the radio operator, sent and received greetings from the Japanese, Soviet, South African and British bases. The 1,450 kilometres (900 miles) to the South Pole was across totally untraversed terrain, most of it on the high plateau at over 3,050 metres (10,000 feet), at times battling high winds or zigzagging round sharp sastrugi ridges of drifting snow. They reached the great geodetic dome of the American South Pole base on 14 December, then on across fearsome glaciers and white-outs to Scott Base.

The Transglobe Expedition spent 1981 sailing north across the Pacific and then through the stormy North-West Passage, to overwinter again in empty huts of Alert weather station on Ellesmere Island. The dash to the North Pole started in the total darkness of mid-February 1982 and involved alternating skidoo travel and manhauling over tangles of ice-pressure ridges. There were many adventures, with a skidoo and sledge sliding into the ocean and freezing nights with much of their equipment gone, but on 10 April Sir Ranulph Fiennes and Charlie Burton became the first men to have travelled over the earth's surface to both poles. The Antarctic scientist Professor G.E. 'Tony' Fogg noted that

the Expedition's southern crossing was done against the advice of many experts. 'That it was successful was due to the perfection of the techniques for travel and survival in polar regions which were available in 1980, careful planning, and the highly developed instinct for survival and determination to succeed of the people concerned. The Arctic crossing, over sea-ice, was even more testing, and one can

only humbly admire the hardiness and courage which enabled Fiennes and his companions to bring the whole preposterous venture to a successful conclusion.'[17]

Inspired by this feat, Fiennes decided to attempt the North Pole again in 1986, but this time 'unsupported'. Rules were devised for this throwback to earlier polar travel: movement was by manhauling, like Captain Scott; the explorers were allowed no motors other than a radio, preferably solar-powered; there was no aerial resupply or caches of food; and if there were a rescue to save a life, all provisions of the evacuated person had to leave with him. Fiennes was driven back by terrible weather and ice tangles,

Below: *In 1981 on the Transglobe Expedition, Ranulph Fiennes and Charlie Burton became the first men to have travelled to both poles. In 1990 Fiennes tried again to reach the North Pole unsupported, having been driven back in 1986 by bad weather. His photograph shows Mike Stroud manhauling supplies across the ice.*

307 nautical miles from his goal. In that same year the French skier Jean-Louis Etienne became the first to get to the Pole solo, but with five resupply flights. The American Will Steger also led a team of skiers to the North Pole in 1986, without resupply. His men devised a way of using their ski poles both as radio aerials and as supports around the edges of a circular tent.

Sir Ranulph Fiennes, slim, handsome and with a lively sense of humour, has the eccentricity and fanatical determination of the archetypal explorer. In 1990, now aged 47, he gallantly tried again with one companion. This time they started from northern Russia; but they were again blocked by unusual weather conditions. Meanwhile, three young and very fit Norwegians set off, unsupported, from Resolute in the Canadian Arctic. One member wrenched his back when his sledge slipped into a crevasse, but the others obeyed the unwritten rules of an unsupported expedition by evacuating all stores of the injured man when he was rescued. Whenever the saltwater ice cracked, this team had perfected the tactic that Wally Herbert attempted two decades earlier. The leader, Bòrge Ousland explained: 'We had designed our sledges extra wide and high to act as boats, and now we lashed them together with our skis to form a stable catamaran and paddled with a shovel or another ski.'[18] They were thus able to cross stretches of open water where other expeditions had to wait for these to freeze over. It was a gruelling two-month trek, zigzagging over jagged pressure ridges, crevasses and open water. The ice they were crossing drifted southwards against them, at up to sixteen kilometres (ten miles) a day, so that they were on a treadmill. They were charged by a polar bear and had to shoot the magnificent animal. Thinking that they were racing

Fiennes's team, Ousland wrote that 'we had to forget the cold and the pain and sprint, with fifteen-hour treks and often twenty-four hours between sleeps'.[19] The Norwegians triumphantly reached their goal on 4 May 1990, after two arduous months, and were airlifted off.

Also at that time, a team of six experienced polar skiers from six nations traversed the Antarctic continent at its very widest, all the way down the spine of the Antarctic Peninsula, through the Ellsworth and Thiel Mountains to the Pole, and then across the vast unexplored expanse of East Antarctica via the Soviet Vostok base. They used dog teams and occasional air drops of food. The team included the American veteran Will Steger, the Frenchman Jean-Louis Etienne and the polar scientists Geoff Somers of the British Antarctic Survey and Victor Boyarsky of the USSR. They started in July 1989 and ended seven months later in March 1990. They had trudged, 'antlike, across 3,700 miles (6,000 kilometres) of brutal terrain, from sea level to lonely elevations above 11,000 feet (3,350 metres) battered for weeks by continuous storms, exhausted and frostbitten in temperatures that approached 60 below, winds that howled at 90 miles an hour (145 kilometres an hour).'[20] Tragedy almost struck a few miles from the end. The six were pinned in their tented camp by a twenty-four-hour storm. The experienced Japanese member, Keizo Funatsu, went to check their dogs and was lost in the raging white-out. The others searched desperately for their missing team-mate in swirling snow, and finally found him huddled in a shallow cavity and half buried by the blizzard.

Three years later, Ousland's north polar companion, the young Oslo lawyer Erling Kagge, became the first person to ski alone to the South Pole. Hauling a 120-kilogram

Above: *In January 1993 Erling Kagge, a young Oslo lawyer, became the first person to ski alone to the South Pole. He hauled a heavy sledge across 800 miles for fifty days.*

(265-pound) sledge over 1,300 kilometres (800 miles) for fifty days, Kagge reached the Pole in January 1993. He had to crawl over crevasses and up the steep slopes to the plateau. Once up on the more open windswept plain, Kagge skied on doggedly, day after day. 'Whenever the wind forces me to my knees, at times blowing me back northwards, and the cold eats into my bones so that I can hardly move, crossing the polar plateau is "hell". My fingers are frozen so stiff that I am unable to pitch the tent, and I know that if I stop now I will not be able to move on.'[21] But he never felt lonely, and he revelled in the beauty of white and blue, and 'the changing colours of the snow and the majestic might of the landscape'.

In that same year, 1993, Sir Ranulph Fiennes and Mike Stroud skied together, unsupported, to the South Pole and then onwards across Antarctica. They suffered terrible muscular loss, because they were not eating nearly enough fat, carbohydrates and protein to support bodies exerting themselves to the utmost in extreme conditions. The two gallant skiers reached the ice flows on the far side of the continent, but could not quite reach the open sea.

These unmechanized expeditions were somewhat artificial. They deliberately eschewed motorized sledges and air support (except for emergencies) in order to turn the clock back to a more challenging past. Because they all moved across country, they were unable to do any serious scientific research — apart from some studies of stress on the bodies of the explorers themselves. This is because science needs time, not motion. Scientific discovery is based on observation and monitoring, preferably in one location for as long as possible, followed by months of laboratory analysis. But the polar exploits involved great courage, endurance and determination. In this they were the equals of the heroic explorations they sought to emulate. They achieved 'firsts' under their self-imposed rules, and they frequently crossed country that had never been traversed. All this fired the public imagination, and thus helped the cause of polar exploration in general.

REFERENCES

INTRODUCTION

1 Dr Robert Ballard quoted in Priit J. Vesilind, 'Why Explore?', *National Geographic* 193:2, February 1998, 42.
2 Dr Maeve Leakey quoted in Vesilind, Idem, 43.

RAIN FORESTS

1 Russell Braddon, *The Hundred Days of Darien* (Collins, London, 1974), 191; Ingrid Cranfield, *The Challengers* (Weidenfeld & Nicolson, London, 1976), 259.
2 Adrian Forsyth and Ken Miyata, *Tropical Nature* (Charles Scribner's Sons, New York, 1984), 17.
3 Klaus Kubitski, 'The dispersal of forest plants', and Ghillean T. Prance, 'The pollination of Amazonian plants', in Ghillean T. Prance and Thomas E. Lovejoy, eds., *Key Environments: Amazonia* (Pergamon Press, Oxford, 1985), 170–1 and 199.
4 Forsyth and Miyata, *Tropical Nature*, 37.
5 Andrew W. Mitchell, *The Enchanted Canopy* (Fontana/Collins, London, 1986), 25–6.
6 Mitchell, Idem, 58.
7 Mitchell, Idem, 140.
8 Edward O. Wilson, 'Rain forest canopy. The high frontier', *National Geographic* 180:6, December 1991, 85.
9 Wilson, Idem, 92.
10 Woodruff W. Benson, 'Amazon ant-plants', in Prance and Lovejoy, eds., *Key Environments. Amazonia,* 239–40.
11 David Attenborough, 'Introduction' to Mark Collins, ed., *The Last Rainforests* (Mitchell Beazley, London, 1990), 9.
12 Dian Fossey, *Gorillas in the Mist* (Hodder and Stoughton, London, 1983), 3.
13 Fossey, Idem, XV.
14 Jane Goodall, 'Foreword' to Richard W. Wrangham, W. C. McGrew, Frans B. M. de Waal, Paul G. Heltne, eds., *Chimpanzee Cultures* (Harvard University Press, Cambridge, Mass., 1994), XVIII–XIX.
15 Biruté Galdikas, 'Indonesia's Orangutans. Living with the great orange apes', *National Geographic* 157:6, June 1980.

16 Mitchell, *The Enchanted Canopy*, 119.
17 Mitchell, Idem, 116.

OCEANS

1 Jacques-Yves Cousteau, *The Silent World* (Hamish Hamilton, London, 1953), 3.
2 Cousteau, Idem, 21.
3 Cousteau, Idem, 130.
4 Rachel Carson, *The Sea Around Us* (London, 1951), 216.
5 Cousteau, *The Silent World*, 92.
6 John B. Corliss and Robert B. Ballard, 'Oases of Life in the Cold Abyss', *National Geographic* 152:4, October 1977, 441.
7 Peter A. Rona, 'Deep-sea geysers of the Atlantic', *National Geographic* 182:4, October 1992, 105–9.
8 Margaret Rule, 'The Search for Mary Rose', *National Geographic* 163:5, May 1983, 663.
9 Robert D. Ballard, 'A Long Last Look at Titanic', *National Geographic*, December 1986.
10 Carson, *The Sea Around Us*, 177.
11 John Pernetta, *Atlas of the Oceans* (Mitchell Beazley, London, 1977), 52.
12 Pernetta, Idem, 53.

MARINE LIFE

1 James Hamilton-Paterson, *Seven-Tenths* (Hutchinson, London, 1992), 176.
2 Victor Hugo, *Les Travailleurs de la Mer* (*Toilers of the Sea*), 1866; Cousteau, *The Silent World*, 106.
3 Cousteau, 106.
4 Fred Bavendam, 'Eye to Eye with the Giant Octopus', *National Geographic* 179:3, March 1991, 88–9.
5 James Hamilton-Paterson, *Seven-tenths: the Sea and its Thresholds*, 169.
6 Cousteau, *The Silent World*, 109.
7 Cousteau, Idem.
8 Cousteau, Idem.
9 Hillary Hauser, *Call to Adventure* (Bookmakers Guild, Longmont, Colorado, 1987), 80; Ron and Valerie Taylor, *Underwater World* (Ure Smith, Sydney, 1976).
10 Hillary Hauser, *Call to Adventure,* 81.
11 Eugenie Clark, *The Lady and the Sharks*

(Harper & Row, New York, 1969); 'Into the Lairs of 'Sleeping' Sharks', *National Geographic,* April 1975; 'Sharks: Magnificent and Misunderstood', *National Geographic,* August 1981
12 Eugenie Clark, 'Gentle Monsters of the Deep: Whale Sharks', *National Geographic* 182:6, December 1992, 123, 130.
13 Roger Payne, *Among Whales* (Scribner, New York, 1995), 21.
14 Payne, *Among Whales*, 21.
15 Payne, *Among Whales*, 212.
16 Sylvia A. Earle, 'Humpbacks: The Gentle Giants', *National Geographic* 155:1, January 1979, 2.
17 James D. Darling, 'Whales. An Era of Discovery', *National Geographic* 174:6, December 1988, 875.
18 Roger Payne, 'Swimming with Patagonian right whales', *National Geographic* 142:4, October 1972, 586.
19 Cliff Tarpy, 'Killer Whale Attack!', *National Geographic* 155:4, April 1979, 543.
20 Sylvia Earle, 'Humpbacks: The Gentle Giants', *National Geographic* 155:1, January 1979, 5.
21 Roger Payne, *Among Whales*, 34.
22 Al Giddings, 'An incredible feasting of whales', *National Geographic* 165:1, January 1984, 88.
23 G. E. Fogg and David Smith, *The Explorations of Antarctica* (Cassell, 1990), 101.
24 Sayed Z. El-Sayed, 'Plankton of the Antarctic Seas', in W. N. Bonner and D. W. H. Walton, eds., *Key Environments: Antarctica* (Pergamon Press, 1985), 150.
25 Phillip Law, *Antarctic Odyssey* (Heinemann, 1983) quoted in Fogg and Smith, *The Explorations of Antarctica* (Cassell, 1990), 106.
26 Michael J. A. Butler, 'Plight of the Bluefin Tuna', *National Geographic* 162:2, August 1982, 223.
27 Eugenie Clark, 'Hidden life of an undersea desert', *National Geographic* 164:1, July 1983.
28 Sylvia Earle quoted in Hillary Hauser, *Call to Adventure*, 149.
29 John B. Corliss and Robert D. Ballard, 'Oases of Life in the Cold Abyss', *National Geographic* 152:4, October 1977, 441. Robert D. Ballard,

'Return to the Oases of the Deep', *National Geographic* 156:5, November 1979, 689–703.

30 Peter A. Rona, 'Deep-sea geysers of the Atlantic', *National Geographic* 182:4, October 1992, 105–9.

DESERTS AND SAVANNAS

1 Michael Asher, *Two Against the Sahara* (Viking Penguin, London, 1988), 62.

2 Asher, Idem, 160.

3 Asher, Idem, 164–5.

4 Tony Allan and Andrew Warren, *Deserts, the Encroaching Wilderness* (Mitchell Beazley, London, 1993), 9.

5 Rick Gore, 'The Desert. An Age-old Challenge Grows', *National Geographic* 156:5, November 1979, 610.

6 William S. Ellis, 'Africa's Sahel, the Stricken Land', *National Geographic* 172:2, August 1987, 51.

7 Dr Mustafa Tolba quoted in Ellis, Idem, 163.

8 Peter Beaumont, *Drylands: Environmental Management and Development* (Routledge, London and New York, 1989), 473.

9 USSR Ministry of Reclamation and Water Management, *Golodnaya Steppe. An Associated Case Study* (Moscow, 27 May 1977), 1, quoted in James Walls, *Land, Man, and Sand* (Macmillan Publishing Co., New York, 1980), 216.

10 William J. Hamilton III, 'The Living Sands of the Namib', *National Geographic* 164:3, September 1983, 367.

11 Tony Allan and Andrew Warren, *Deserts, the Encroaching Wilderness* (Mitchell Beazley, London, 1993), 48.

12 Anthony Smith, *The Great Rift, Africa's Changing Valley* (BBC Books, London, 1988), 181.

13 George Schaller, quoted in Gareth Patterson, *With my Soul Amongst Lions* (Hodder and Stoughton, London, 1995), 25–6.

14 Colin Willock, *Africa's Rift Valley* (Time-Life Books, Amsterdam, 1974), 160.

15 Willock, Idem, 165.

16 Nicholas Gordon, *Ivory Knights. Man, Magic and Elephants* (Chapmans Publishers Ltd., London, 1991), 5.

17 Malcolm Coe, *Islands in the Bush* (George Philip, London, 1985), 151.

18 Esmond Bradley Martin, 'They're killing off the rhino', *National Geographic* 165:3, March 1984, 408.

19 Glenn Prestwich, 'Dwellers in the Dark: Termites', *National Geographic* 153:4, April 1978, 535.

20 Richard E. Leakey, *The Making of Mankind* (Michael Joseph, London, 1981), 15.

21 Donald C. Johanson and Maitland A. Edey, *Lucy, The Beginnings of Humankind* (Granada Publishing Ltd., St Albans, Herts., 1981), 15–17.

22 Leakey, *The Making of Mankind*, 67.

23 Anthony Smith, *The Great Rift*, 188–9.

MOUNTAINS AND CAVES

1 Edmund Hillary, 'Everest: the Last Lap', in Chris Bonington, ed., *Great Climbs* (Mitchell Beazley, 1994), 162.

2 Hillary, Idem, 163.

3 Stephen Venables, 'High Asia', in Bonington, ed., Idem, 151.

4 Maurice Herzog, *Annapurna* (translated by Nea Morin and Janet Adam Smith, Jonathan Cape, London, 1952) quoted in Ian Cameron, *Mountains of the Gods* (Century Publishing, London, 1984), 166–8.

5 Kurt Diemberger, *Summits and Secrets* (Allen & Unwin, London, 1971) quoted in Chris Bonington, *Quest for Adventure* (Hodder & Stoughton, London, 1981), 261.

6 Ardito Desio, *Ascent of K2* (1955) quoted in Ian Cameron, *Mountains of the Gods*, 176.

7 Venables, in Bonington, ed., *Great Climbs*, 152.

8 Noel Grove, 'Volcanoes, Crucibles of Creation', *National Geographic* 182:6, December 1992, 41.

9 Katia and Maurice Krafft, *The Conquest of the Volcanoes*, quoted in Michèle Gavet-Imbert, ed., *The Guinness Book of Explorers and Exploration* (Guinness Books, Enfield, Middlesex, 1991), 267.

10 Gavet-Imbert, Idem, 266.

11 Noel Grove, 'Volcanoes, Crucibles of Creation', *National Geographic* 182:6, December 1992, 28.

12 Franco Barberi quoted in Grove, Idem, 35.

13 John L. Eliot, 'Glaciers on the Move', *National Geographic* 171:1, January 1987, 113.

14 Keith Miller, *Continents in Collision* (George Philip, London, 1982), 102.

15 Miller, Idem.

16 Bradford Washburn, 'Mount Everest: Surveying the Third Pole', *National Geographic* 174:5, November 1988, 657.

17 Anthony Waltham, 'Caves in the Mulu Hills', *Geographical Magazine*, 1979, quoted in Ian Cameron, *To the Farthest Ends of the Earth* (Macdonald and Jane's, London, 1980), 247.

18 Robin Hanbury-Tenison, *Mulu: The Rain Forest* (Weidenfeld and Nicolson, London, 1980), 82.

19 Tony Waltham and Mike Farnworth quoted in Robin Hanbury-Tenison, Idem, 84.

POLAR REGIONS

1 Charles Swithinbank, *An Alien in Antarctica*, 61.

2 Sir Vivian Fuchs, *Of Ice and Men* (Anthony Nelson, Oswestry, 1982), 211.

3 Swithinbank, *An Alien in Antarctica*, 43.

4 Swithinbank, Idem, 63.

5 Swithinbank, Idem, XIII.

6 Swithinbank, Idem, 15.

7 G. E. Fogg, *A History of Antarctic Science*, (Cambridge U P, 1992), 272–3.

8 Swithinbank, *An Alien in Antarctica*, 102.

9 Fogg, *A History of Antarctic Science*, 312.

10 W. Nigel Bonner, 'Birds and Mammals – Antarctic Seals', in W. N. Bonner and D. W. H. Walton, eds., *Key Environments: Antarctica* (Pergamon Press, Oxford, 1985), 203.

11 G. E. Fogg and David Smith, *The Explorations of Antarctica*, 181.

12 Bernard Stonehouse, 'Birds and Mammals – Penguins', in W. N. Bonner and D. W. H. Walton, eds., *Key Environments: Antarctica* (Pergamon Press, 1985), 269–70.

13 Wally Herbert, *Across the Top of the World* (Longmans, London and Harlow, 1969) quoted in Ingrid Cranfield, *The Challengers* (Weidenfeld and Nicolson, 1976), 61.

14 Wally Herbert, *Across the Top of the World* quoted in Chris Bonington, *Quest for Adventure* (Hodder and Stoughton, London, 1981), 331.

15 Naomi Uemura, 'Solo to the North Pole', *National Geographic* 154:3, September 1978, 300.

16 Ranulph Fiennes, *From Pole to Pole* (Reader's Digest, London etc., 1997), 87, condensed from Fiennes, *To the Ends of the Earth* (Hodder and Stoughton, 1983).

17 G. E. Fogg and David Smith, *The Explorations of Antarctica*, 189.

18 Börge Ousland, 'The Hard Way to the North Pole', *National Geographic* 179:3, March 1991, 128.

19 Ousland, Idem, 133.

20 Will Steger, 'Into the Teeth of the Ice. Six Across Antarctica', *National Geographic* 178:5, November 1990, 68.

21 Erling Kagge, *Pole to Pole and Beyond* (N W Damm & Son, Oslo, 1994), 89.

INDEX

INDEX

ACKNOWLEDGEMENTS

The publisher would like to thank to the following copyright holders for permission to reproduce illustrations supplied (page numbers are in bold type):

2 Nigel Winser/RGS/Mkomazi Ecological Research Project 1992/98 **5, 6–7, 8, 12, 58, 82, 192** Land Rover Photographic Library **9, 41** Paul Harris/RGS/Brunei Rainforest Project 1991/92 **10, 16, 17, 18, 19, 21** John Hemming **11, 130** Victoria Southwell/RGS/Kora Research Project 1983 **13** Chris Caldicott/RGS/Brunei Rainforest Project 1991/92 **14–15** Planet Earth Pictures/André Bartschi **20** BBC Natural History Unit/© Martin Dohrn **22, 23, 24–5, 27, 42, 49, 127** BBC Natural History Unit/© Pete Oxford **26** BBC Natural History Unit/© Nick Garbutt **28, 46–7** Planet Earth Pictures/Hans Christian Heap **30** British Motor Industry Heritage Trust **34** Ardea/Nick Gordon **35** South American Pictures/Steve Bowles **37, 80, 179** Heather Angel **38** RGS Picture Library/Dudu Tresca **45** BBC Natural History Unit/© Gerry Ellis **48** Ardea/Pascal Goetgheluck **52** BBC Natural History Unit/© John Sparks **54** Planet Earth Pictures/K & K Ammann **55** Ardea/Adrian Warren **56** Ardea/Jean-Paul Ferrero **59** Planet Earth Pictures/Chris Huxley **61** Ardea/David Nance **63** Science Photo Library/Karen Marks, NOAA Geosciences Laboratory **65** Planet Earth Pictures/Ned Kelly **67** Science Photo Library/BP/NRSC **68** Emery Christof/National Geographic Image Collection **69** Planet Earth Pictures/Norbert Wu **70, 71** Woods Hole Oceanographic Institution **73, 78** Southampton Oceanography Centre **74** The Mary Rose Trust **76–7** Woods Hole Oceanographic Institution/Robert D Ballard **81** Planet Earth Pictures/Robert Arnold **83** Planet Earth Pictures/Gary Bell **84** Planet Earth Pictures/Ken Lucas **86** Planet Earth Pictures/Peter David **87** Planet Earth Pictures/Georgette Douwma **89, 93** Ardea/Ron and Valerie Taylor **90** Planet Earth Pictures/Doug Perrine **92** Ardea/Valerie Taylor **95** BBC Natural History Unit/© Barbara Todd **97** Planet Earth Pictures/Marty Snyderman **98** Ardea/ D Parer and E Parer-Cook **101** Planet Earth Pictures/Duncan Murrell **105** Planet Earth Pictures/Peter Scoones **106** BBC Natural History Unit/© Jeff Rotman **107** Ardea/Becca Saunders **108** Planet Earth Pictures Flip Schulke **110, 113, 122** Nigel Winser/RGS/Oman Wahiba Sands Project 1986 **111, 123, 126** Chris Caldicott/Jordan Badia Research and Development Programme 1994/99 **112, 125** Richard Turpin/RGS/Oman Wahiba Sands Project 1986 **114** Planet Earth Pictures/Alain Dragesco **119** South American Pictures/Tony Morrison **121** Planet Earth Pictures/Danny Dedeurwaerdere **129, 132** Ardea/Ferrero-Labat **131** BBC Natural History Unit/© Simon King **134** Planet Earth Pictures/Jonathan Scott **135** BBC Natural History Unit/© John Downer **138** Land Rover Picture Library/Paul O' Connor **139** Chris Bonington Picture Library/Doug Scott **140** RGS Picture Library/© Sir Edmund Hillary **141** RGS Picture Library/© George Bend **142** Chris Bonington Picture Library/Chris Bonington **144** Mountain Camera/Tadashi Kajiyama **146–7** Mountain Camera/John Cleare **148, 149, 150** Planet Earth Pictures/Images et Volcans/Krafft **153** Planet Earth Pictures/Bourseiller **155** Planet Earth Pictures/Richard Coomber **156** Robert Holmes/RGS/International Karakoram Project 1980 **159** Planet Earth/Kurt Ansler **161** Andy Eavis **162** B & C Alexander **163** Cherry Alexander **164** B & C Alexander/Ann Hawthorne **165, 166** RGS Picture Library/Transantarctic Expedition **168** B & C Alexander/Mike Jaques **169** Scott Polar Research Institute, Cambridge/Charles Swithinbank **171** RGS Picture Library/© Charles Swithinbank **174** B & C Alexander/Paul Drummond **175** Science Photo Library/Baerbel K Luccitta/US Geological Survey **176** B & C Alexander/NASA **178** Ardea/Clem Haagner **182, 183** RGS Picture Library/© Ranulph Fiennes **185** Erling Kagge